One has to know what the rules are
before one can break them.
—Supon Phornirunlit

ROCKPORT
PUBLISHERS

Rockport Publishers, Rockport, Massachusetts

North Light Books, Cincinnati, Ohio

BROCHURES & COLLATERAL

Dogstar Logo Awards Promotion

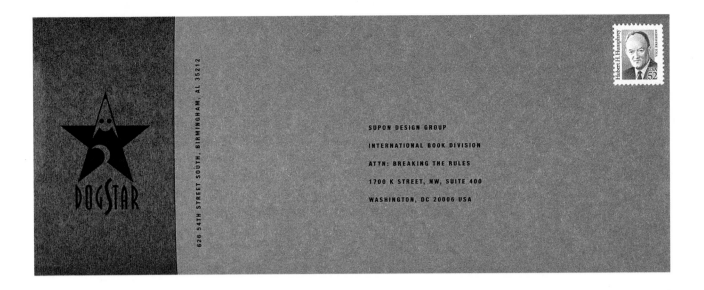

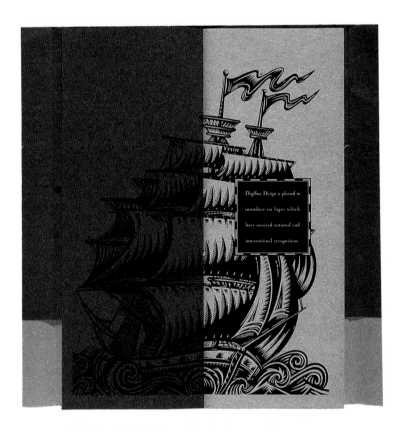

Design Firm: Dogstar Design
Art Director: Rodney Davidson
Designer: Rodney Davidson
Illustrator: Rodney Davidson
Copywriter: Rodney Davidson
Client: Dogstar Design

Objective: To create a self-promotion that reflects the designer's illustration and design skills, as well as "a view of the world" from his corner

Innovation: Construction paper printed through a laser printer gives this handmade piece its unique composition. This promotion features Davidson's best logos and an entertaining group of true and folksy stories to accompany them and provide insight into his design process.

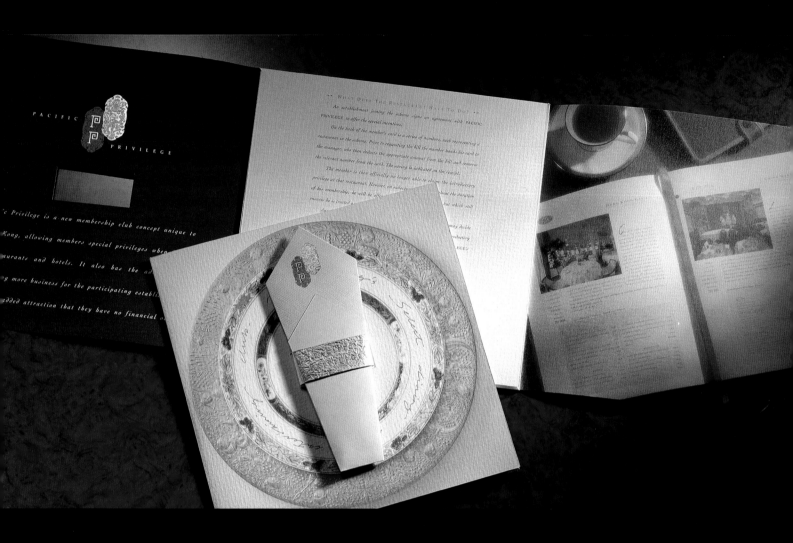

Design Firm: Kan Tai-keung Design
& Associates Ltd.
Art Directors: Freeman Lau Siu Hong,
Eddy Yu Chi Kong
Designers: Freeman Lau Siu Hong,
Eddy Yu Chi Kong, Janny Lee Yin Wa
Photographer: C.K. Wong
Client: Membership Etc. Ltd.

Objective: To develop a promotional kit
to attract clientele to a dining and enter-
tainment club

Innovation: A refreshing response to the
client's upscale business audience, this
solution attracts attention while maintaining
a sophisticated look. An imitation napkin
made of paper can be removed from its ring
and unfolded to reveal a letter of introduc-
tion to the new club.

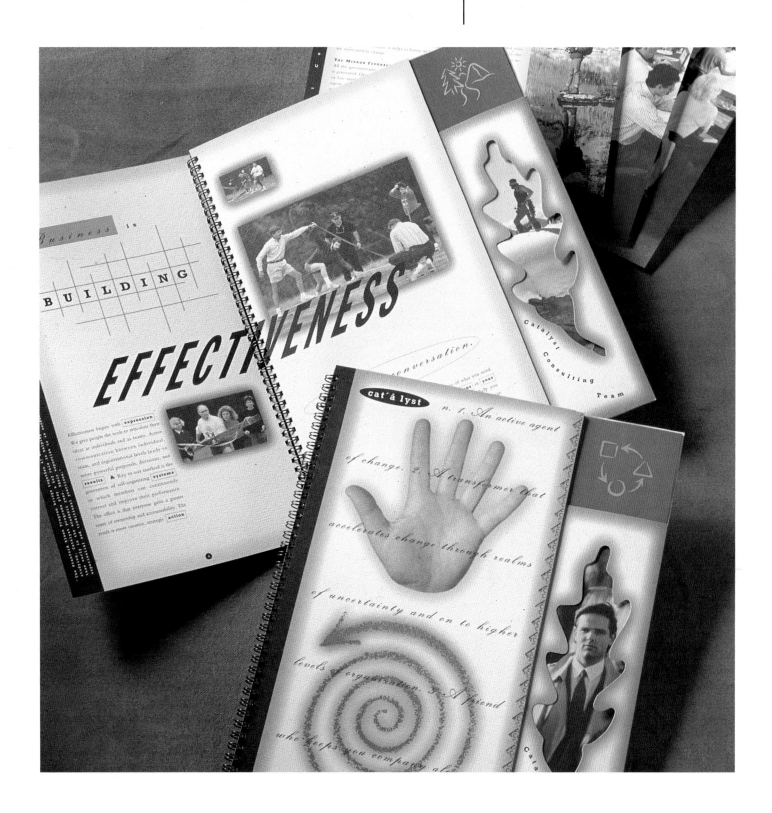

Design Firm: Earl Gee Design
Art Director: Earl Gee
Designers: Earl Gee, Fani Chung
Illustrator: Earl Gee
Photographers: Geoffrey Nelson,
Lenny Lind, and associates
Client: Catalyst Consulting Team

Objective: To create a unique capabilities brochure and folder with insert sheets for a management consulting firm specializing in experiential learning

Innovation: The unusual design combines the functionality of a brochure with the flexibility of a pocket folder: The client can customize each brochure for a particular prospect by changing insert sheets to reveal different images through the die-cut leaf.

Central Cross Brochure

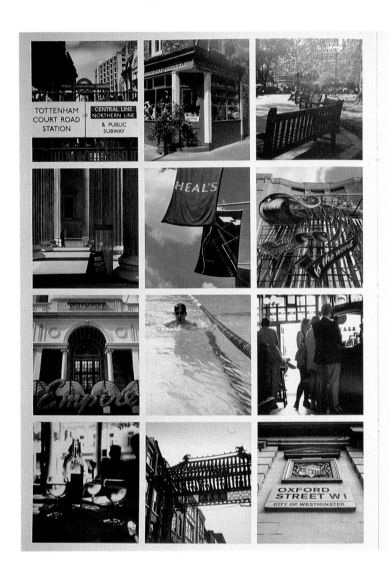

How many locations offer your staff 10 cinemas, 165 restaurants and a small toy museum?

There may be a few other buildings of 150,000 square feet available in other parts of central London.

Not one of them, however, is likely to match the range of attractions that are all within a few minutes' walk of Central Cross, W1.

Starting with 10 cinemas and 22 theatres.

Lunch is a foodie's dream. Within a half-mile radius you'll find 165 restaurants covering virtually every kind of cuisine known to Evening Standard reviewers.

Serious shoppers will be happy, too. Oxford Street is 200 yards from the front door. Tottenham Court Road is even closer.

Cultural interests are catered for. There are 5 libraries in the area, Pollock's Toy Museum is nearby, and the British Museum is only three blocks away. You can keep fit in any one of the 11 leisure clubs.

Central Cross, W1 has exceptional commercial benefits, including proximity to suppliers and clients' head offices; all of which makes business contact easier.

But for staff, its biggest advantage is being located in the liveliest part of town. Quality-of-life factors are, as human resources managers will testify, a vital motivator in attracting and keeping quality personnel.

For employees, too, Central Cross, W1 means a great deal in the West End.

Central Cross, W1
A great deal in the West End

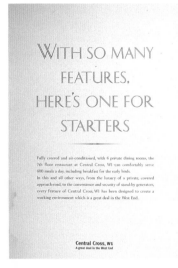

WITH SO MANY FEATURES, HERE'S ONE FOR STARTERS

Fully catered and air-conditioned, with 6 private dining rooms, the 7th floor restaurant at Central Cross, W1 can comfortably serve 600 meals a day, including breakfast for the early birds.
In this and all other ways, from the luxury of a private, covered approach-road, to the convenience and security of stand-by generators, every feature of Central Cross, W1 has been designed to create a working environment which is a great deal in the West End.

Central Cross, W1
A great deal in the West End

Design Firm: Sampson Tyrrell Ltd.
Art Director: David Freeman
Designer: Jon Henry
Client: Prudential Property Investment Management

Objective: To create public interest in a large office block in the center of London

Innovation: Each brochure spread is designed in the rousing style of a series of attention-getting magazine or poster advertisements. Measuring 16.5 by 23 inches, the brochure's size alone provides drama and breaks a rule or two for presentation.

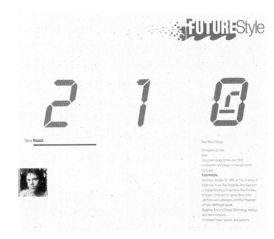

Design Firm: Byron Jacobs Design
Art Director: Byron Jacobs
Designer: Byron Jacobs
Client: Art Direction & Design
of Orange County

Objective: To create an announcement that clearly communicates the details of the symposium and simultaneously displays a unique visual for the design and computer event

Innovation: Recipients are compelled to keep turning the pages of this die-cut, hand-folded leaflet, in which each guest speaker's photograph is bit-mapped and elevated on boxes. This singular technique closely links the design to the technological theme of the symposium.

The IDA Brochure

Design Firm: The Weller Institute
for the Cure of Design
Art Director: Don Weller
Designers: Don Weller, Chikako Weller
Photographer: Michael Schoenfield
Client: Industrial Design Associates

Objective: To present an industrial designer's
portfolio in a manner interesting to the reader

Innovation: A unique format involves the reader in
the design process as he or she turns the pages.
One is captivated by product photos, which are
represented as full-bleed squares, that contrast
with other pages produced in odd shapes and angles
with strong colors and unusual stock. Mylar and
translucent materials, where appropriate, add to
the quality of the images portrayed.

Advertising Law International Brochure

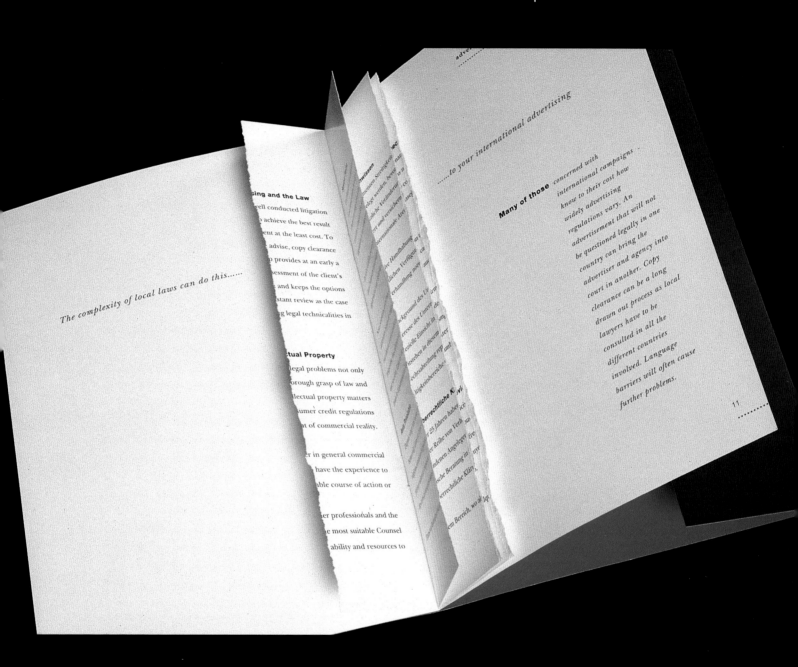

The complexity of local laws can do this......

...to your international advertising

Many of those concerned with international campaigns know to their cost how widely advertising regulations vary. An advertisement that will not be questioned legally in one country can bring the advertiser and agency into court in another. Copy clearance can be a long drawn out process as local lawyers have to be consulted in all the different countries involved. Language barriers will often cause further problems.

11

...ing and the Law
...well conducted litigation ...o achieve the best result ...ent at the least cost. To ... advise, copy clearance ...o provides at an early a ...sessment of the client's ... and keeps the options ...stant review as the case ...g legal technicalities in

...tual Property
...egal problems not only ...orough grasp of law and ...lectual property matters ...umer credit regulations ...t of commercial reality.

...r in general commercial ... have the experience to ...ble course of action or

...er professionals and the ...e most suitable Counsel ...ability and resources to

Design Firm: Trickett & Webb
Art Directors: Lynn Trickett, Brian Webb
Designers: Lynn Trickett,
Brian Webb, Steve Edwards
Client: Advertising Law International

Objective: To compose a brochure, directed at the advertising industry, that explains the services of a group of international lawyers

Innovation: You may not be able to read them, but the center pages torn out of the brochure effectively communicate a warning from the client. In this original approach, the brochure demonstrates its heading: "The complexity of local laws can do this to your international advertising."

The Box Media Kit

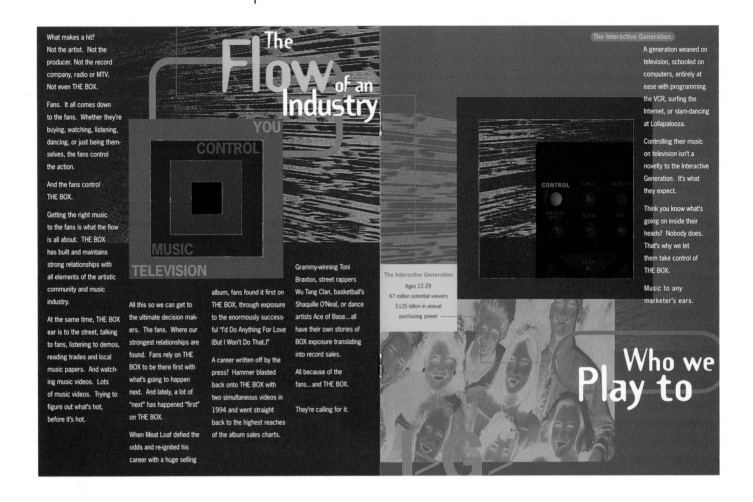

What makes a hit?
Not the artist. Not the
producer. Not the record
company, radio or MTV.
Not even THE BOX.

Fans. It all comes down
to the fans. Whether they're
buying, watching, listening,
dancing, or just being them-
selves, the fans control
the action.

And the fans control
THE BOX.

Getting the right music
to the fans is what the flow
is all about. THE BOX
has built and maintains
strong relationships with
all elements of the artistic
community and music
industry.

At the same time, THE BOX
ear is to the street, talking
to fans, listening to demos,
reading trades and local
music papers. And watch-
ing music videos. Lots
of music videos. Trying to
figure out what's hot,
before it's hot.

The Flow of an Industry

YOU CONTROL MUSIC TELEVISION

All this so we can get to
the ultimate decision mak-
ers. The fans. Where our
strongest relationships are
found. Fans rely on THE
BOX to be there first with
what's going to happen
next. And lately, a lot of
"next" has happened "first"
on THE BOX.

When Meat Loaf defied the
odds and re-ignited his
career with a huge selling

album, fans found it first on
THE BOX, through exposure
to the enormously success-
ful "I'd Do Anything For Love
(But I Won't Do That.)"

A career written off by the
press? Hammer blasted
back onto THE BOX with
two simultaneous videos in
1994 and went straight
back to the highest reaches
of the album sales charts.

Grammy-winning Toni
Braxton, street rappers
Wu Tang Clan, basketball's
Shaquille O'Neal, or dance
artists Ace of Base...all
have their own stories of
BOX exposure translating
into record sales.

All because of the
fans...and THE BOX.

They're calling for it.

The Interactive Generation
Ages 12-29
67 million potential viewers
$125 billion in annual
purchasing power

The Interactive Generation.

A generation weaned on
television, schooled on
computers, entirely at
ease with programming
the VCR, surfing the
Internet, or slam-dancing
at Lollapalooza.

Controlling their music
on television isn't a
novelty to the Interactive
Generation. It's what
they expect.

Think you know what's
going on inside their
heads? Nobody does.
That's why we let
them take control of
THE BOX.

Music to any
marketer's ears.

Who we Play to

Design Firm: Parham Santana Inc.
Art Director: Rick Tesoro
Designer: Rick Tesoro
Copywriter: Diana Amsterdam
Client: The Video Jukebox Network

Objective: To alert recipients and announce the
restructuring of The Video Jukebox Network and
its benefits to a youthful audience

Innovation: A square die-cut throughout the
brochure reveals a VCR "control button." The
client's mission statement—"music television
you control"—builds as the pages are turned.
Another innovation is found in the images,
which were scanned from music videos and com-
bined with typography and color that visually
translate the excitement and interactive expe-
rience of viewing the client's music videos.

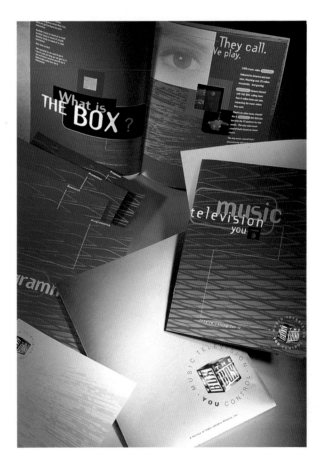

Heritage Insert

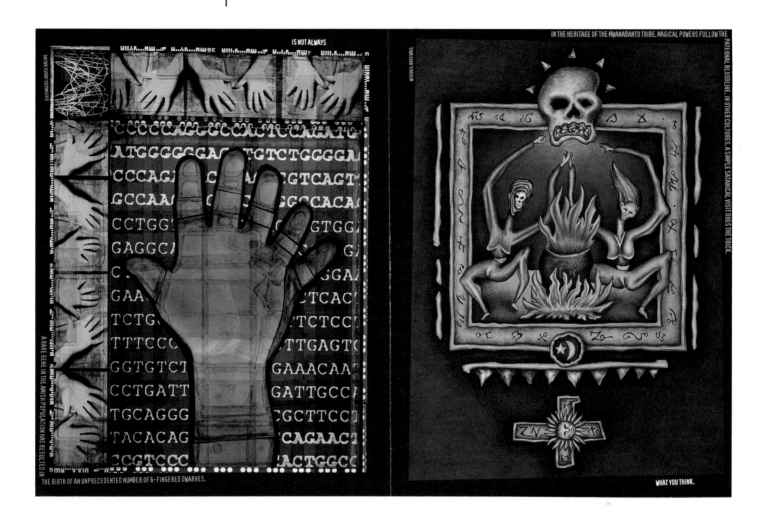

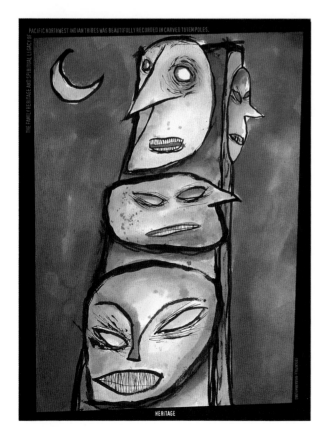

Design Firm: After Hours Creative
Art Director: Russ Haan
Designer: Todd Fedell
Illustrators: Rose Johnson, Bruce Racine,
Russ Wall, Brian Marsland
Client: Heritage Graphics

Objective: To demonstrate to the design
community the client's ability to deliver
top-quality printing

Innovation: Instead of the typical listing
of equipment available and clients served,
unusual typography and a slightly deranged
play on the meaning of the word "heritage"
help set this printer's advertisement
apart from its competitors. The insert
also opens backwards—on the left side
rather than the right.

Hoi Sing Construction 15th Anniversary Leaflet

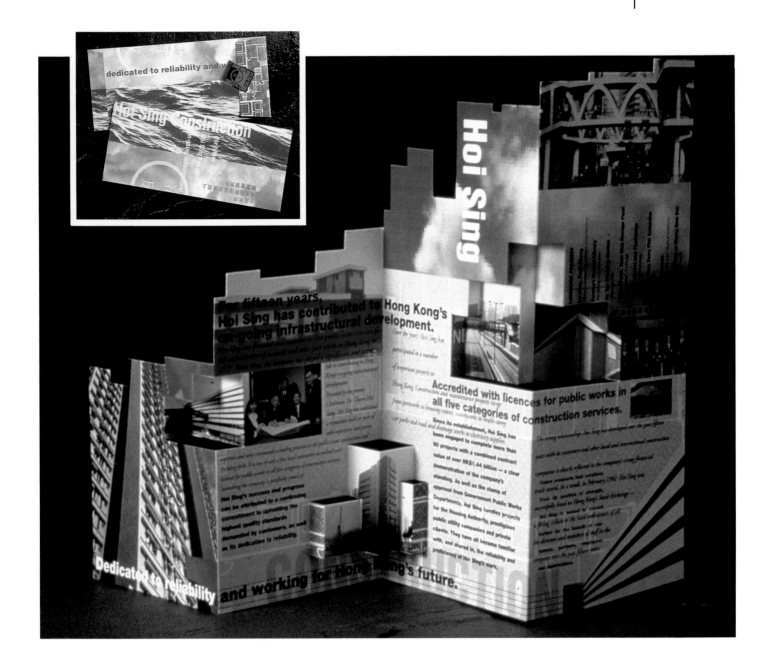

Design Firm: PPA Design Limited
Art Director: Byron Jacobs
Designers: Byron Jacobs, Bernard Lau
Printer: Hong Kong Prime Printing Co., Ltd.
Client: Hoi Sing Construction Co., Ltd.

Objective: To create a promotional leaflet/direct mail piece, for a Hong Kong-based industrial and commercial construction company, that will be kept by recipients after the event has ended

Innovation: The leaflet's die-cut shape represents the an abstraction of the city skyline, against which the client company is built, while the vertical lines suggest the client's positive financial growth throughout its 15 years. The uniqueness of this approach becomes more obvious when compared to existing client promotional materials.

Pac-Link Direct Mail Brochure

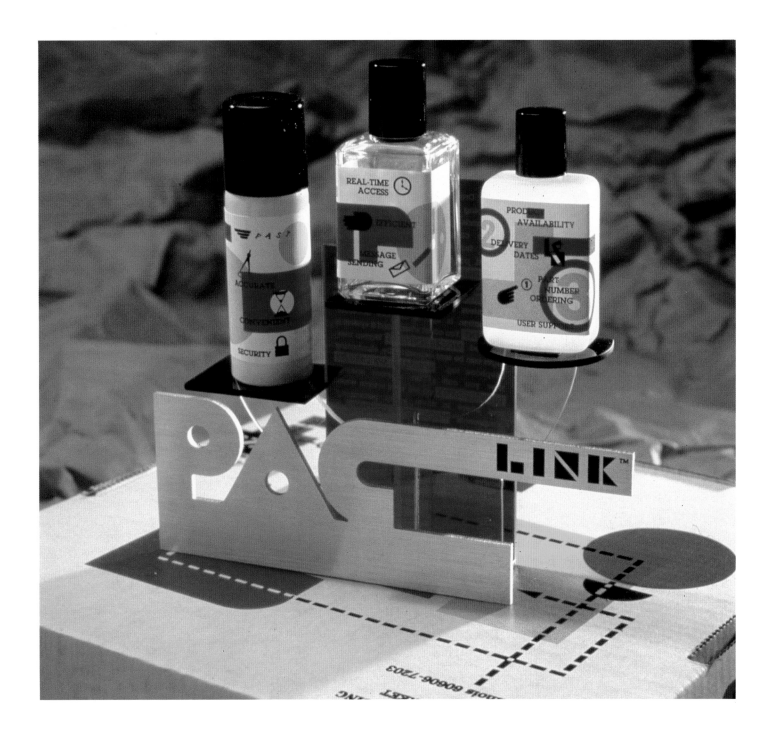

Design Firm: Sayles Graphic Design
Art Director: John Sayles
Designer: John Sayles
Copywriter: Wendy Lyons
Client: Berlin Packaging

Objective: To introduce the client's computerized ordering system to its top 50 customers

Innovation: A bevy of bizarre materials is presented in this three-dimensional brochure made from Plexiglas, metal, corrugated chipboard, and samples of the client's products. Copy is printed on the back of the piece and explains the benefits of the computerized system being promoted.

"Brainstorm" Promotion

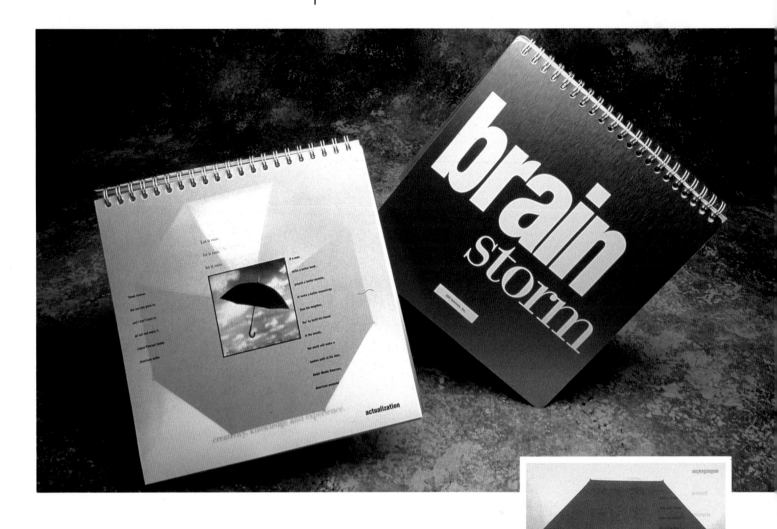

Design Firm: Mark Oldach Design
Designer: Mark Oldach
Writer: Marlene Marks
Project Manager: Linda Goldberg,
USG Interiors, Inc.
Photographers: Allen Short,
Jim Matusich, Stock
Illustrator: David Csicsko
Printer: First Impression Printers
and Lithographers, Inc.
Client: USG Interiors, Inc.

Objective: A brochure that introduces a new cus-
tomized-product service to architects and inte-
rior designers, the primary market of this ceil-
ing, wall, and floor systems manufacturer

Innovation: A brushed-aluminum cover, and ink
that shows through the paper, make this a very
inventive product brochure. It redefines USG as
a creative (not just technical) organization by
layering thought bites from an actual three-hour
brainstorming session with illustrations repre-
senting the product's benefits. The unusual use
of translucent paper throughout makes this tech-
nique possible.

Shaw Contract Mailer

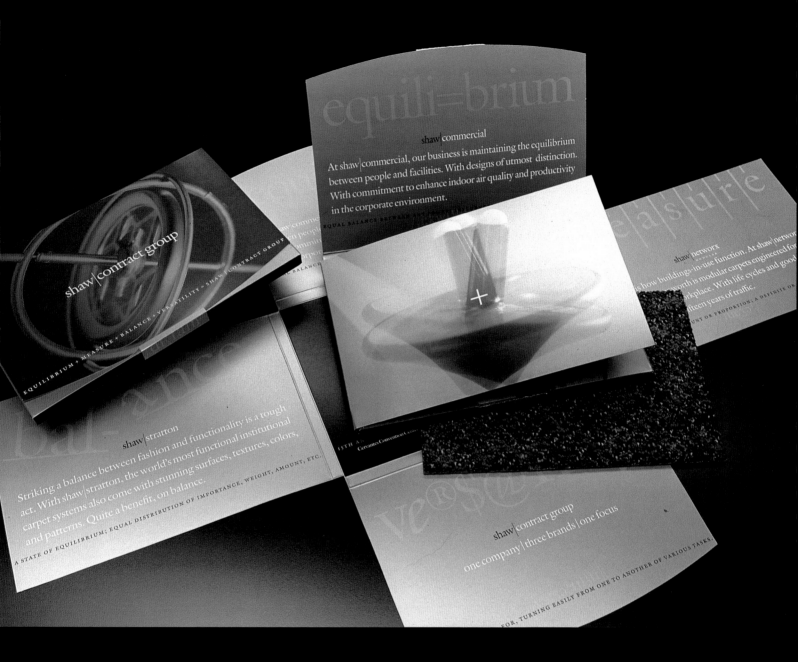

Design Firm: Wages Design
Art Director: Rory Meyers
Designer: Rory Meyers
Copywriter: Tony King
Client: Shaw Contract

Objective: To introduce the client's new corporate identity and demonstrate to the interior design community the client's dedication to both aesthetic quality and its product's technical superiority

Innovation: Using a complex combination of die-cuts and metallic inks, this mailer introduces the Shaw/Contract Group's new identity and its "one company, three brands, one focus" beliefs. Combined with other roll-out pieces, this direct-mail project shatters the client's negative image among some interior designers and helps the company reshape itself as a leader in carpetmaking.

Sing Cheong Printing Co. Brochure

Design Firm: PPA Design Limited
Art Director: Byron Jacobs
Designers: Byron Jacobs, Chris Chan
Illustrators: Percy Chung, Robin Whyler
Printer: Sing Cheong Printing Co. Ltd.
Client: Sing Cheong Printing Co. Ltd.

Objective: To create a capabilities brochure that clearly communicates the attributes and services of the company

Innovation: The imaginative structure of the brochure resembles the format of an ink swatch book. Each panel illustrates a particular client attribute or service. In addition to the creative concept and bold visuals, multiple printing and finishing effects show the level of Sing Cheong's printing quality.

La Santé C'est Pas du Ciné Kit

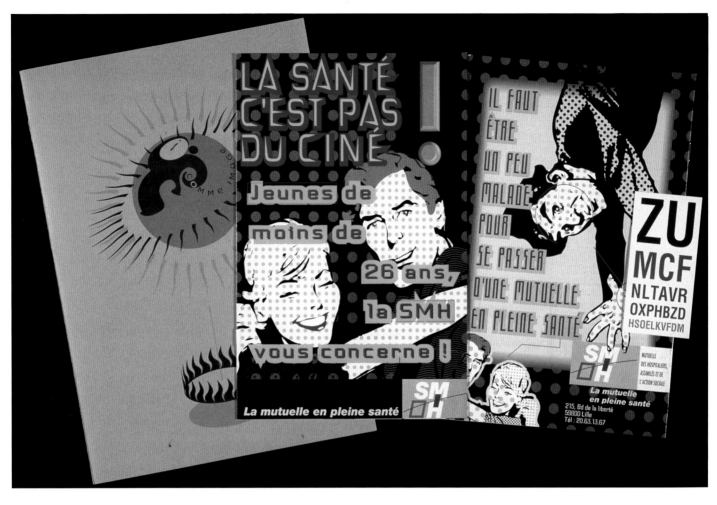

Design Firm: I Comme Image
Art Director: Jean-Jacques Tachdjian
Designer: Jean-Jacques Tachdjian
Computer Illustrator: Jean-Jacques Tachdjian
Client: E.D.P Communication

Objective: To find new prospects under the age of 25 for a hospital mutual insurance company

Innovation: A lively approach to promoting a service that is often regarded as dull and uninteresting, this kit uses a combination of illustrations reminiscent of the 1960s work of pop artist Roy Lichtenstein and a typographic layout with specially designed fonts. The package fuses sedate and comic images to explain company philosophy and prices to a youthful audience.

Creation of Warmth Brochure

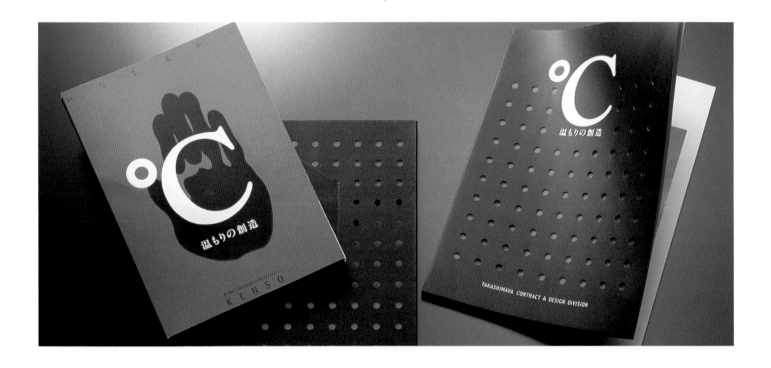

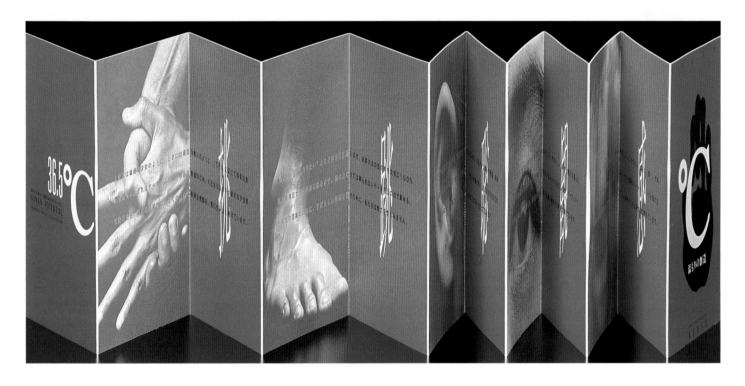

Design Firm: Tad Co., Ltd.
Art Director: Takashi Matsuura
Designers: Takashi Matsuura, Fumikazu Fukunaga
Photographer: Masumi Harada
Copywriter: Toshikazu Hamada
Client: Takashimaya Contract & Design Division

Objective: To create a brochure that elegantly communicates the "warmth" of human emotions

Innovation: The imprint on the brochure cover uses a special heat-sensitive ink that changes color at the touch of a human hand. This component, combined with other striking features such as beautiful pop-up symbols on every spread, helps the reader "feel" the warmth and illustrates the emotional elements of human potential: harmony, inclusion, direction, and more.

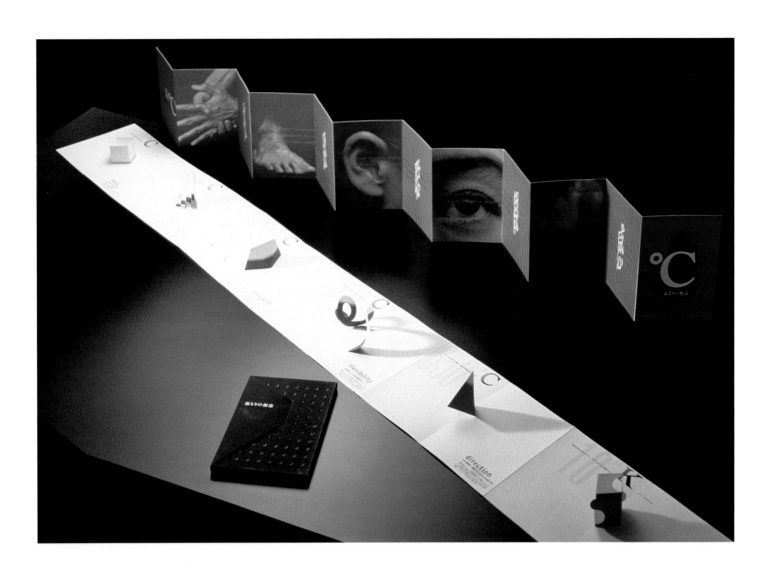

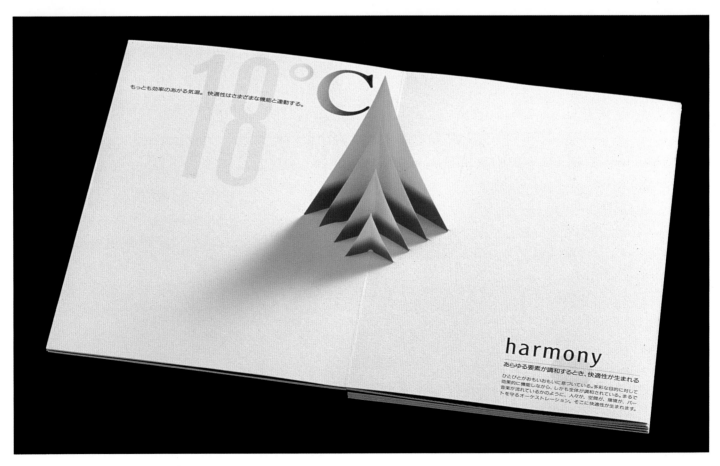

Tresedie Promotional Materials

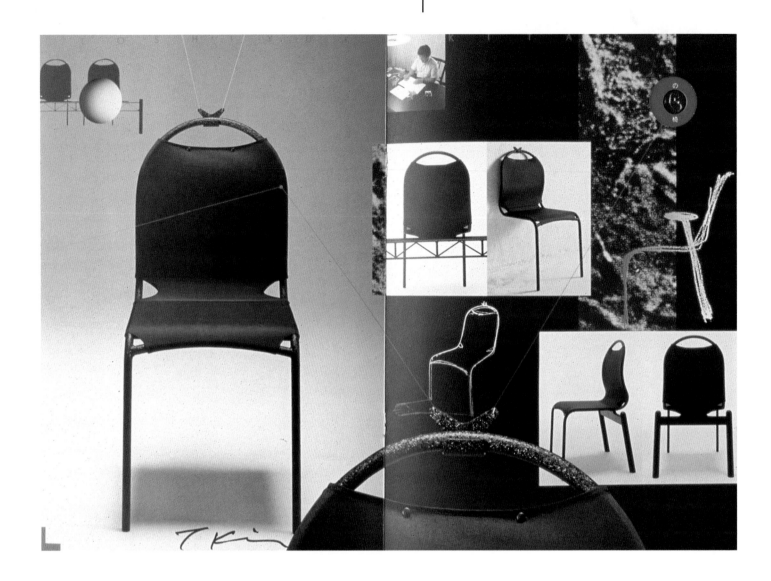

Design Firm: Tad Co., Ltd.
Art Director: Takashi Matsuura
Designer: Takashi Matsuura
Client: Aidec Co., Ltd.

Objective: To create a poster, brochure, and direct-mail piece promoting artists who design chairs

Innovation: These pieces herald three renowned designers of modern chairs who have exhibited throughout the world. The promotional pieces use die-cut circles, placed one on top of the other, and translucent screens of concentric orbs to stress both the precision and abstraction of the craft they promote.

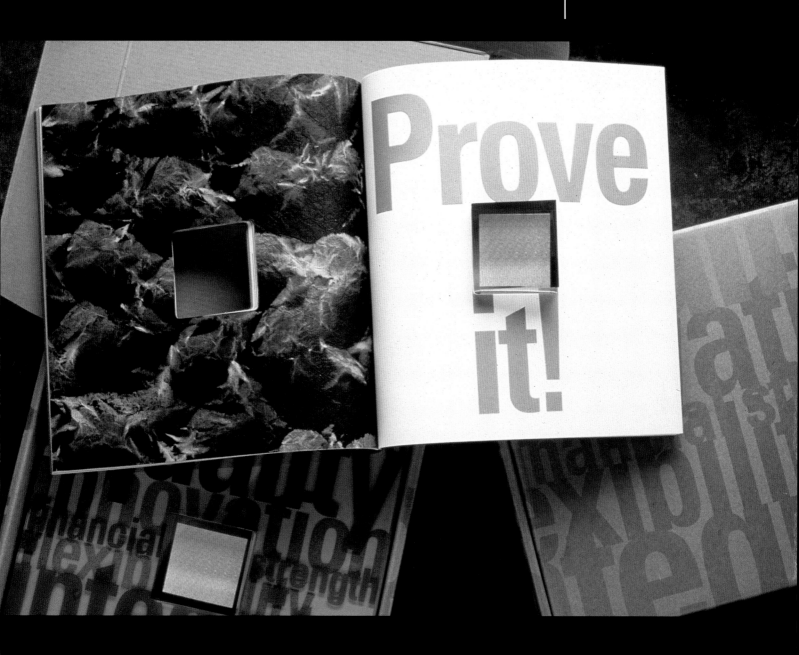

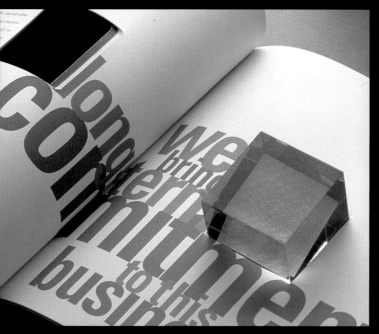

Design Firm: Hornall Anderson Design Works
Art Directors: John Hornall, Lisa Cerveny
Designers: John Hornall, Lisa Cerveny,
Suzanne Haddon, Mary Hermes
Client: GE Capital Assurance

Objective: To develop a program that would attract
a select group of brokerage agencies and introduce
them to financial services

Innovation: This promotion breaks with the sedate
look typical of the financial community by using a
tactile, three-dimensional approach. Centered in
the piece is an acrylic paperweight that incorpo-
rates the floating "magic eye" image from the com-
pany's advertising campaign. The brochure sur-
rounds the cube, and employs aluminum fastener
binding, textured paper stocks, bold type treat-
ments, and a creative application of embossing to
emphasize key selling points and convey innovation
while retaining a responsible image.

Design Firm: Nesnadny + Schwartz
Art Directors: Tim Lachina, Michelle Moehler
Designers: Tim Lachina, Michelle Moehler
Writer: Sue Omori
Client: Cleveland Clinic Foundation

Objective: To create a fundraising publication that increases financial support and informs the audience of the work being done at the Clinic

Innovation: Most brochures that promote health care facilities emphasize the facility's "hardware" and technological capabilities. This piece balances high tech with a human approach by developing something visually, as opposed to scientifically, appealing. A mix of materials, including vellum paper, creates an expensive look at a low cost.

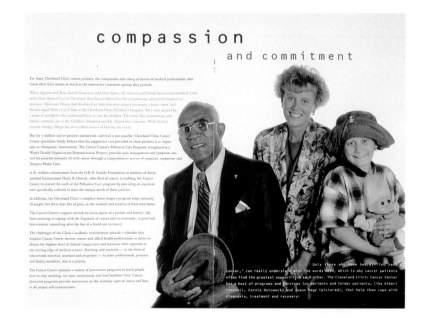

Sybase Intermedia Brochure

Managing the Interactive Maze SYBASE INTERMEDIA SERVER

SYBASE Intermedia Server manages the maze of systems, messages, media sources, and transactions to deliver interactive information services on demand to homes and businesses. Its open architecture provides easy integration with external applications such as subscription management systems, and interoperability with multiple video processors. Based on proven, high-performance Sybase client/server technology, SYBASE Intermedia Server is highly reliable, compatible with client/server standards, and scalable. As innovative interactive services are expanded from the trial phase to mass market audiences, SYBASE Intermedia Server will rapidly scale up to meet demands. ■ For many decades, businesses have tried to reach mass market consumers through conventional broadcast and print media. But getting a prospect's attention is a hit-or-miss proposition. Similar issues apply in business-to-business communications, because the most influential decision-makers face a blizzard of advertising, unsolicited mail, and phone calls. SYBASE Intermedia Server's ability to coordinate interactive information and manage video processors transcends the limitations of noninteractive broadcast and print media. Now the enterprise can reach its prospects through sensory-rich, "narrowcasting" interactions that target each individual user on the basis of preferences, past transactions, or realtime interactions.

TECHNICAL HIGHLIGHTS

The SYBASE Intermedia Server is the integration and management component of the SYBASE Intermedia architecture. It is deployed in a networked environment to support the following major functions:

■ Storage and management of information about content, services, subscribers, and applications

■ Coordination of messages among client applications, content sources, and back-end subscription management systems for billing and pricing

■ User authorization and access control for systems, services, applications, and content stored throughout the interactive environment

■ Logging of all events in persistent storage to enable offline business system transaction processing

■ Basic application templates for video services, shopping services, and anonymous services

■ Management of service transitions, including failover, and context restoration

Managing the Interactive

SYBASE Intermedia Server manages the m
messages, media sources, and transactions to d
tive information services on demand to hom
nesses. Its open architecture provides easy integ
external applications such as subscription ma
systems, and interoperability with multiple video pr
Based on proven, high-performance Sybase clien
technology, SYBASE Intermedia Server is highly re
compatible with client/server standards, and scalabl
innovative interactive services are expanded from the
phase to mass-market audiences, SYBASE Intermedia Serv
will rapidly scale up to meet demands. ■ For many decade
businesses have tried to reach mass market consumers

TECHNICAL HIGHLIGHTS

The SYBASE Intermedia Server is the integration and management component of the SYBASE Intermedia architecture. It is deployed in a networked environment to support the following major functions:

■ Storage and management of information about content, services, subscribers, and applications

■ Coordination of messages among client applications, content sources, and back-end subscription management systems for billing and pricing

■ User authorization and access control for systems, services, applications, and content stored throughout the interactive environment

■ Logging of all events in persistent storage to enable offline business system transaction processing

■ Basic application templates for video services, shopping services, and anonymous services

■ Management of service transitions, including failover, and context restoration

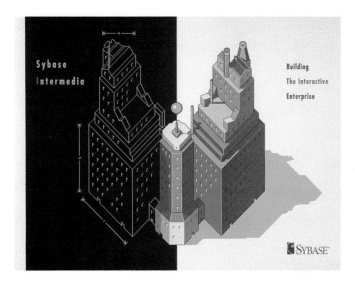

Design Firm: Gordon Mortensen Design
Art Director: Gordon Mortensen
Creative Director: Andrea Bryck
Designers: Gordon Mortensen, David Stuhr
Illustrators: John Craig, Glenn Mitsui, John Bleck, Ron Chan, Hiro Kimura, Theo Rudnak
Copywriters: Bob Runge, Gary Seeman
Client: Sybase, Inc.

Objective: To produce a brochure that would inform software developers about the client's interactive products

Innovation: To emphasize the interactive nature of the client's product, the designers created several interactive pages for this brochure. To illustrate the perception that corporations can extend their business globally, for example, a pull-out page reveals prospective growth as the page is opened. Carefully placed die-cuts also display interesting views before the pages are turned, as well as after.

Courage Brochure

Design Firm: Sampson Tyrrell Ltd.
Art Director: David Freeman
Designer: Shane Greaves
Client: Fiat

Objective: To produce a brochure for CEOs that repositions an organization by gaining commitments to a seven-year investment program

Innovation: This concept brochure goes beyond the expected by using design as language. Powerful colors and crisp images project a strong, singular message, unlike brochures commonly found in this industry that concentrate on copious pictures of trucks, details of engines, and so on.

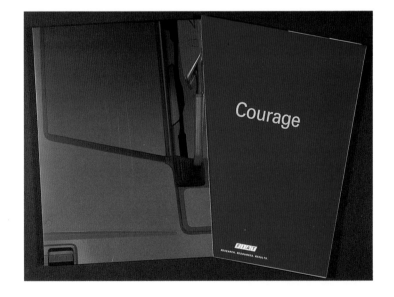

IVECO Whatever the need, Iveco makes no compromises. In the search for maximum productivity, it approaches each and every task from the client's point of view. **IVECO** Transporting perishable fruit, delivering pallets, moving garden equipment. These are just some of the 400 or so different tasks Iveco has identified as requiring a specialised vehicle – which is why Iveco has designed advanced subsystems and organised its production plants so as to guarantee maximum flexibility. **IVECO** For a client to achieve maximum return on investment everything has to be right, down to the smallest detail. For example: take a highly specialised business like fruit transport. The lorry needs to carry as much fruit as possible, but at the same time, it has to be transported safely and unloaded quickly. Iveco achieves this by fitting custom-built suspension that dramatically dampens vibration. Also, the interior of the truck and its loading and unloading systems are specifically designed for the job in hand. **IVECO** As demand is no longer standard, almost every feature of every vehicle – from cabin to engine, from gearbox to axles – is designed to be assembled in a wide variety of configurations. Iveco offers a complete, integrated and open range of products. Their job is to provide transport that is cheap to operate, well designed and highly versatile – while at the same time offering a level of quality second to none.

IVECO Truck owners and transportation companies know exactly what's meant by high performance. For them it means: efficient use of space; time-saving features; zero damage to goods; low vehicle or fleet operating costs; no repairs; low maintenance. **IVECO** It's not easy to fulfil promises like these. But Iveco does, because of its quality design, fine engineering and highly automated, tightly controlled manufacture and assembly. But, above all, because when Iveco customises the truck, it pays great attention to the all-important relationship between the vehicle and its driver. Manoeuvrability, good visibility, easy access, low fuel consumption, quick maintenance and low repair costs, low noise and low pollution, and, in particular, the use of highly specialized components – all have a direct bearing on a driver's safety, comfort and efficiency. **IVECO** These features, thanks to Iveco, have become a point of reference for the industry. They were developed after a complete renewal of Iveco's four test laboratories, where sophisticated computer simulation gives, far in advance, an assurance that truck performance will be high. As promised.

U S West Future Present Campaign

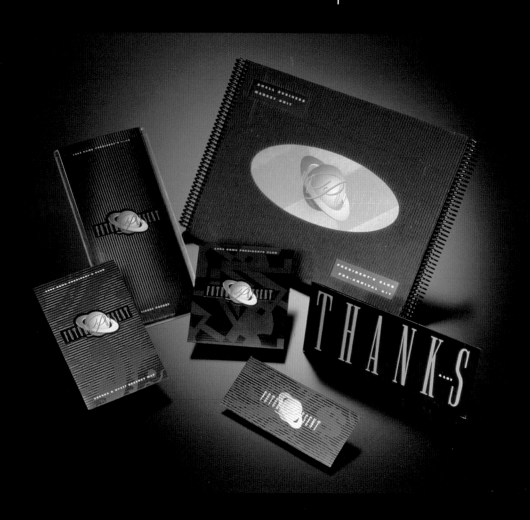

Design Firm: Vaughn Wedeen Creative
Art Directors: Steve Wedeen, Rick Vaughn
Designers: Steve Wedeen, Rick Vaughn
Client: U S West Communications

Objective: To develop a theme and materials for an event celebrating the client's top performers

Innovation: Materials such as plastics, metals, and color corrugated stock, and liberal use of techniques such as die-cutting, ensured all components are thoroughly immersed in imagination. To encourage interactivity and playfulness, a dual spiral-bound guidebook sports an aluminum cover, uncoated graphic pages, translucent plastic text pages, and short sheets. A crystal ball with a screw-bound instruction book can be left in hotel rooms to help participants imagine themselves in the future.

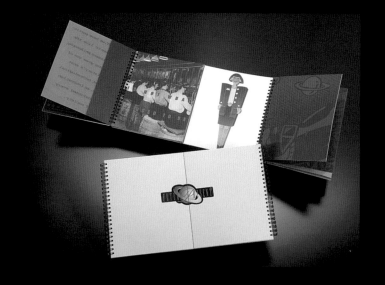

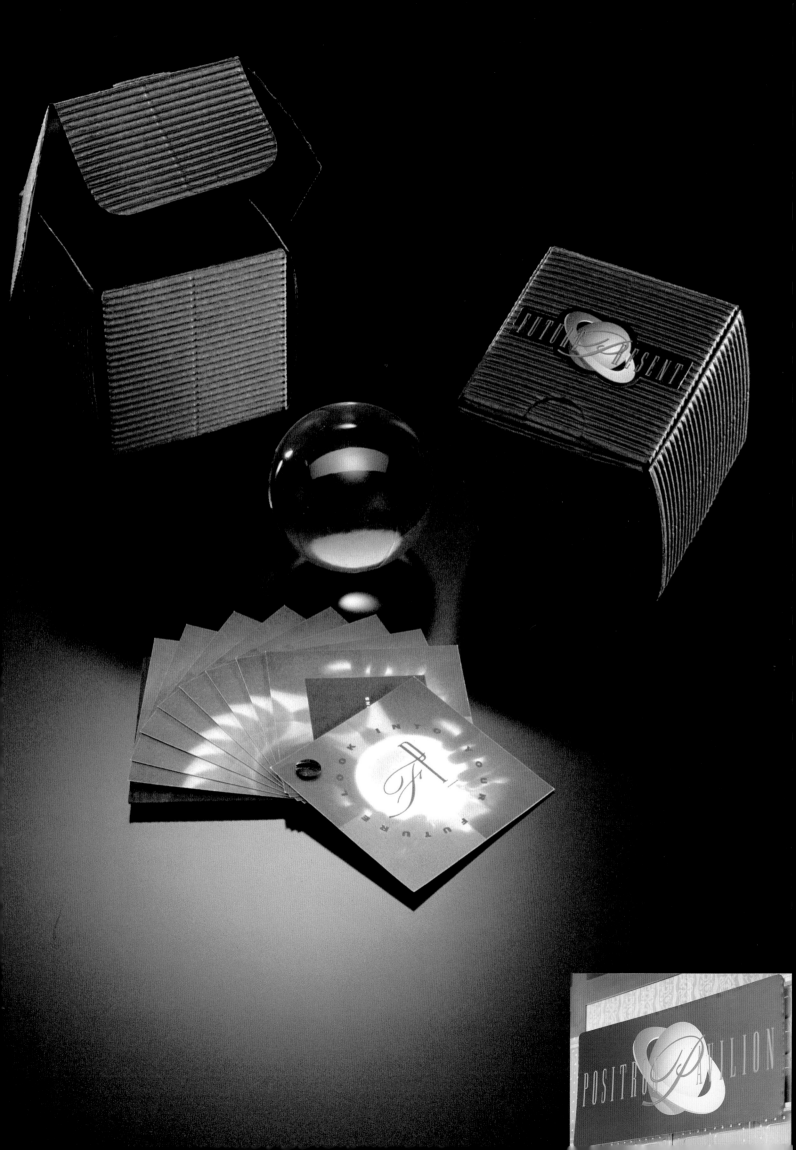

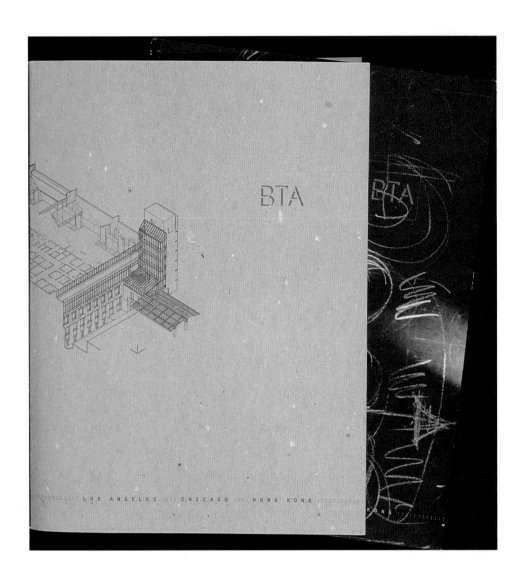

Design Firm: COY
Art Director: John Coy
Designers: John Coy, Albert Choi, Rokha Srey
Production: Rokha Srey
Client: BTA

Objective: To emphasize to the company and potential clients the respect BTA has for taste, quality, and aesthetic concerns

Innovation: To expand the conservative image of an architectural firm and give the project a design awareness, the designers use artful, textural, sensuous, and intellectual graphics to complement reprints from the publication *Architectural Record.* They then take a functional item (the work folder), give it engraved type and artful stock, and let it effectively express the work in transit and the value of the employees' perspective.

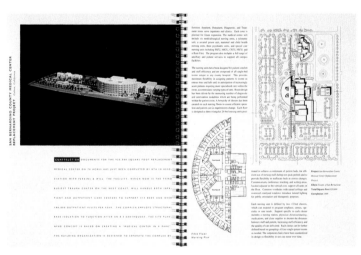

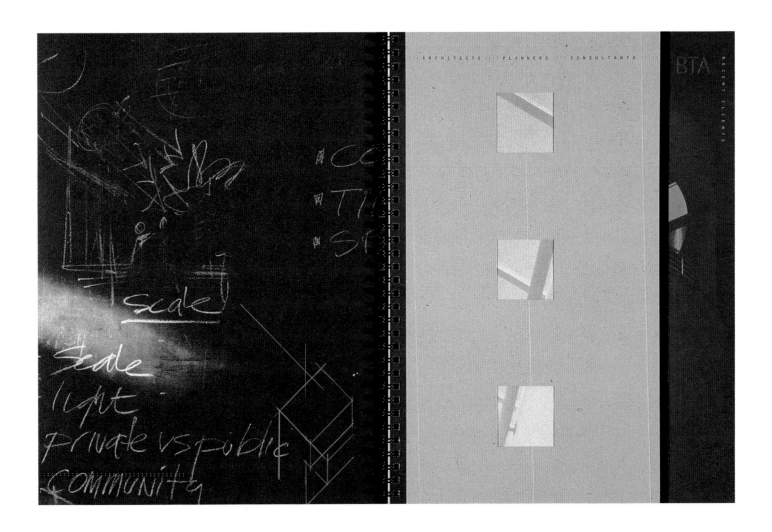

Our staff's continuing involvement in teaching, research and public forums has established our position as a leader in the direction of new design methods. BTA's consulting, architectural and planning services include:

ARCHITECTURE AND DESIGN

Architectural Design
Renovation & Remodeling
Interior Architecture
Interior Design
Equipment Planning
Wayfinding/Signage
Computer-Aided Drafting &
 Design (CADD)
3-Dimensional Modeling
Code Analysis

PLANNING AND CONSULTING

Strategic Planning
Strategic Master Planning
Physical Master Planning
Land Development Feasibility
 Studies
Long Range Services Planning
Urban Design/Planning
 Design Guidelines
 & Standards
Zoning Analysis
Medical Planning
Facility Programming
Equipment Planning

In addition to a wide range of project consulting, planning and design services, the firm is dedicated to supporting these activities with a strong foundation of project management. Management activities include a strong emphasis on project pre-planning, detailed project scheduling, project workplans and timeline reports, integrated/automated S.M.A.R.T. AutoCAD systems, continual cost control monitoring and value engineering, and a clearly defined decision-making process for all participants. Specific management services include:

PROJECT MANAGEMENT

CPM Scheduling
Cost Estimating
Program Management
Resource Management
Construction Administration
Post Occupancy Evaluation
Facilities Management
AutoCAD Systems
 (S.M.A.R.T. Documents)
 These management tools help to ensure that the most cost-effective facility is built that is consistent with program requirements. In addition, this effective project management system has resulted in a long history of BTA projects that are completed according to our clients' budget, schedule and quality goals.

BTA has been honored with a diversity of awards. This recognition extends from national Awards of Merit from the American Institute of Architects and the U.S. Naval Facilities Engineering Command to Planning, Design, Beautification, and Conservancy Awards. BTA projects acknowledged for outstanding design include Shriners Hospital for Crippled Children, Los Angeles; Daniel Freeman Memorial Hospital, Los Angeles; U.S. Navy Medical Clinic at Port Hueneme, California and Kaneohe Air Station, Hawaii; the Motion Picture and Television Fund, Woodland Hills, California; Kings Road Housing for the Elderly, Los Angeles; and Parsons-Gates Hall of Administration at the California Institute of Technology, Pasadena.

As leaders in architecture and planning, members of our staff have also had the opportunity to lecture at universities and at numerous design and trade conferences, and have served as jurors on various awards committees. In addition to articles written by staff members, our firm and projects have been featured in many distinguished journals. Recent examples of our work can be found in:

Progressive Architecture
Architectural Record
The Los Angeles Times
USA Today
Hospitals
Modern Healthcare
Architecture
Architecture + Urbanism
 (Japan)
Building Design & Construction
L'Industria delle Costruzioni
 (Italy)
Healthcare Executive
Contract Design
The New York Times

BET Affiliate Sales Promotion

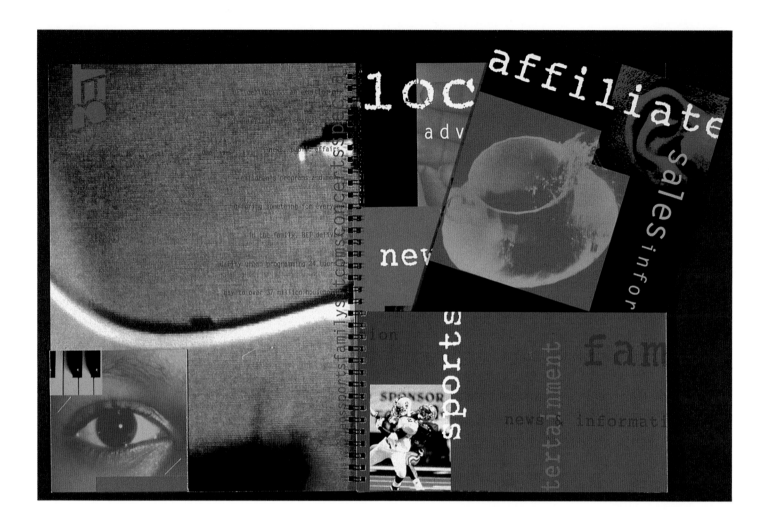

Design Firm: Supon Design Group, Inc.
Art Directors: Supon Phornirunlit,
Andrew Dolan
Creative Director: Scott Perkins
Designer: Andrew Berman
Project Directors: LaTanya Butler,
Angela Scott, Matilda Ivey
Client: Black Entertainment Television

Objective: To design a sales promotion kit
that would project the diversity and excitement
of the client's programming

Innovation: Using a folder with a wild array
of pockets unmatched in most print pieces,
this project sports not only novel type treat-
ment and kinetic graphics, but also odd-sized
pockets that include a tiny corner niche that
conveniently holds a business card.

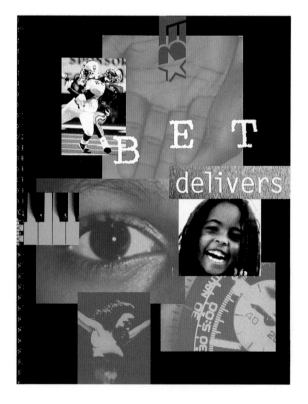

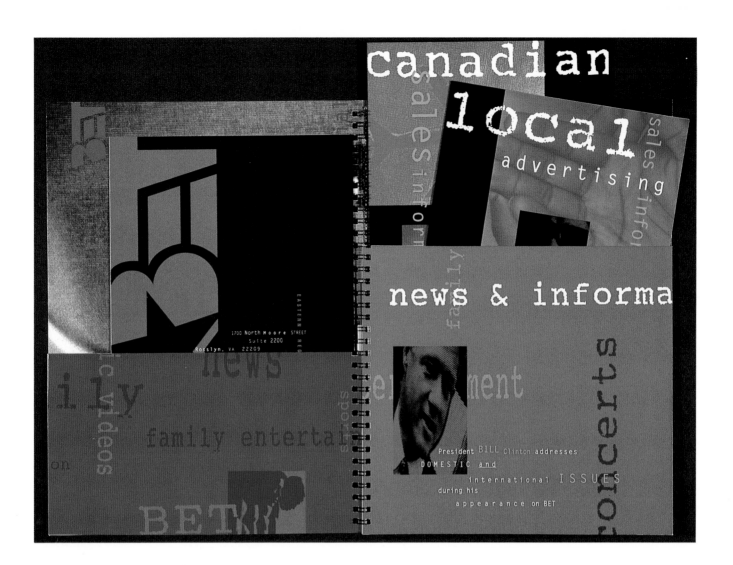

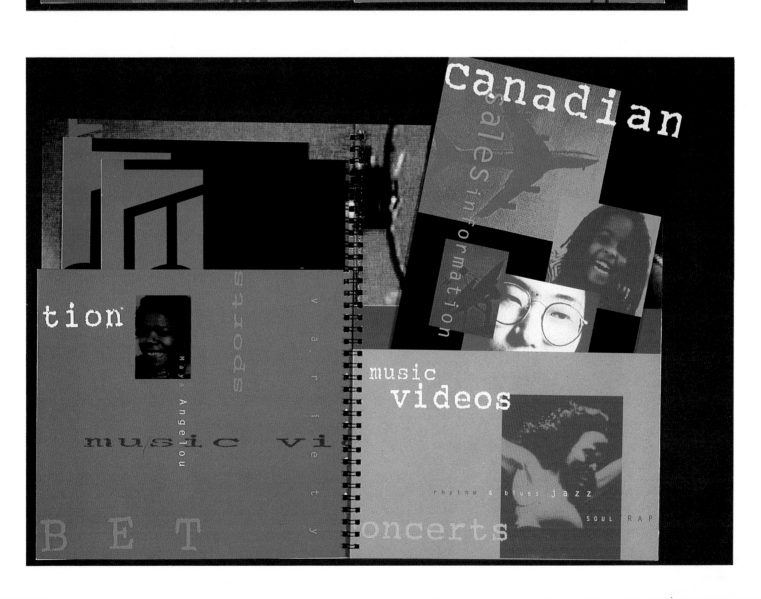

PACKAGING

Xinet Software Packaging

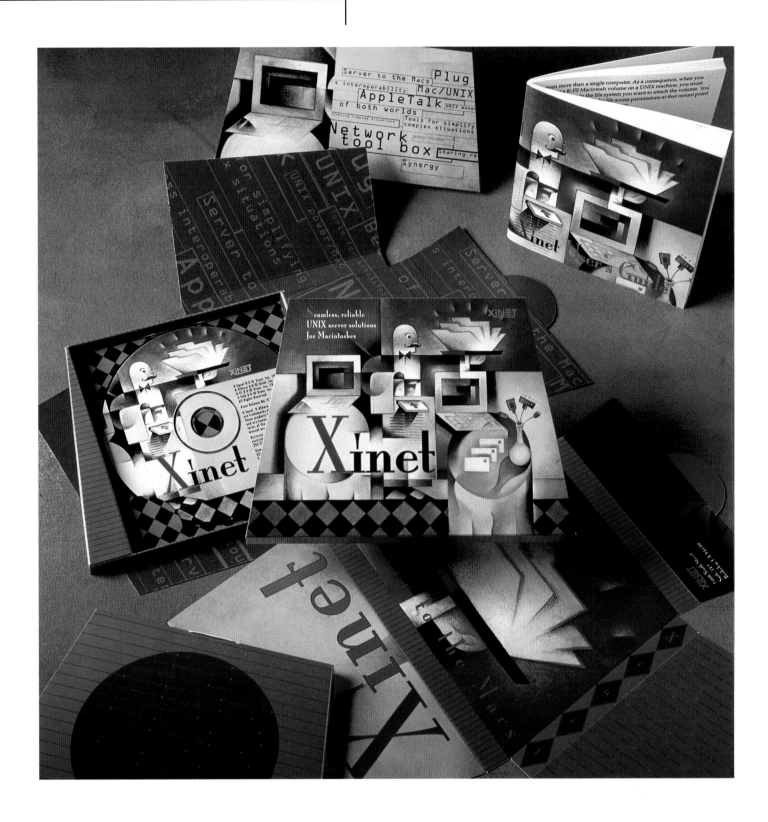

Design Firm: Earl Gee Design
Art Director: Earl Gee
Designers: Earl Gee, Fani Chung
Illustrator: Robert Pastrana
Client: Xinet, Inc.

Objective: To create an out-of-the-ordinary CD-ROM software package for Macintosh/UNIX server software

Innovation: The odd "trapezoidal" shape was designed to stand out in a retail environment, as well as on an end user's shelf. The package opens via four unexpected folds printed with text that reveals multiple product benefits. It also functions as a secondary typographic pattern to convey the software's versatility.

"Art in the Park '94" Promotional Campaign

Design Firm: Sayles Graphic Design
Art Director: John Sayles
Designer: John Sayles
Illustrator: John Sayles
Client: Des Moines Art Center

Objective: To promote central Iowa's annual art festival by designing creative specialty items on a limited budget

Innovation: The event's promotional poster is designed to be interactive: printed on brown-paper feed sacks (an abundant Iowa resource), the poster can be hung flat on a wall or filled and stood upright. Such pylons may be used as landmarks and space dividers throughout the festival grounds. Other unique items include limited-edition pins, metal charms, neckties, and shirts.

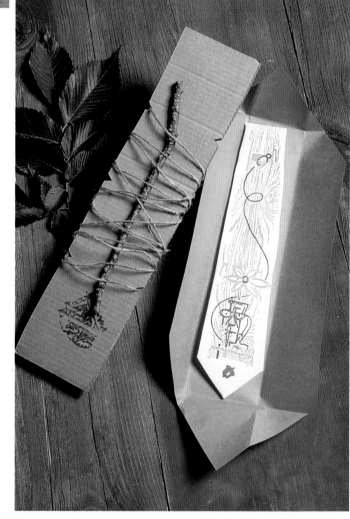

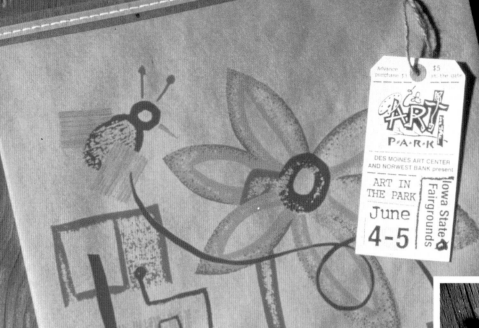

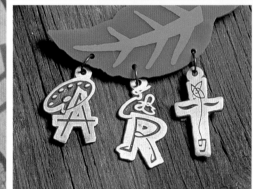

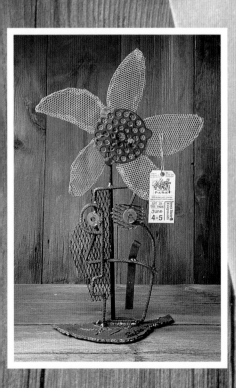

Advance $5
purchase $3 at the door

ART
P·A·R·K

DES MOINES ART CENTER
AND NORWEST BANK present

ART IN
THE PARK

June
4-5

Iowa State
Fairgrounds

*Art
in the
Park*

John Sayles

Molinari Salami Canister

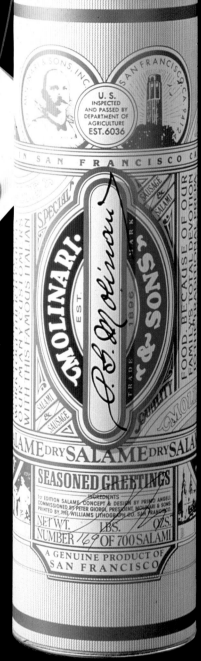

Design Firm: Primo Angeli Inc.
Art Director: Primo Angeli
Designers: Primo Angeli, Mark Jones
Client: P.G. Molinari & Sons

Objective: To design a highly original mailer for salami products

Innovation: The uncommon approach is the depiction of salami as a piece of art rather than a piece of meat. The result: the world's first designer salami in a limited-edition mailing canister, produced as a "seasoned greeting" from the client, and numbered and signed by the designer.

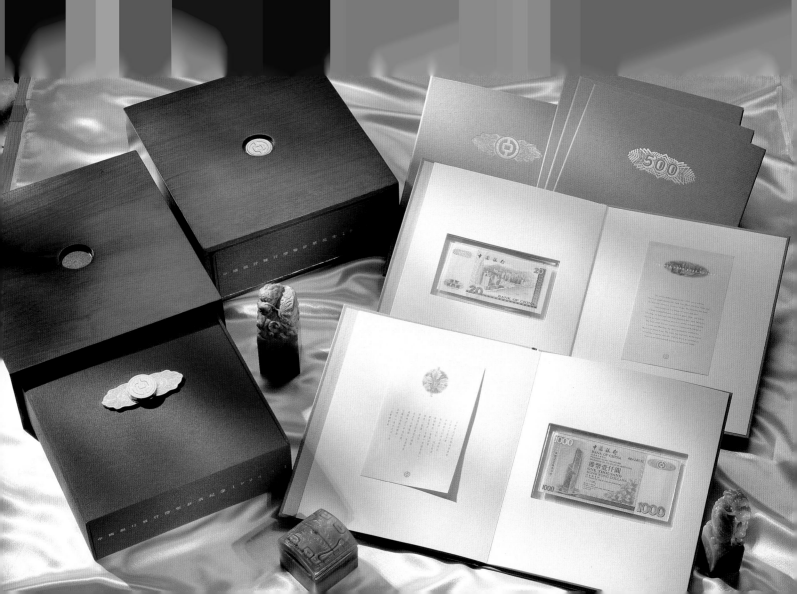

The Visual Library

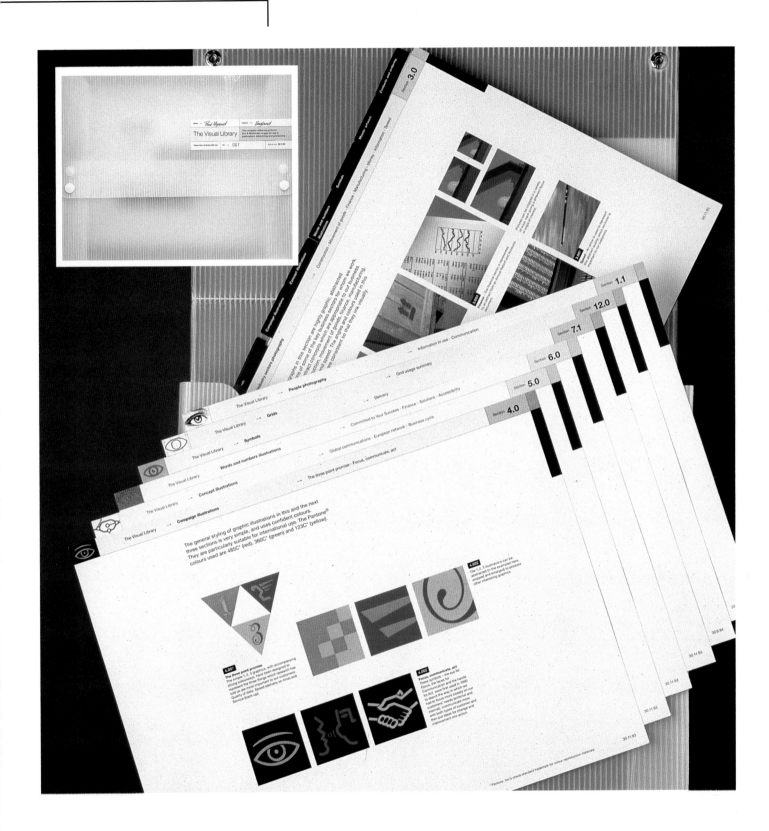

Design Firm: Sampson Tyrrell Ltd.
Art Director: David Freeman
Designers: Mathew Tollis, Paul Mynard
Client: Dun & Bradstreet

Objective: To supply a photo library of images to be used in client publications

Innovation: A durable box made of plastic provides an unexpected solution for a collection of images. Rather than produce a traditional photo library catalog, the project evolved into a user-friendly container that allows easy access to materials and uses a variety of visual "eye" imagery to adorn the divider pages.

Dune CD-ROM Packaging

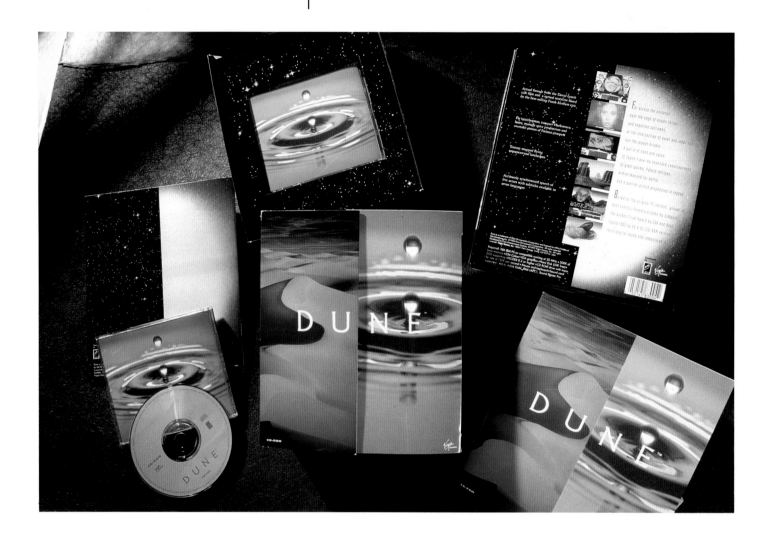

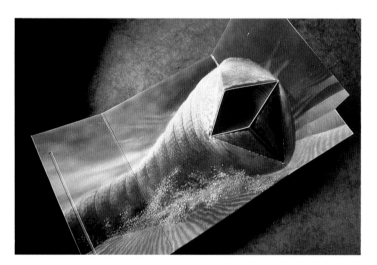

Design Firm: Maureen Erbe Design
Art Director: Maureen Erbe
Designers: Maureen Erbe, Rita A. Sowins
Client: Virgin Games

Objective: To produce packaging for the CD-ROM game based on the science-fiction book and film, *Dune*

Innovation: Cleverly constructed die-cut cover panels open to reveal a pop-up sand-worm. This and the pertinent icons of the story—the dunes and a drop of water—recurring throughout the components are two techniques that make this packaging solution unexpected. Striking images are carried through from the cover to the back of the manual and to the CD packaging.

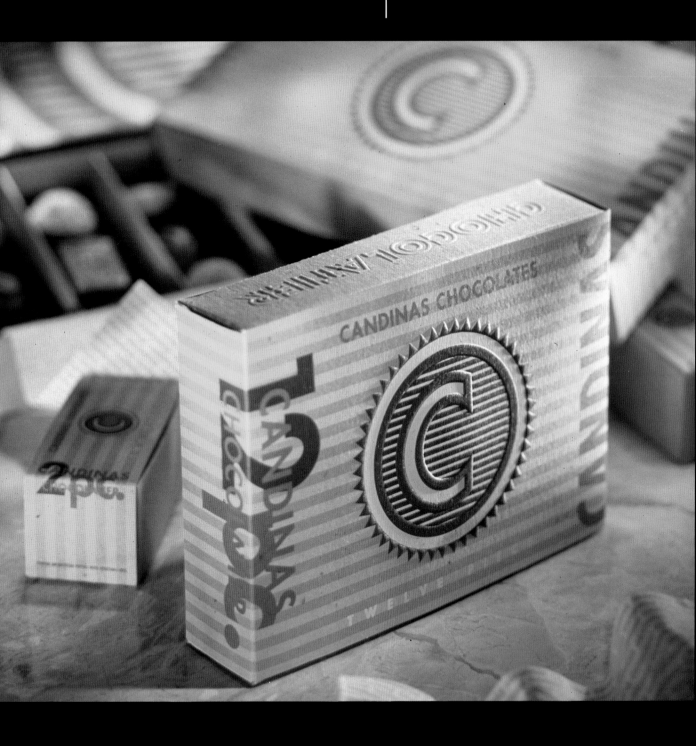

Design Firm: Planet Design Company
Art Directors: Kevin Wade, Dana Lytle
Designers: Kevin Wade, Martha Graettinger

Objective: To create an environmentally friendly
package for a new, high-end chocolate confectioner

Cherry Hill Shopping Bag

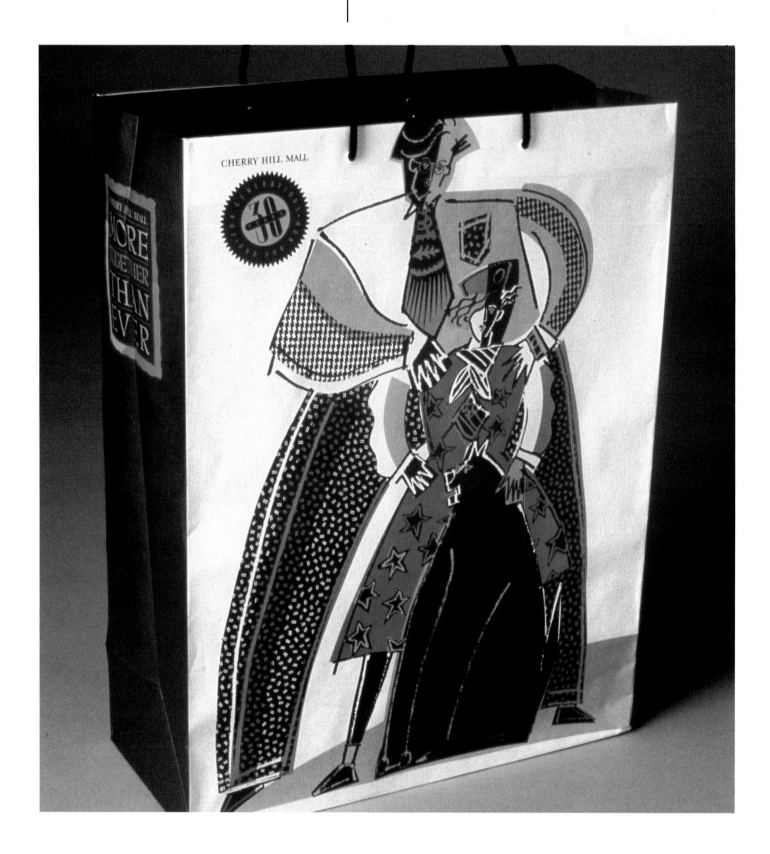

Design Firm: SullivanPerkins
Art Director: Ron Sullivan
Designer: Jon Flaming
Illustrator: Jon Flaming
Client: Cherry Hill Mall

Objective: To produce a shopping bag that is interesting, exciting, and provocative

Innovation: An excellent example of how small elements can add up to an effective new idea. Unconventional design and color imagery, a fresh concept of a father and daughter shopping together, and an odd package handle all work to create a shopping bag with style.

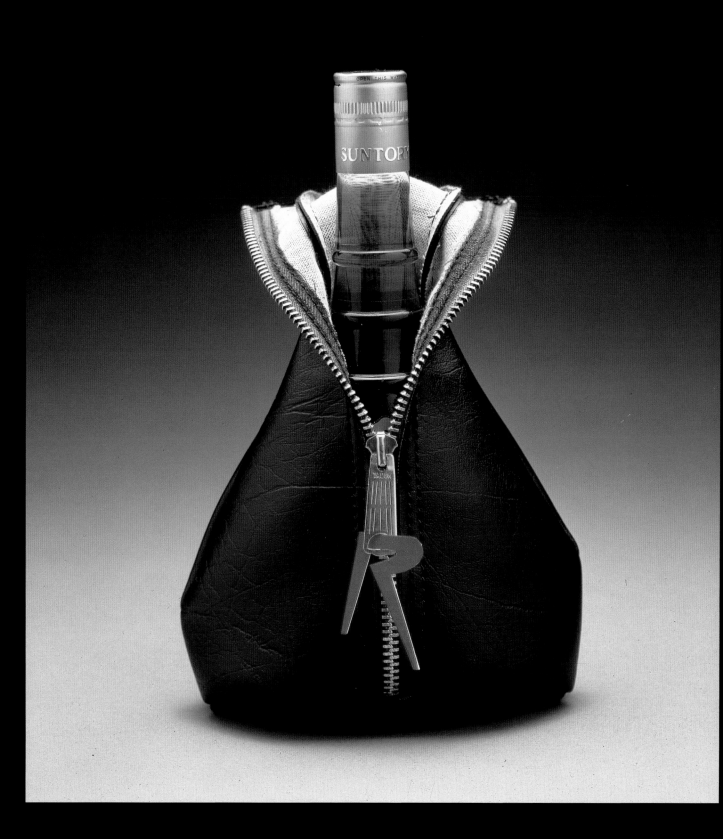

Design Firm: Mike Salisbury Communications
Art Director: Mike Salisbury
Designer: Mike Salisbury
Client: Suntory

Objective: To produce packaging for a "late night" liqueur

Innovation: From the rich black leather texture to the bright red zipper pull, this packaging says "exotic" tinged with the "dramatic" when the rest of the market just says "moderate."

Guess? Eyewear Collectible Tins

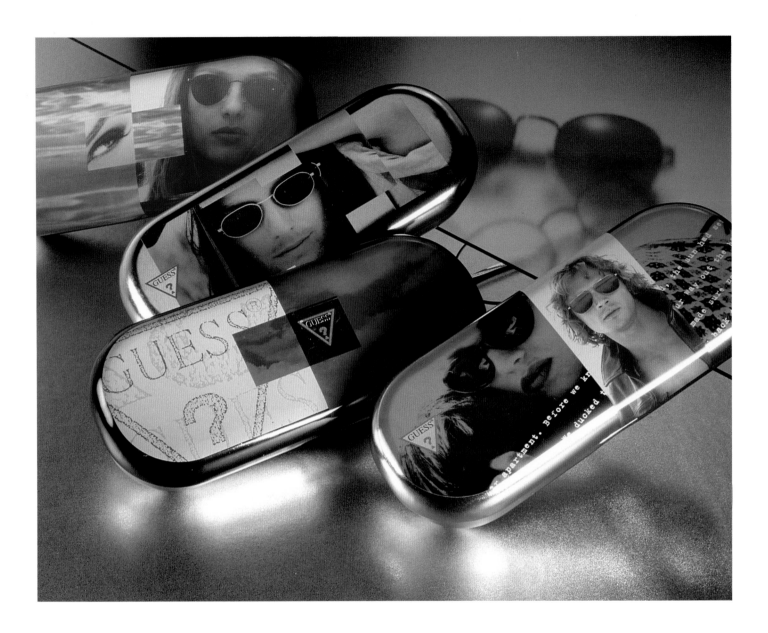

Design Firm: Parham Santana Inc.
Art Director: Millie Hsi
Designers: Millie Hsi, Lori Reinig
Client: VIVA International Group

Objective: To design a set of four collectible tins that serves as a point-of-purchase display and also helps distinguish the client in a mature and crowded eyewear market

Innovation: These designs play between true and manipulated duotones (black halftones over a solid background color), while they incorporate textural images—sky and water—to create a mood. Model shots feature the products; words that suggest a story provide intrigue; a layered logo becomes a texture, and an image broken up into five parts creates the illusion of refraction.

The Cat's Out of the Bag Invitation

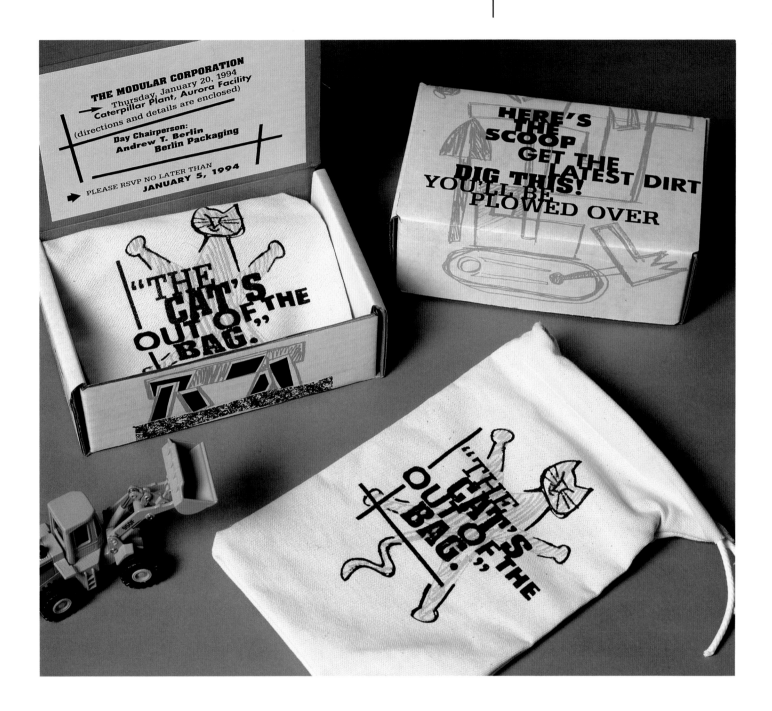

Design Firm: Sayles Graphic Design
Art Director: John Sayles
Designer: John Sayles
Illustrator: John Sayles
Client: Young Presidents Organization

Objective: To creatively invite recipients to attend a program

Innovation: A toy Caterpillar tractor, representing the product of the event's sponsor, becomes both a keepsake and novel design element when it is placed inside a screen-printed cloth bag and shipped in a corrugated box printed with teaser copy and graphics.

The Flying Marsupials CD Packaging

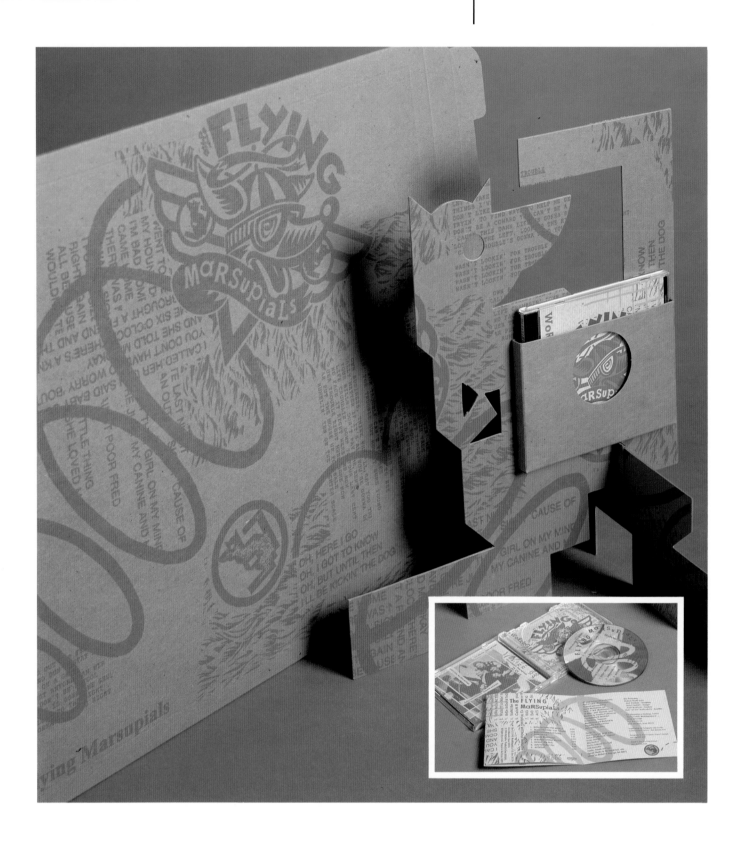

Design Firm: Sayles Graphic Design
Art Director: John Sayles
Designer: John Sayles
Illustrator: John Sayles
Client: The Flying Marsupials

Objective: To design CD packaging and in-store promotions for a band

Innovation: A limited-edition chipboard kangaroo serves two purposes: to hold and display the CD, and to be used as a point-of-purchase display. The kangaroo is mailed in a chipboard envelope printed with graphics from the CD's cover.

Curtis Creatives Paper Promotion

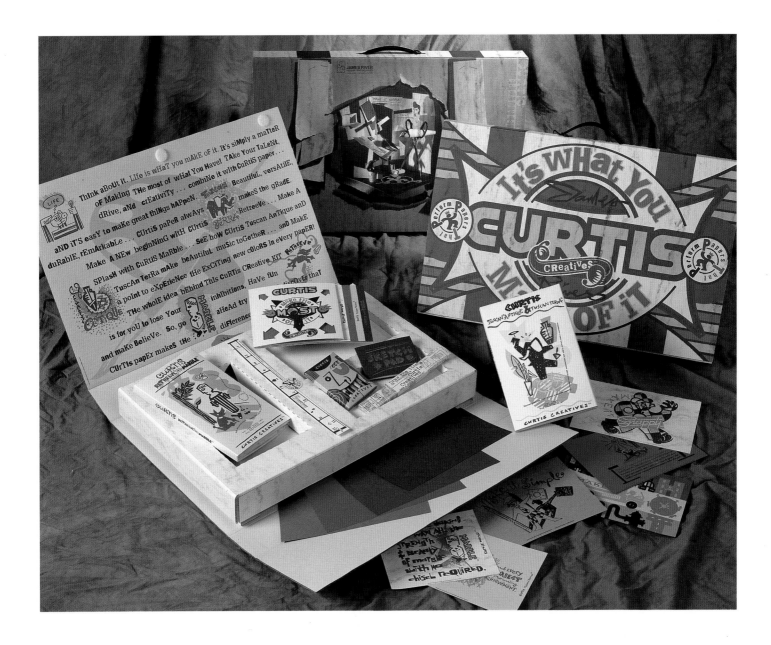

Design Firm: Sayles Graphic Design
Art Director: John Sayles
Designer: John Sayles
Illustrator: John Sayles
Copywriter: Wendy Lyons
Client: James River Corporation

Objective: To show designers that the client's paper is "what you make of it" and to entice them to specify it

Innovation: Everything about this promotion breaks the rules—from the kit format that includes pencils, crayons (custom-made to match the newest paper colors), and paper samples, to the use of photographed paper sculptures in the kit's brochure. The entire kit—even the box—is made out of the client's brand of paper.

Christmas Brandy Bottle

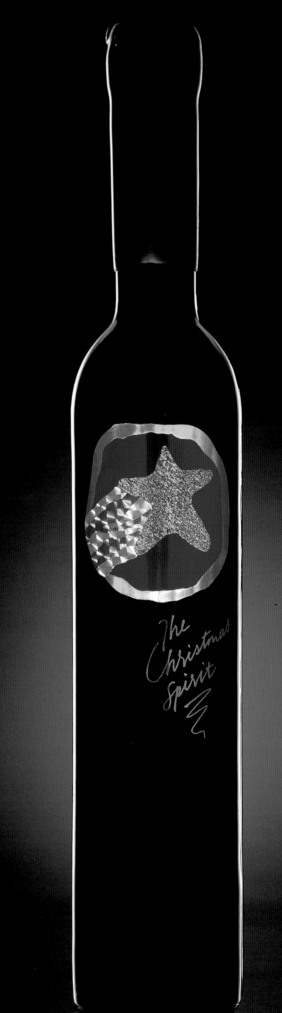

Design Firm: Tucker Design
Art Director: Barrie Tucker
Designer: Barrie Tucker
Finished Art: Joe Marrapodi
Client: Avon Graphics

Objective: To design a bottle that could be given as a Christmas gift

Innovation: These limited-edition bottles are adorned with a sparkling—concept design element—a star made from a variety of holographic foils. The hand-packaged bottles contain a high-quality 25-year-old pot still brandy, and promote Tucker Design's innovative foil and embossing printing capabilities.

125th Anniversary Wine Bottle

Design Firm: Tucker Design
Art Director: Barrie Tucker
Designers: Barrie Tucker, Hans Kohla
Finished Art: Hans Kohla
Engraving: Russell Fischer
Client: Woods Bagot

Objective: To design a wine bottle that could
be given as a gift to clients and staff on the
occasion of the 125th anniversary of Australia's
oldest architecture firm

Innovative: The packaging for this gift bottle
applies industrial processes to traditional items
in an innovative way, similar to the way architects
apply them to a building. Using in-depth sandblast-
ing, wax-sealing, and a specially constructed con-
tainer with corrugated board lining, the packaging
draws attention to its dimensionality. Engraving
and the color of the bottle form the image of a
monumental sculpture made to last for generations.

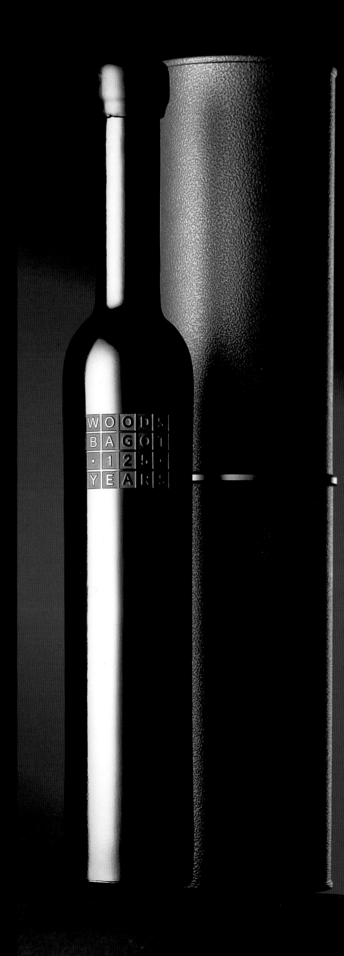

Vaughn Wedeen Christmas Promotions

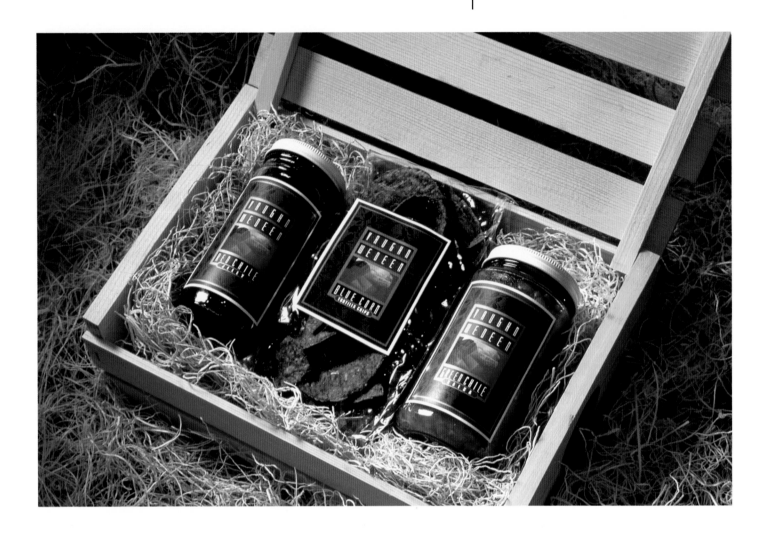

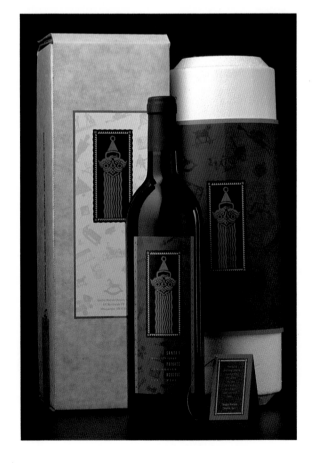

Design Firm: Vaughn Wedeen Creative
Art Directors: Steve Wedeen,
Rick Vaughn, Daniel Michael Flynn
Designers: Daniel Michael Flynn,
Rick Vaughn, Nicky Ovitt
Illustrators: Bill Gerhold, Nicky Ovitt
Client: Vaughn Wedeen Creative

Objective: To thank clients and vendors with
a gift of New Mexico products

Innovation: The handmade touch is apparent in
these tasty promotions: hand-applied wine bottle
labels, hand-assembled wooden crates of red chili
jelly, green chili salsa, and blue corn tortilla
chips, and hand-constructed boxes of vinegar and
chutney packaged in a silkscreened corrugated
container. The most labor-intensive element is
the homebaked cookies—200 made by each staff
member and placed in foil bags, tied with jute
twine, and topped with recipe cards. Container
design features gold hand-lettering and black
line drawings in the shape of each cookie name,
with silver brushstroke backgrounds.

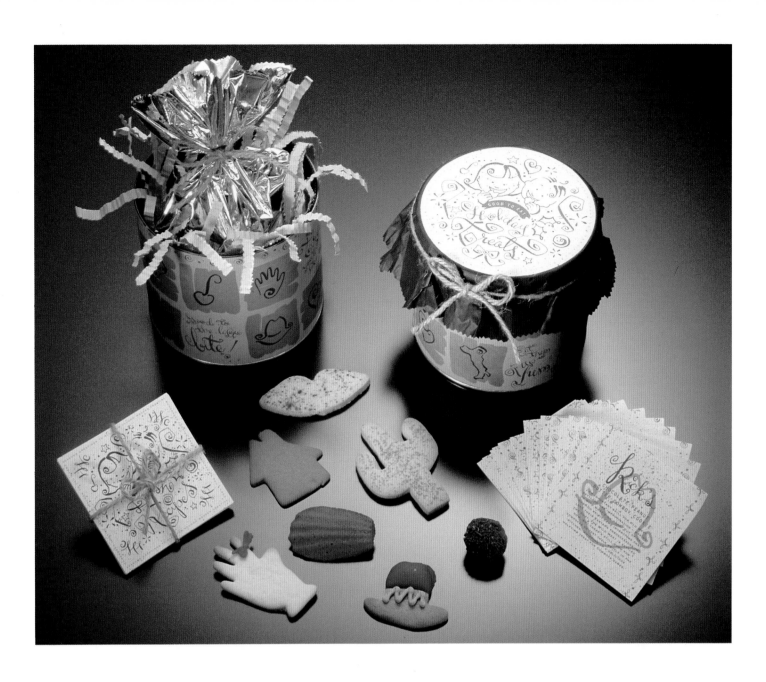

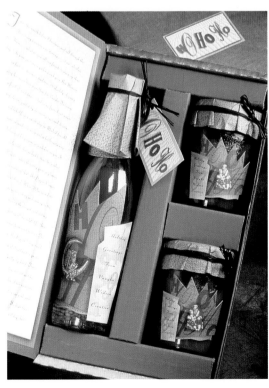

The Tea Box at Takashimaya Packaging

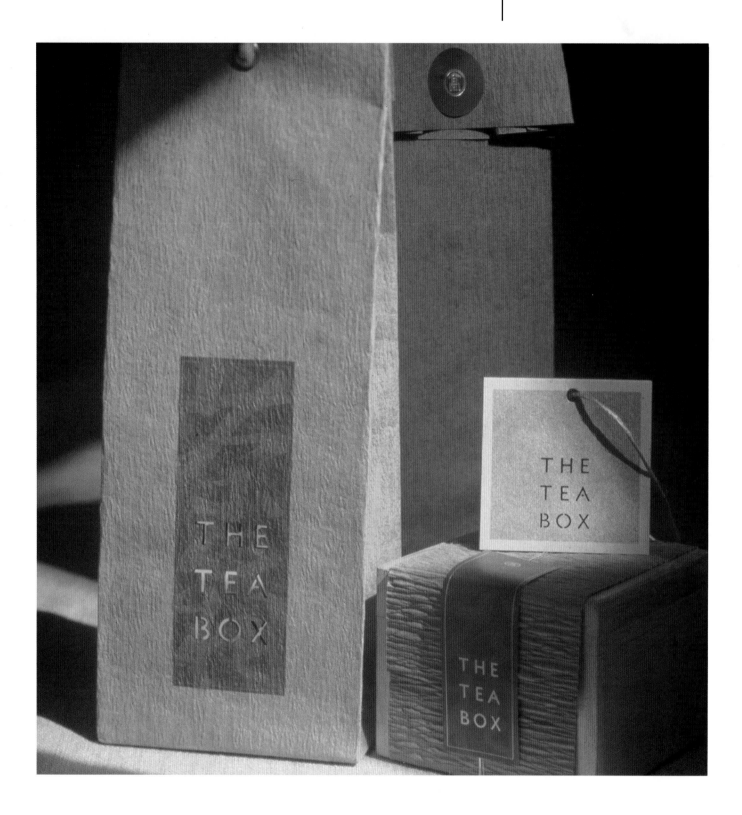

Design Firm: m/w design
Art Directors: Allison Muench, J.P. Williams
Client: Takashimaya New York

Objective: To create packaging that is both refined and rustic for bulk-packaged tea and accessories

Innovation: An assortment of interesting details distinguish this project: the tea bag is made of creped Kraft paper; laser die-cutting reveals the gold foil liner bag and ornaments the hang tag; and gilt edging on the menu and check folders lends a sophisticated approach to the design.

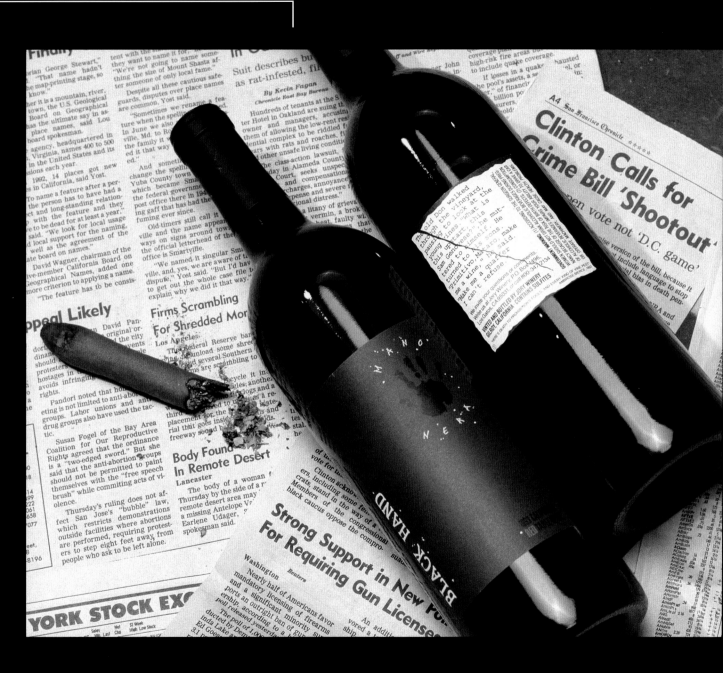

Design Firm: THARP DID IT
Art Directors: Stillman Brown,
Dan Lewis, Rick Tharp
Designer: Rick Tharp

Objective: To design a wine label on a
tight deadline (one night) and with an
even tighter budget

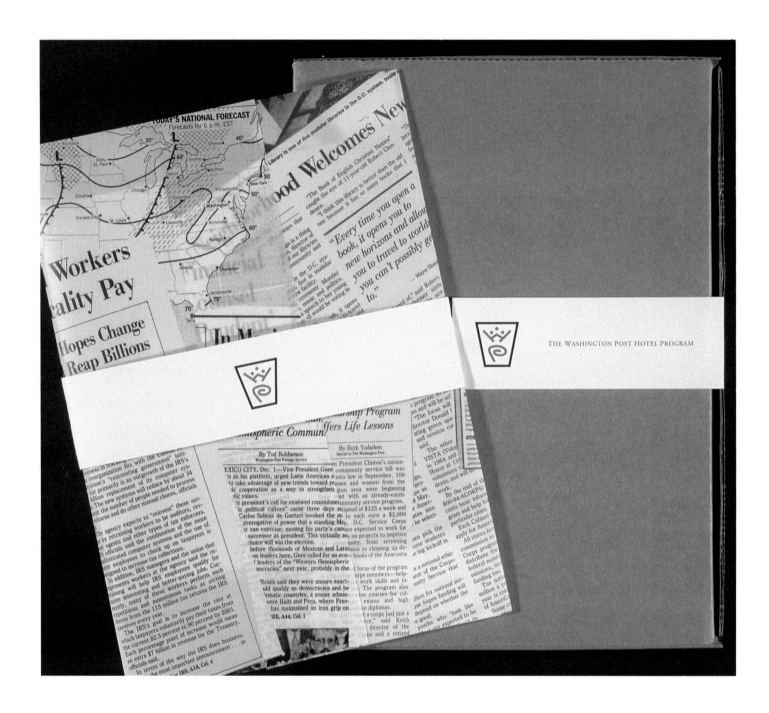

Design Firm: Supon Design Group, Inc.
Art Directors: Supon Phornirunlit,
Andrew Dolan
Designers: Apisak "Eddie" Saibua,
Richard Boynton
Client: *The Washington Post*

Objective: To design a promotion that encourages local hotels to offer the client's daily newspaper to guests

Innovation: A promotion that seems more like a gift to its recipients, this project reflects the high standards of the participating hotels with its sophisticated elements that include a box in which to house the collateral materials and a tissue paper band securing three descriptive brochures.

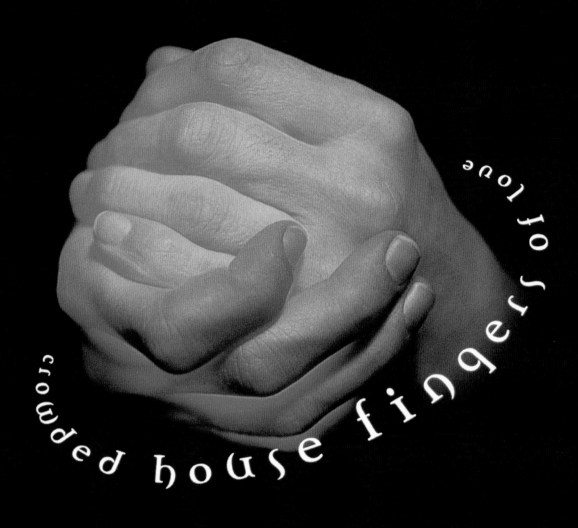

Design Firm: Margo Chase Design
Art Director: Margo Chase
Designer: Margo Chase
Photographer: Sidney Cooper
Client: Capitol Records

Objective: To create appropriate packaging for a pop-rock compact disk

Innovation: In music packaging, typography usually plays a descriptive role, but in this instance, the type is integral to the image. The song's title is portrayed literally in an image of glowing, interlaced fingers floating in space, orbited by elliptical type. The design evokes the levity and intensity of being in love.

Talking Rain "Sparkling Ice" Bottle and Can Packaging

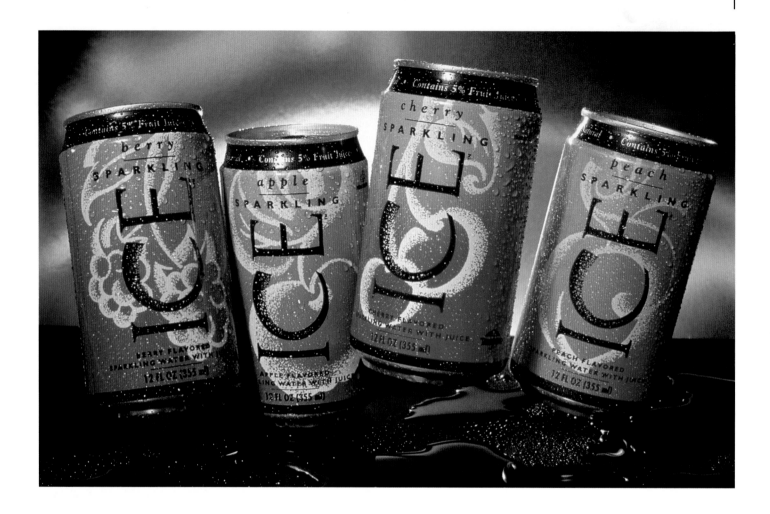

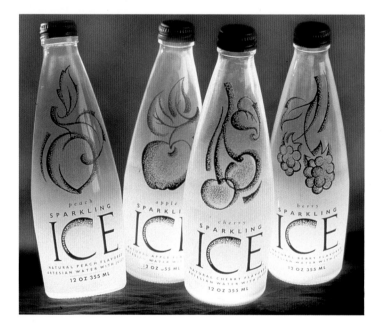

Design Firm: Hornall Anderson Design Works
Art Director: Jack Anderson
Designers: Jack Anderson, Julia LaPine,
Jill Bustamante, Jana Nishi,
Leo Raymundo, Heidi Favour
Illustrator: Julia LaPine
Client: Talking Rain

Objective: To redesign packaging to enhance
the positioning of the brand as a leader in
the beverage industry and to allow for expanded
marketing opportunities

Innovation: Contemporary graphics and typography
create a distinct, premium family look: bold,
playful illustration creates a solid image and
allows for individual product differentiation.
The stylized interpretation of the fruit flavors
distinguishes the brand from competing products
that focus on realistic images of fruit. Other
unique bottle elements include graphics applied
directly to the surface rather than on paper
labels; gradational frost that creates the "ice"
effect; and the black cap. The cans incorporate
an uncharacteristic two-color gradation and use
line drawings to indicate the flavors.

Bottega Olive Oil Packaging

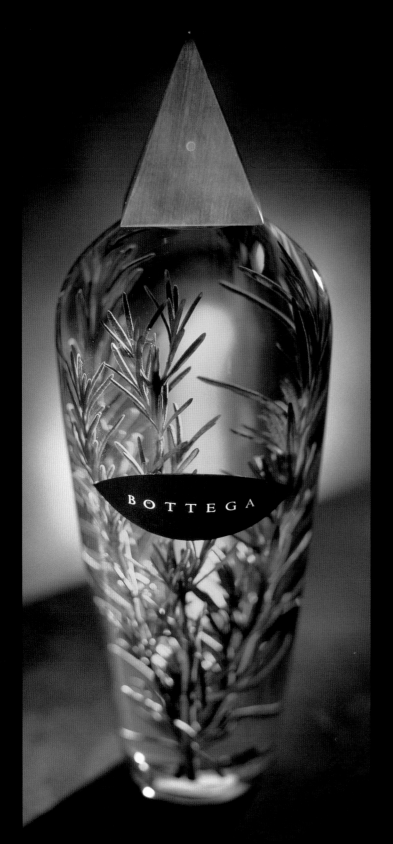

Design Firm: SlaughterHanson Advertising
Art Director: Terry Slaughter
Designer: Marion English
Client: Bottega Restaurant

Objective: To package a restaurant's product so that, after the product is used, the bottle will continue to serve as an innovative object

Innovation: The bottle's shape, with its slender bottom and full, rounded top, is the opposite of conventional bottles. Its brushed steel top, a tedious point of production, is even and sleek, not rough or matte, and applied with a finish that makes fingerprints less visible. The bottle cap, which houses a cork, also produces an air-tight seal for the oil inside. The red dot—suggesting an olive's pimento center—is screened on two sides of the pyramid top and recalled on the label.

Design Firm: Woods + Woods
Art Director: Alison Woods
Designers: Alison Woods, Colleen Stokes
Illustrator: John Mattos

Objective: To create a memorable, eye-catching
package for a first-time software publisher

Boingo Audio/Visual Packaging

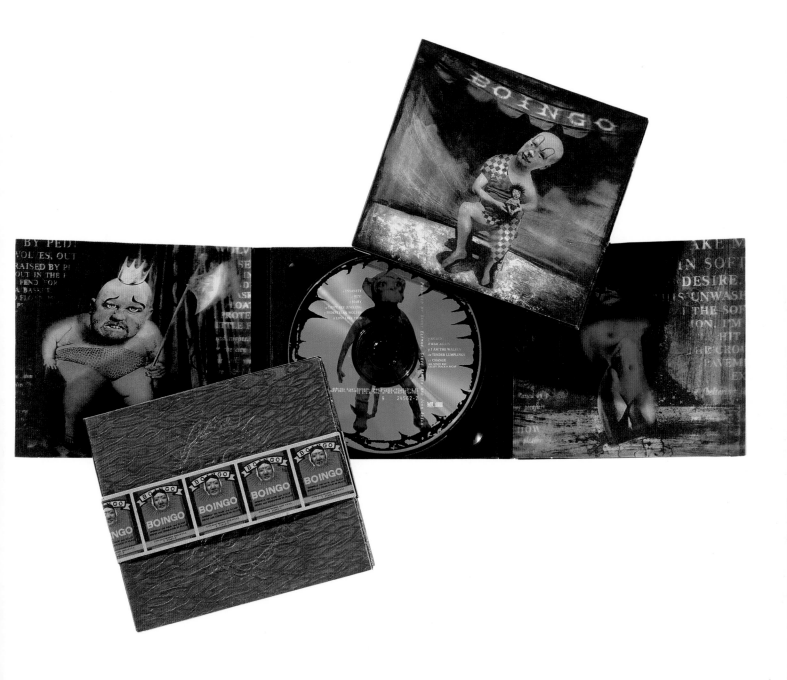

Design Firm: Warner Bros. Records
Art Director: Deborah Norcross
Designer: Deborah Norcross
Photographers: Anthony Artiaga,
Melodie McDaniel (Band)
Ideoque Typeface: Mike Diehl
Client: Giant Records
(© 1994 Giant Records)

Objective: To design audio/visual packaging that defines the band but also takes into consideration band originator Danny Elfman's particular visual quirks

Innovation: Lack of a concrete concept makes this package slightly incongruous—and therefore more interesting—and its visual solutions are unexpected. It is customized by displaying some of Elfman's vast collection of religious and voodoo-style art and artifacts in the special booklet. The booklet's "rip" of type also provides a new wrinkle, created electronically by bringing a grayscale TIFF into a QuarkXPress document and defining the background as "none."

Renowned 15 Salute Best 15 Poster

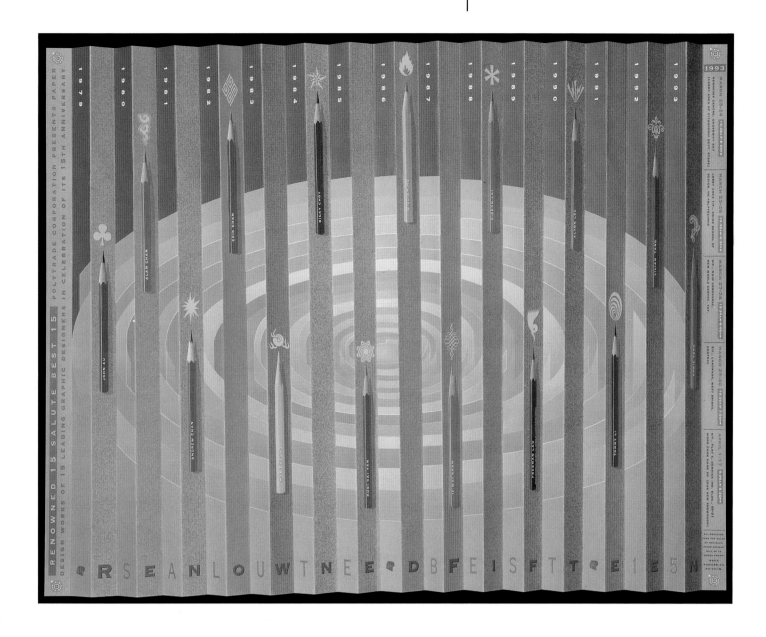

Design Firm: Kan Tai-keung Design
& Associates Ltd.
Art Director: Freeman Lau Siu Hong
Designers: Freeman Lau Siu Hong,
Veronica Cheung Lai Sheung
Computer Illustrator: Benson Kwun Tin Yau
Client: Polytrade Corporation

Objective: To produce a poster announcing the
15th anniversary of a paper company

Innovation: A single poster displays three
different perspectives. In the right view, 15
pencils represent the 15 designers and their
celebratory icons. In the left view, 15
sheets of paper form an unending spiral, rep-
resenting the client's concept of synergy.
From the front, pencils and spiral join to
form a 15th-birthday cake for the client.

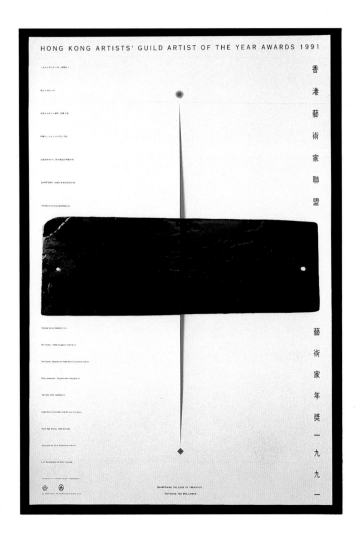

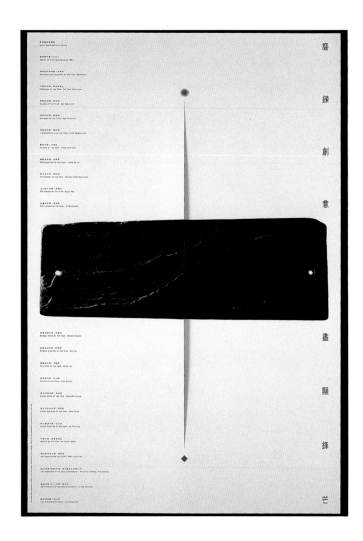

Design Firm: Kan Tai-keung Design & Associates Ltd.
Art Director: Kan Tai-keung
Designer: Kan Tai-keung
Client: Hong Kong Artist's Guild

Objective: To develop a poster promoting the Artist of the Year Awards

Innovation: This poster breaks two traditional rules of poster design: it is printed on two sides, and it displays a die-cut in the center, which enables it to go beyond the standard, two-dimensional graphic. Yupo paper, which has a plastic quality, increases the poster's durability.

HKDA Directions 22 Exhibition

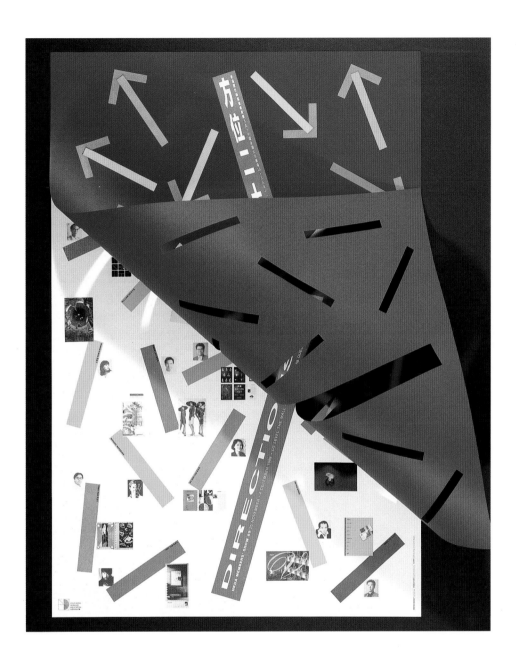

Design Firm: Kan Tai-keung Design & Associates Ltd.
Art Director: Freeman Lau Siu Hong
Designer: Freeman Lau Siu Hong
Client: Hong Kong Designers Association

Objective: To fashion a poster that would promote the Hong Kong Designers Association's "Directions 22" exhibition

Innovation: A two-layered poster is a fresh approach. The top layer, with 22 arrows pointing in different directions, signifies the exhibition participants and their 22 individual perspectives of design. The second layer reveals 22 colorful bars, each accompanied by a participant's photo and a sample of his or her work.

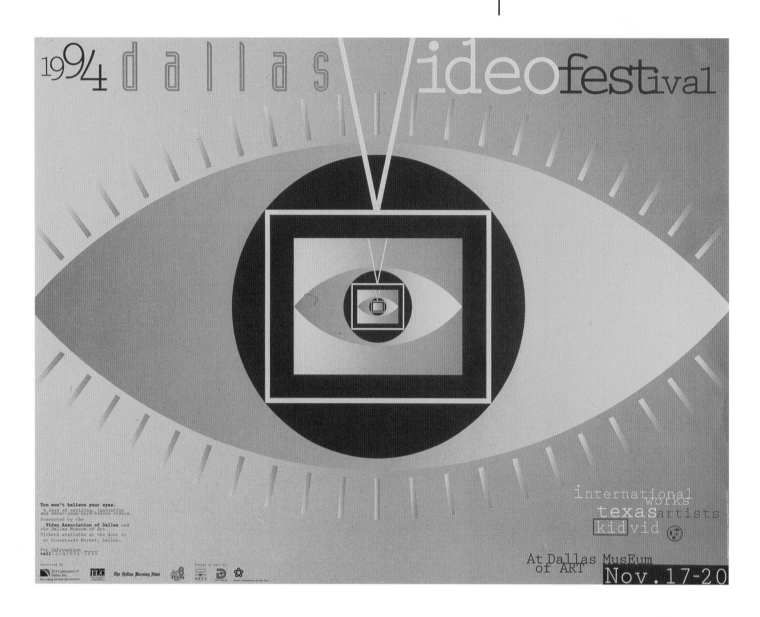

Design Firm: John Evans Design
Art Director: John Evans
Designer: John Evans
Illustrator: John Evans
Client: Video Association of Dallas

Objective: To generate excitement about the festival through an eye-catching poster and collateral material

Innovation: Type treatments that break conventional thinking about typography, and convey the lively atmosphere of the selective event, are one way this project achieves success. Brightly colored stock, gradations, and bold imagery make a splash, and also give the impression of a bigger budget than the designer actually has.

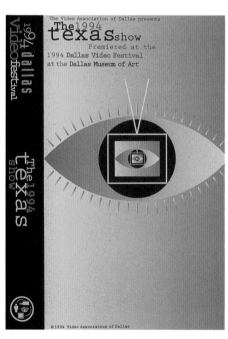

Hotel Invitation and Poster

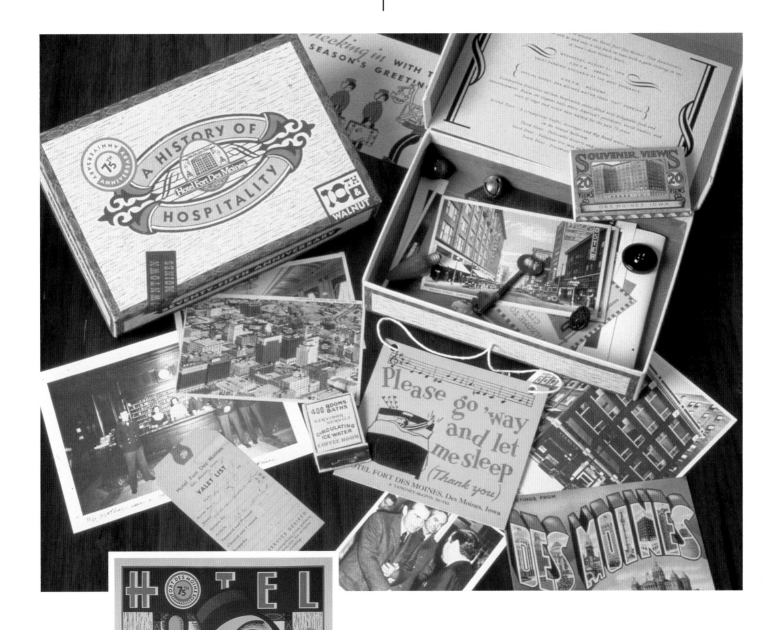

Design Firm: Sayles Graphic Design
Art Director: John Sayles
Designer: John Sayles
Illustrator: John Sayles
Copywriter: Wendy Lyons
Client: Hotel Fort Des Moines

Objective: To capture in its promotions the elegance and atmosphere of an historic hotel

Innovation: Reproductions of vintage hotel memorabilia—a valet tag, a "do not disturb" sign, matchbooks, and postcards—are tipped onto a poster to create a three-dimensional effect. The poster is directed to company meeting planners as a promotion. To create a party invitation, Sayles uses reproductions of old photos, postcards, buttons, and hotel keys, mailed in a container that resembles an old-fashioned cigar box. The invitation's format helps get the piece past the "gate-keepers" to the "movers and shakers" invited.

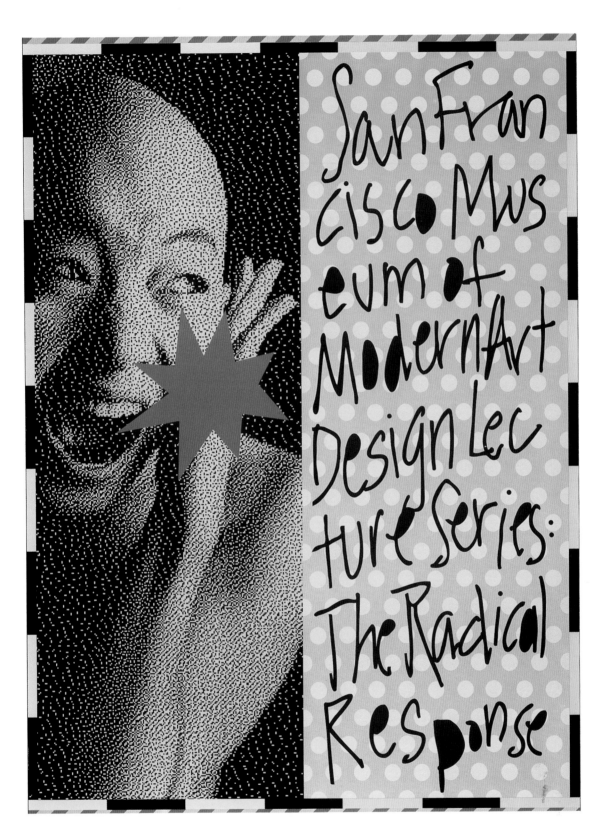

Design Firm: Morla Design
Art Director: Jennifer Morla
Designers: Jennifer Morla, Sharrie Brooks
Illustrator: Jennifer Morla
Client: American Institute of Graphic Art

Objective: To create an image for an art lecture series that captures its spirit

Innovation: The aggressive portrayal of the series' title, "Radical Response," commands attention in this poster. The series investigated the qualities that make design radical, and featured four individuals whose approach to design transformed the ordinary into the extraordinary.

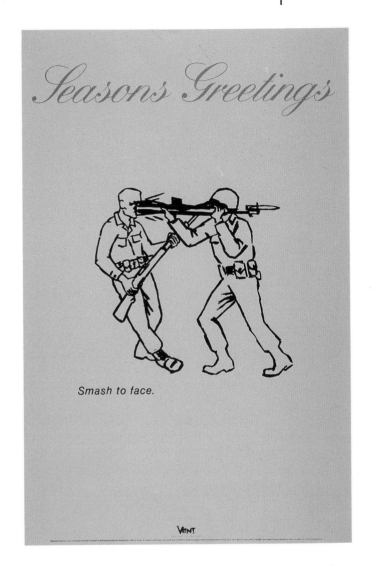

Smash to face.

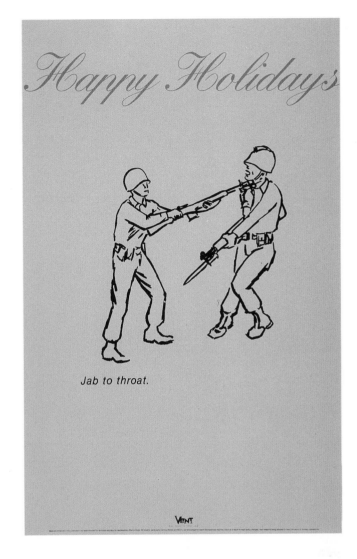

Jab to throat.

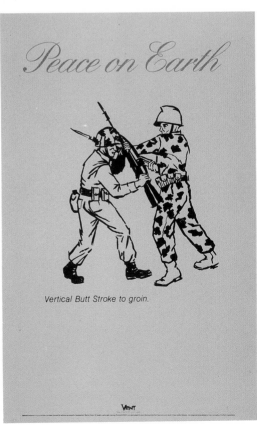

Vertical Butt Stroke to groin.

Design Firm: After Hours Creative
Art Directors: Russ Haan, Todd Fedell
Designer: Todd Fedell
Client: Vent

Objective: To make a statement about military violence by contrasting it with the joyful holiday season and peace on Earth

Innovation: To create immediate viewer impact, the studio turns simple holiday cards into huge posters with an off-beat green hue. Actual quotes from military training manuals throw the warm seasonal wishes traditionally extended at this time of year into sharp relief.

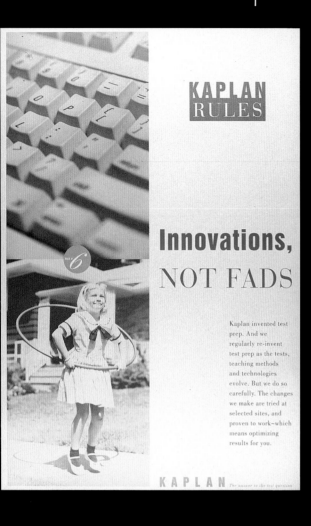

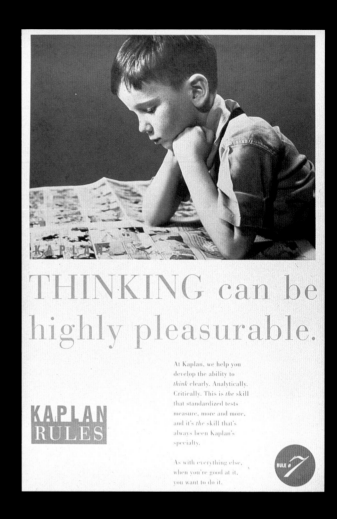

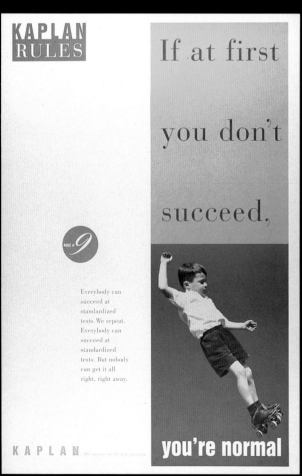

Design Firm: Parham Santana Inc.
Art Directors: John Parham, Alexander Knolton
Designer: Alexander Knolton
Copywriter: Diana Amsterdam
Client: Stanley Kaplan Educational Center

Objective: To create a series of ten posters featuring the rules for successful test-taking proposed by the client

Innovation: So that viewers can better relate the client to the wide scope of visual metaphors, the design approach avoids specifically defining the client. Rather than shoot models on locations to portray certain values, the studio uses archival imagery that appears modern to teens, and warm and nostalgic to a parent or pre-med student. The images also reinforce the retro look established with an earlier campaign.

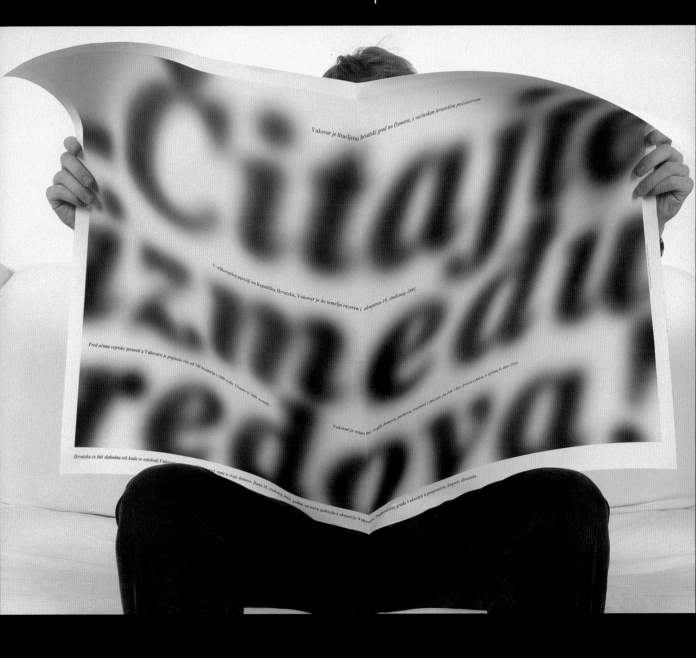

Design Firm: Studio International
Art Director: Boris Ljubičić
Designer: Boris Ljubičić
Illustrator: Boris Ljubičić
Photographer: Damir Fabijanić
Client: Studio International

Objective: To design an informational poster commemorating a highly charged political event

Innovation: Unique type treatment and use of color produce a highly creative two-sided poster. With the English version on one side printed in black and cyan and the Croatian words on the other in black and magenta, the huge type demands attention while the small type "between the lines" tells the story of the forced occupation of the town of Vukovar in 1991.

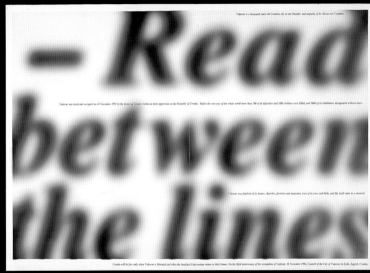

Envision XX Conference Poster

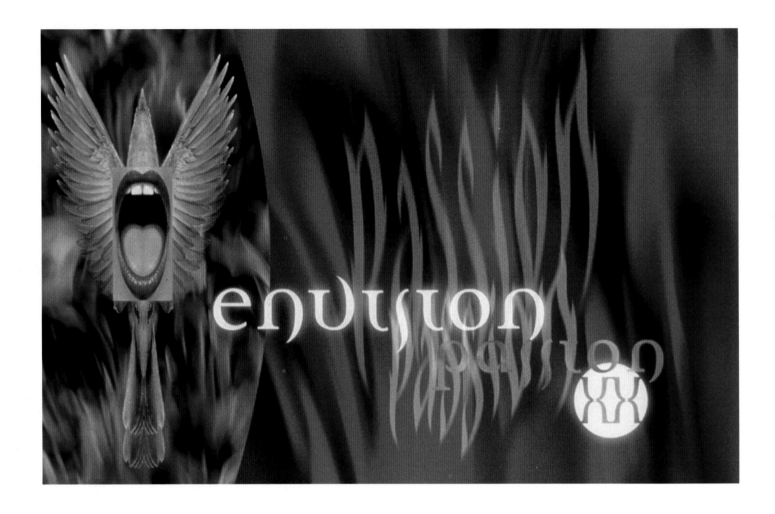

Design Firm: Margo Chase Design
Art Director: Margo Chase
Designer: Margo Chase
Photographer: Sidney Cooper
Client: ADAC Sacramento

Objective: To create a poster announcement for a 20th annual design conference

Innovation: A custom typeface, created for the poster, is also used on related graphics. The juxtaposition of images forms a new, jarring, and unfamiliar metaphor. The imagery is meant to question the passions toward work, love, and life, and the background ghosted typography evokes the smoke of memory.

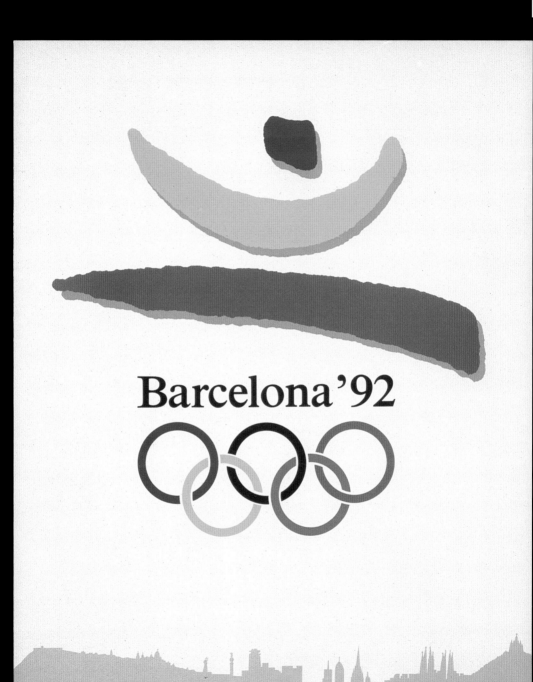

Barcelona'92

Jocs de la XXVa Olimpíada
Barcelona 1992

Juegos de la XXV Olimpíada
Barcelona 1992

Jeux de la XXVe Olympiade
Barcelona 1992

Games of the XXV Olympiad
Barcelona 1992

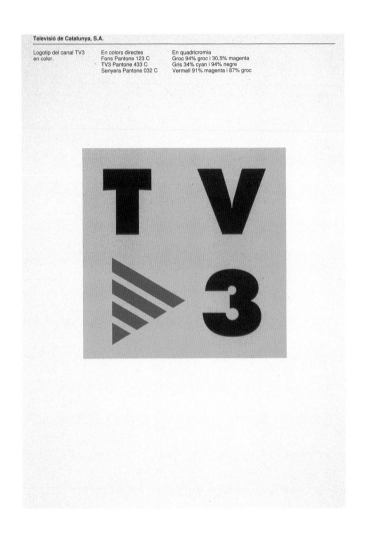

Televisió de Catalunya, S.A.

Logotip del canal TV3 en color.

En colors directes
Fons Pantone 123 C
TV3 Pantone 433 C
Senyera Pantone 032 C

En quadricromia
Groc 94% groc i 30,5% magenta
Gris 34% cyan i 94% negre
Vermell 91% magenta i 87% groc

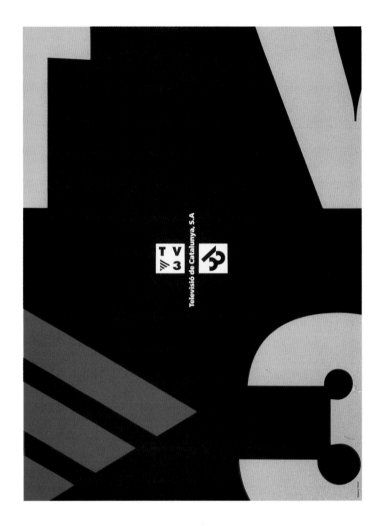

Design Firm: Quod Diseño y Marketing, S.A.
Art Director: Josep M. Trias Folch
Designer: Josep M. Trias Folch
Client: TV3 Catalonia Television

Objective: To develop a new logotype and graphic development to celebrate the client's 10th anniversary

Innovation: What is unique about this mark is that it is not linear—which would be the common solution for the network—and that its two major components—the letters "T" and "V" and the "3" and the triangle—are separated, so that the viewer reads in a circular fashion rather than from side to side. The design also directs the eye to the "3" by pointing both "arrows" (the triangle and the letter "V") in the direction of the numeral.

Vía Láctea (Milky Way) Identity

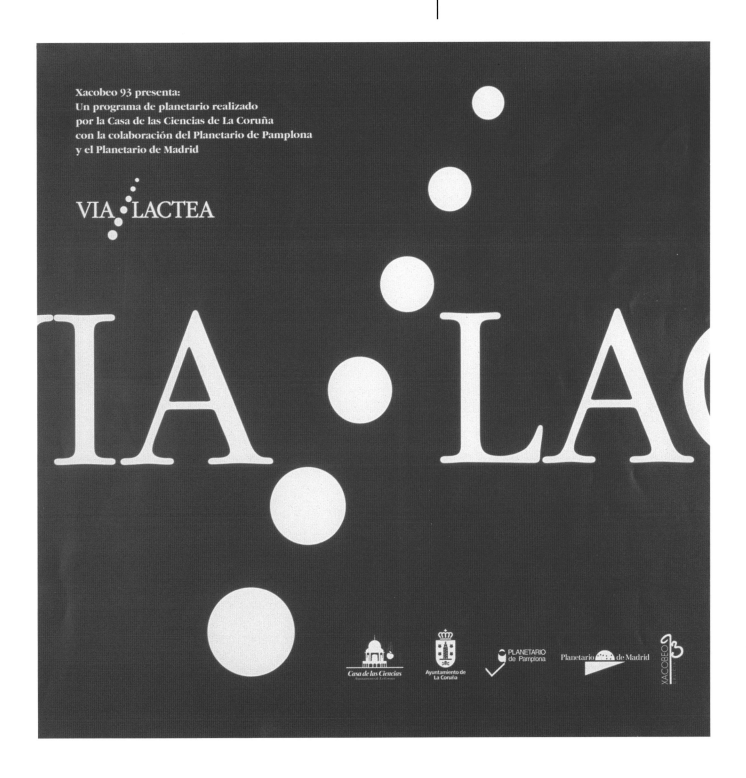

Design Firm: Quod Diseño y Marketing, S.A.
Art Director: Josep M. Trias Folch
Designer: Josep M. Trias Folch
Client: Vía Láctea

Objective: To design a graphic image for the Milky Way exhibit for a consortium of planetariums and science centers

Innovation: This logo is composed of two images in two sizes: a smaller version shows the complete logo, while a much larger version that is "cut off" on both sides gives the impression that the viewer is looking at the Milky Way from very close up and is concentrating on its luminous band of stars. This solution also helps provide an understanding for the galaxy name "Milky Way."

ANNOUNCEMENTS & IDENTITY

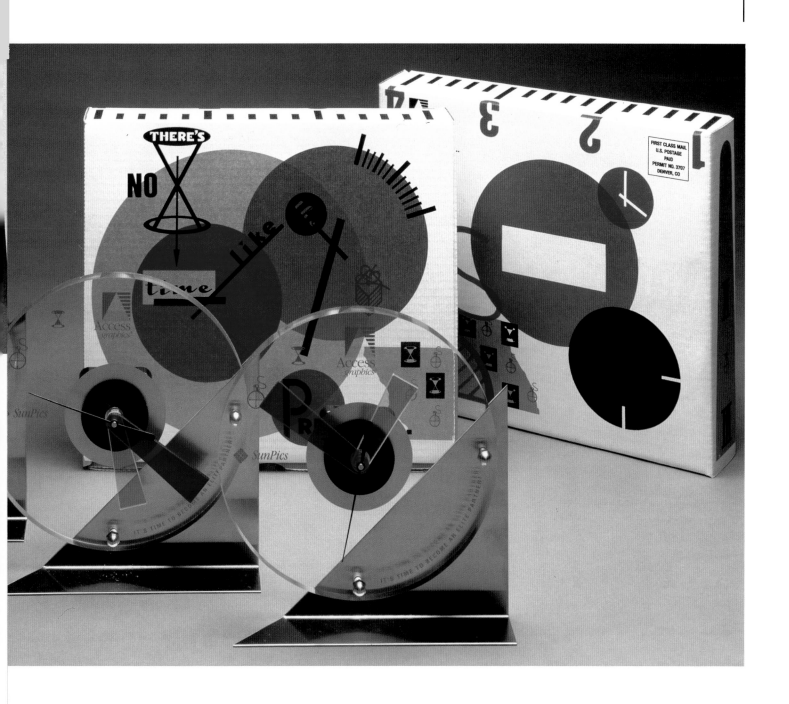

Design Firm: Sayles Graphic Design
Art Director: John Sayles
Designer: John Sayles
Copywriter: Wendy Lyons
Client: Access Graphics

Objective: To announce a promotion
through a direct-mail package targeted
to a specific audience

Innovation: A custom clock and copy that sup-
ports the concept give this mailing an impact
when it arrives, and helps it succeed with
consumers. The message is kept short and
direct so that it will be read by recipients.

Ragence Lam Christmas Card

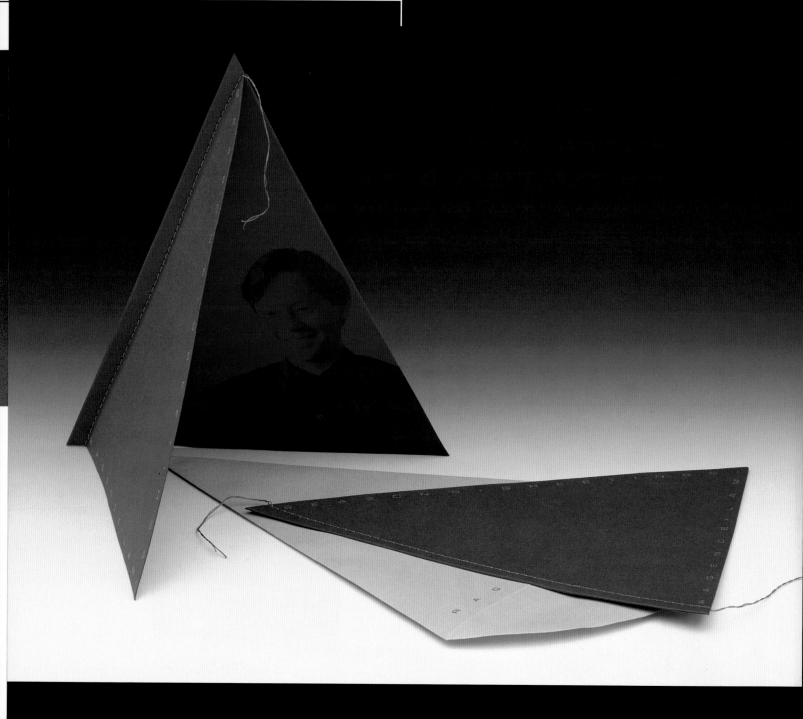

Design Firm: Kan Tai-keung Design & Associates Ltd.
Art Director: Kan Tai-keung
Designer: Kan Tai-keung
Client: Ragence Lam Ltd.

Objective: To design a personalized greeting card for Mr. Ragence Lam

Innovation: In this non-traditional design, two sheets of Christmas tree-shaped paper are sewn together with red and green thread. A photo inside further personalizes the card, and an envelope in an original shape completes the design.

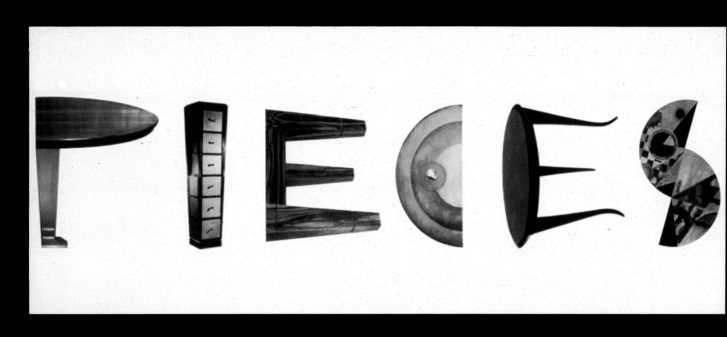

Design Firm: COY
Art Director: John Coy
Designers: John Coy, Rokha Srey
Production: Rokha Srey
Client: Pieces

Objective: To create an identity package to stimulate sales for a store dealing in custom, limited-edition furniture

Innovation: This studio breaks with tradition by creating letters with furniture, such as a table leg for the letter "P," and mixing them with a computer font. As a result, COY is able to

Invito Invitation

Design Firm: Pencil Corporate Art
Designer: Achim Kiel
Illustrators: Achim Kiel, Thomas Przygodda
Client: Archipause

Objective: To compose a party invitation to a celebration that took place backstage in a theater. The invitation was from an architects' copy shop that uses the Leaning Tower of Pisa as part of its trademark.

Innovation: Both concept and composition distinguish this invitation: a pop-up stage/set tower and a host of theatrical characters, ranging from a medieval imperial couple to Superman (which the 600 recipients pop up for themselves), represent the party theme. Because of the significance of the architect's logo and relevance of Italian culture in architecture, opera, and theater, half of the text is written in Italian, half in English.

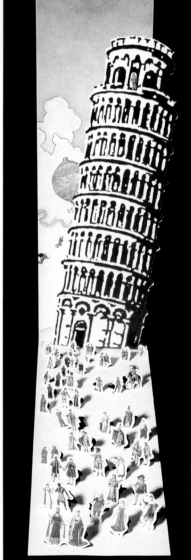

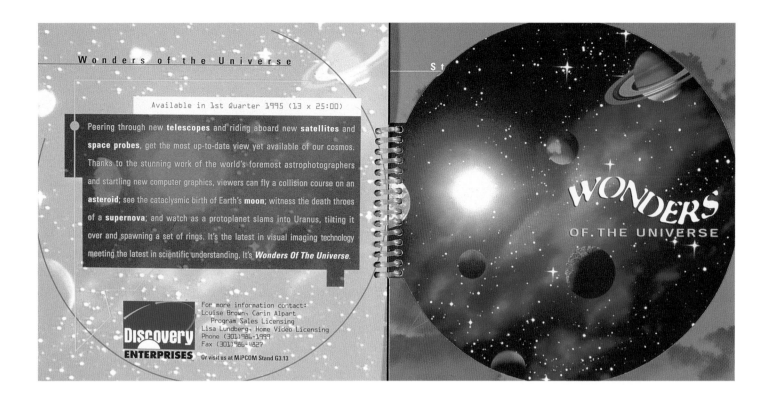

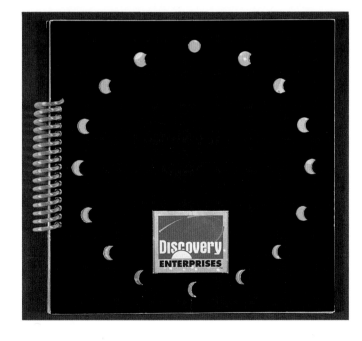

Design Firm: Discovery Design Group
Art Director: Richard Lee Heffner
Designer: Richard Lee Heffner
Client: Discovery Networks, Inc.

Objective: To produce an eye-catching invitation/catalog to draw prospective buyers to the client's trade booth

Innovation: The theme of the MIPCOM event, "science & technology," offers design latitude. The piece, however, also has to clearly communicate information to the client's international market. Although trendy solutions don't often work, this one is successful due to the use of original binding and color treatments, round interior pages, astronomical die-cuts, lines, and textures.

Rouse Holiday Card 1993

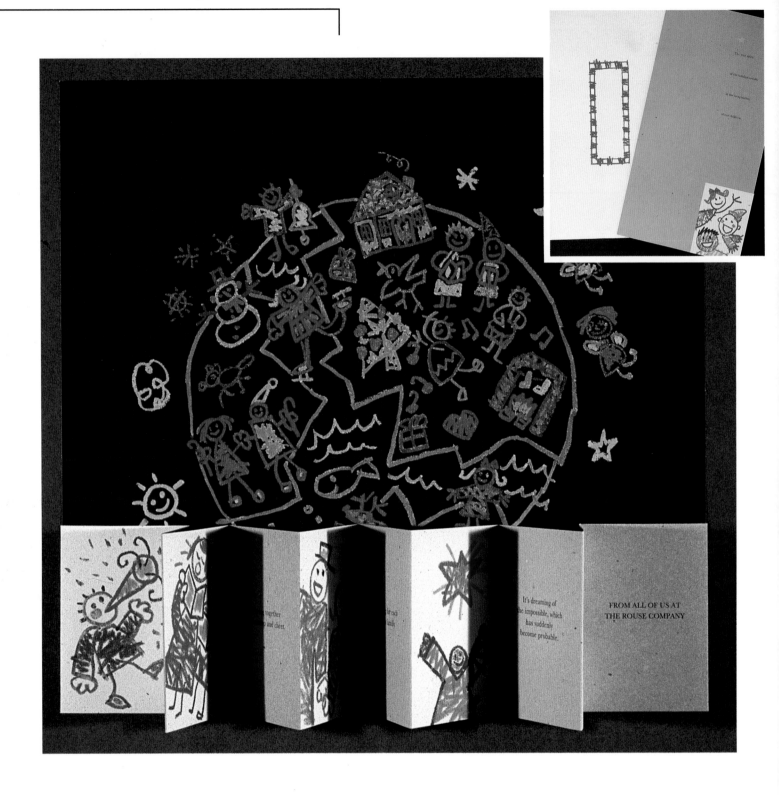

Design Firm: SullivanPerkins
Art Director: Ron Sullivan
Designer: Rob Wilson
Illustrators: Rob Wilson,
children of client employees
Client: The Rouse Company

Objective: To create a corporate holiday card
that involved the participation of the children
of the client's employees

Innovation: Instead of relying on traditional
visuals, the card design takes on the challenge
of transforming youngsters' unwieldy scrawls into
works of art. Children's drawings were chosen from
a client holiday art contest. Interesting folds
and simple text animate the piece and direct the
focus to the colorful illustrations.

Rachel Brown Birth Announcement

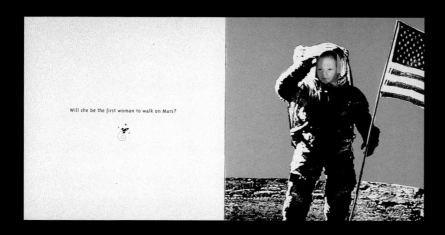

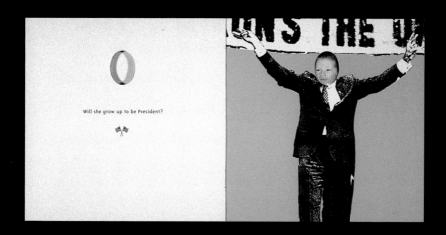

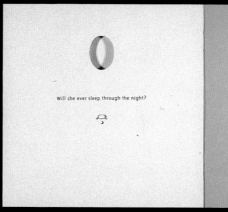

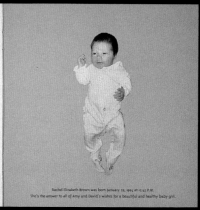

Design Firm: SullivanPerkins
Art Director: Ron Sullivan
Designer: Dan Richards
Illustrator: Dan Richards
Clients: Amy and David Brown

Objective: To excite the recipient and provide information about the event

Innovation: An unconventional idea and die-cutting process produce a humorous birth announcement. The design also provides all the basic information on the new arrival using a minimum of text.

Dominic Munson Garcia Birth Announcement

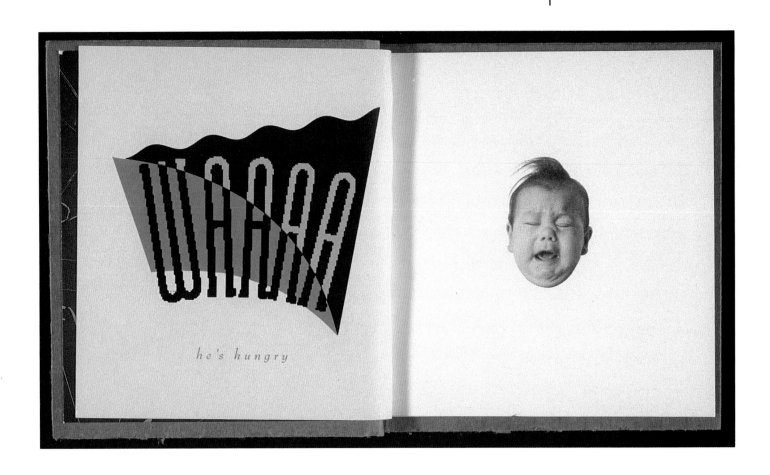

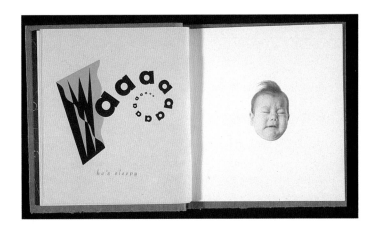

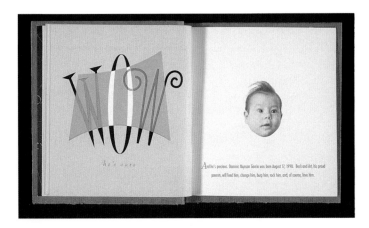

Design Firm: SullivanPerkins
Art Director: Art Garcia
Designer: Art Garcia
Photographer: Jeff Covington
Client: Beck and Art Garcia

Objective: To announce the birth of a son and to offer insights into his personality

Innovation: Rather than showing the baby in a passive state, which is the more common approach, this design portrays him as a "real" child. Typographic treatments convey the messages baby Dominic is trying to communicate.

Andrew Frawley Birth Announcement

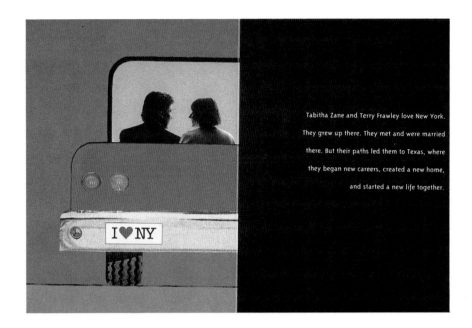

Tabitha Zane and Terry Frawley love New York. They grew up there. They met and were married there. But their paths led them to Texas, where they began new careers, created a new home, and started a new life together.

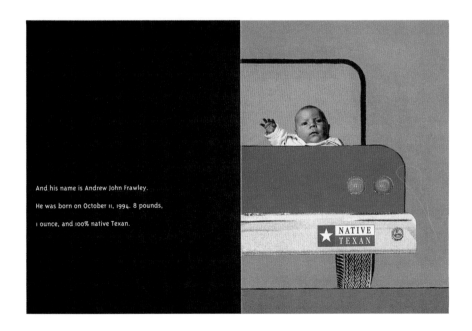

And his name is Andrew John Frawley. He was born on October 11, 1994. 8 pounds, 1 ounce, and 100% native Texan.

Design Firm: SullivanPerkins
Art Directors: Ron Sullivan, Kelly Allen
Designer: Kelly Allen
Illustrator: Kelly Allen
Photographer: John Dyer
Clients: Tabitha Zane, Terry Frawley

Objective: To interest, enlighten, and excite the recipient about the event

Innovation: An unconventional idea married to a conventional three-page format—created by gluing together two panels of an accordion fold—produces a playful announcement that also provides some before-baby history.

Book of Hours Promotion

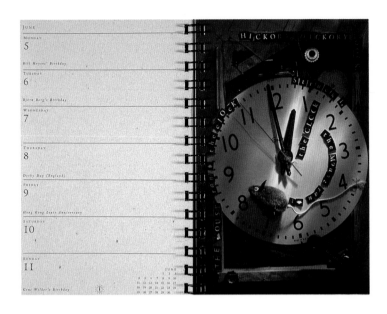

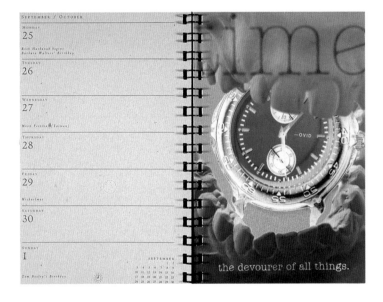

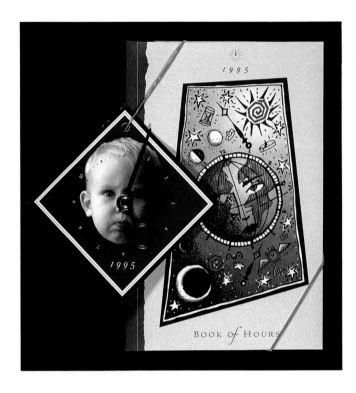

Design Firm: Osborn & DeLong
Art Director: Victoria Szymcek
Designer: Victoria Szymcek
Illustrators: Victoria Szymcek, Doug DeLong, Jane Osborn, Terri Jasperson, Al Fleener, Christine Schuring
Photographer: Christopher Kemp
Client: Osborn & DeLong

Objective: To create an out-of-the-ordinary holiday promotion to show off the talents of the staff and that recipients would use and keep

Innovation: The concept is a twist on a traditional Book of Hours, with a novel, easy-to-understand format. For this calendar highlighting time, international holidays, and birthdays of favorite people, the staff did the handwork for everything—from adding page markers with clock stickers, to gluing the odd-shaped cover art, to attaching clock hands to cards.

Laughing Dog Identity

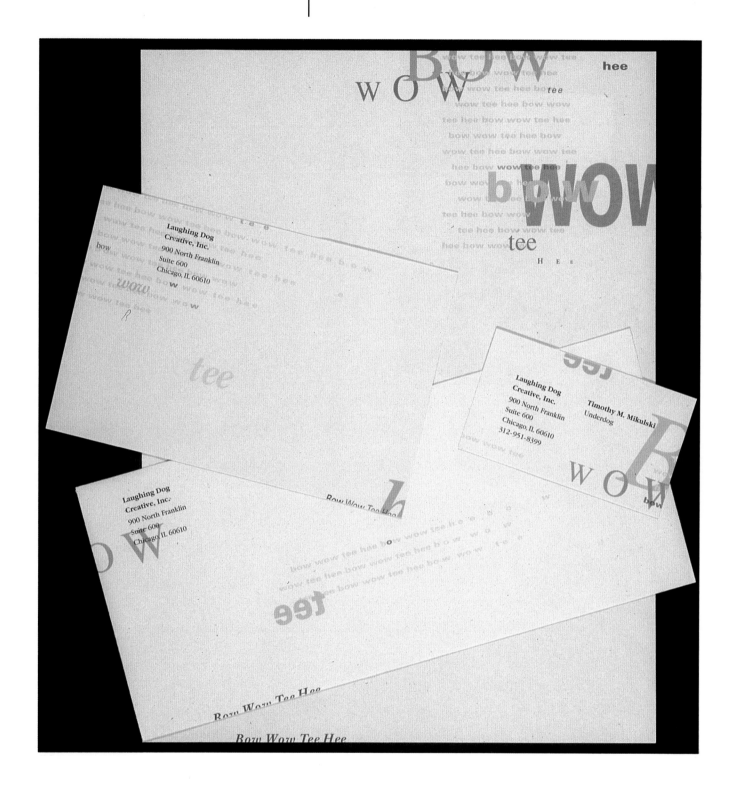

Design Firm: Laughing Dog Creative, Inc.
Art Director: Frank EE Grubich
Designer: Joy Panos
Client: Laughing Dog Creative, Inc.

Objective: To communicate the studio's address and phone number to potential clients

Innovation: A corporate identity that is about as un-corporate as possible inspired this atypical design. With titles like "Top Dog" and "Underdog" on business cards, and type that spells out "bow wow" and "tee hee" while overlapping and running off the page, this studio's secondary intention for their identity is to make people smile. They pay little attention to where type falls so that different patterns appear on each sheet.

Cheese Logo

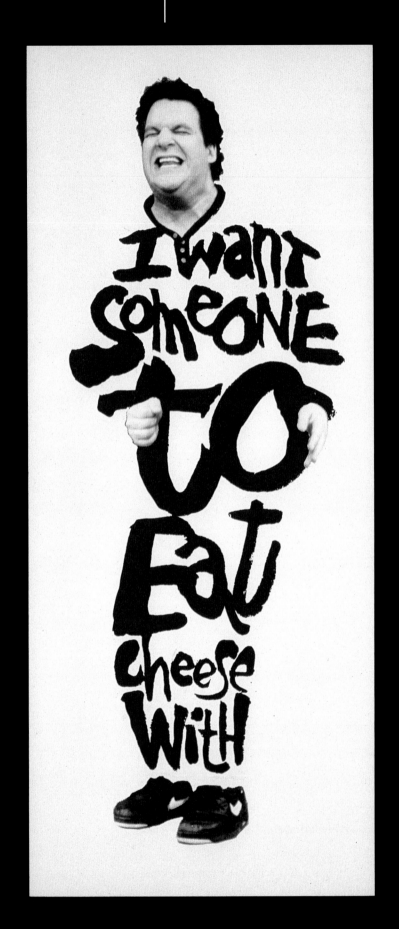

Design Firm: Laughing Dog Creative, Inc.
Art Director: Frank EE Grubich
Designer: Jamie Apel
Client: Remains Theater

Objective: To announce a new, one-man comedy show at a local Chicago theater

Innovation: The client asked only that the title be big and that his photo be legible. The studio thought the title should also be funny, so they stretched the normal parameters of type usage to accomodate their—and the audience's—sense of humor.

A Very Tuffy Christmas Card

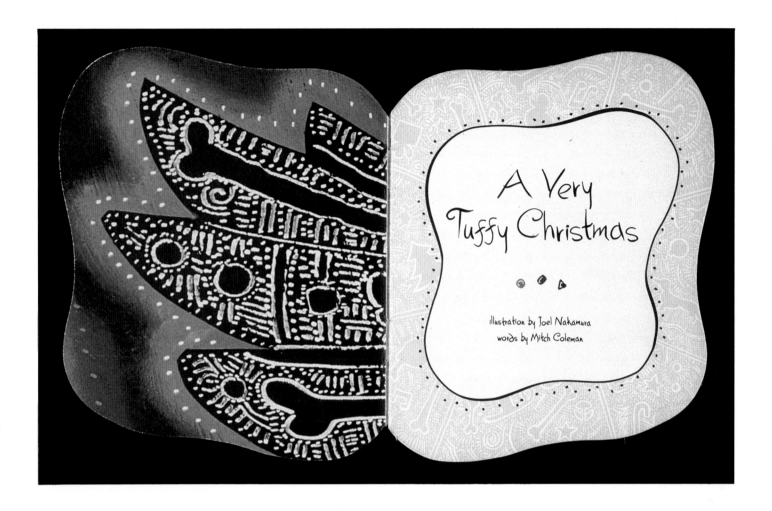

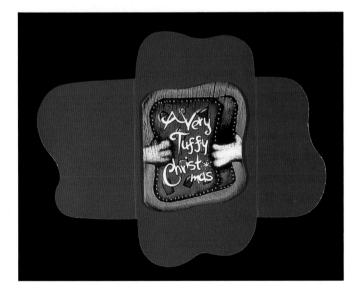

Design Firm: Laughing Dog Creative, Inc.
Art Director: Frank EE Grubich
Designer: Tim Meyer
Illustrator: Joel Nakamura
Writer: Mitch Coleman
Client: Laughing Dog

Objective: To produce a promotion that would spread holiday greetings everywhere

Innovation: Instead of a promotion that promoted, the primary intention of this piece was to create something innovative, so the studio name is printed so small it was barely readable, and the irreverent concept breaks with the tradition of a politically correct Christmas card. An unusual shape, and an envelope, which fastens with a clear, wafer-seal sticker, complete the effect.

The Bang Calendar

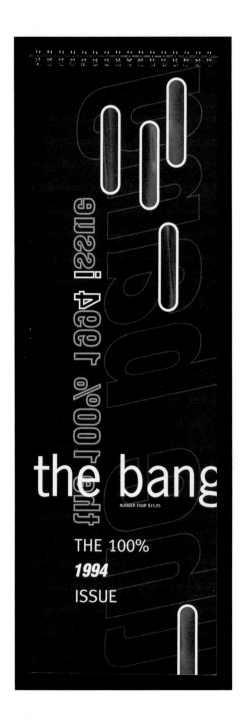

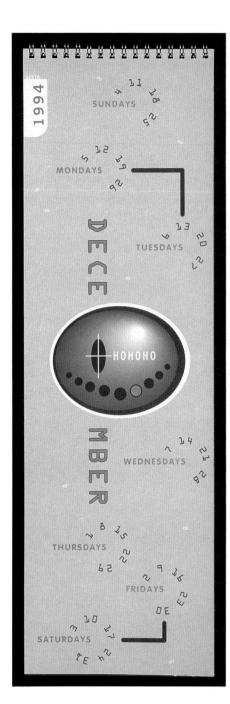

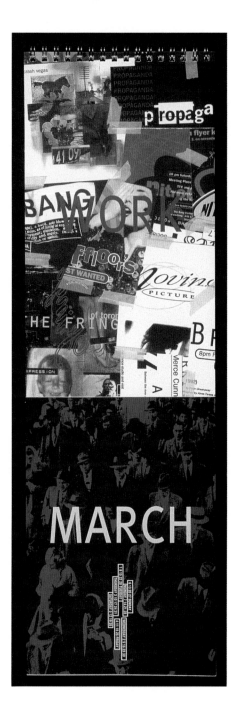

Design Firm: The Bang
Art Director: Bill Douglas
Designer: Bill Douglas
Client: The Bang

Objective: To create a promotional calendar that displays the studio's work and is also appealing to the reader

Innovation: Although the calendar is fully functional, the emphasis is on depicting each month as an individual design, which gives the reader a fresh start 12 times a year. Eccentric dimension and formats combine to produce a calendar whose variety and differences actually work to keep whole project together.

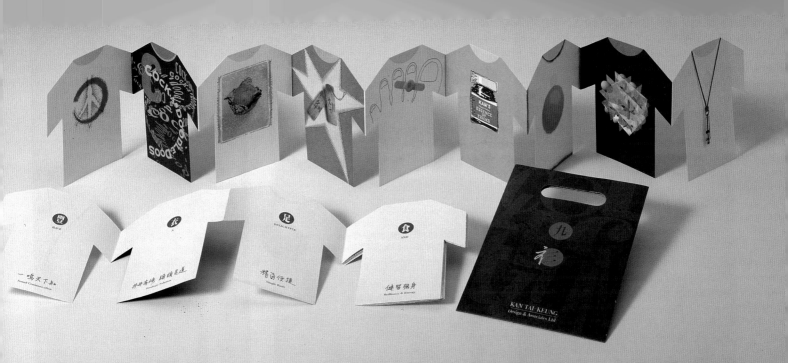

on screen

what the computer can make sense of

is limited. *Spell Check* is a computerised high speed dictionary, not a form of artificial

intelligence. You can **sale away** into the sunset or have a **supermarket sail** and the computer

won't know **write** from wrong. Pairs of words used together in the calendar may sound

correct but in print make no sense. The translations of the words into visual form may be

nonsense

but work as pictures on the page

The actions of a **hell** razor
-not to mince words about it.

jul

				1	2								
3	4	5	6	7	8	9							
10	11	12	13	14	15	16	17	18	19	20	21	22	23
24	25	26	27	28	29	30							
31													

Op Sunwear Advertisements

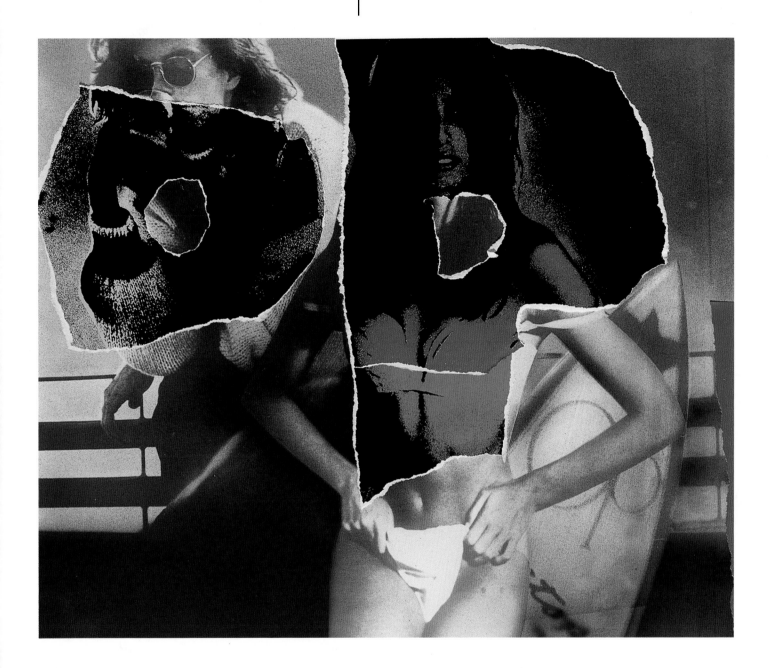

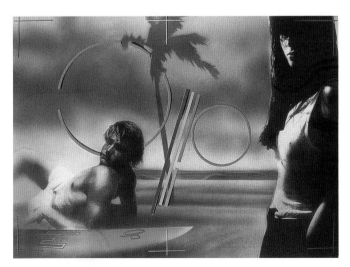

Design Firm: Mike Salisbury Communications
Art Director: Mike Salisbury
Designer: Mike Salisbury
Illustrator: Terry Lamb
Client: Op Sunwear

Objective: To create a more youthful image for a mature surfwear company

Innovation: Breaking rules for the client can mean an entirely new image. Softly hued colors, sexual innuendo, obscure logos—all firsts for a very conservative beachwear company—add up to a successful campaign.

Design Firm: After Hours Creative
Art Director: Russ Haan
Designer: Sharp Emmons
Client: Phoenix Advertising Club

Objective: To invite firms to submit work for an advertising competition

Innovation: It is not customary to shoot holes in the pieces you create. In this case, the studio simulated "target practice" by actually hand-drilling hundreds of perforations to make the materials look as if they survived a ses-

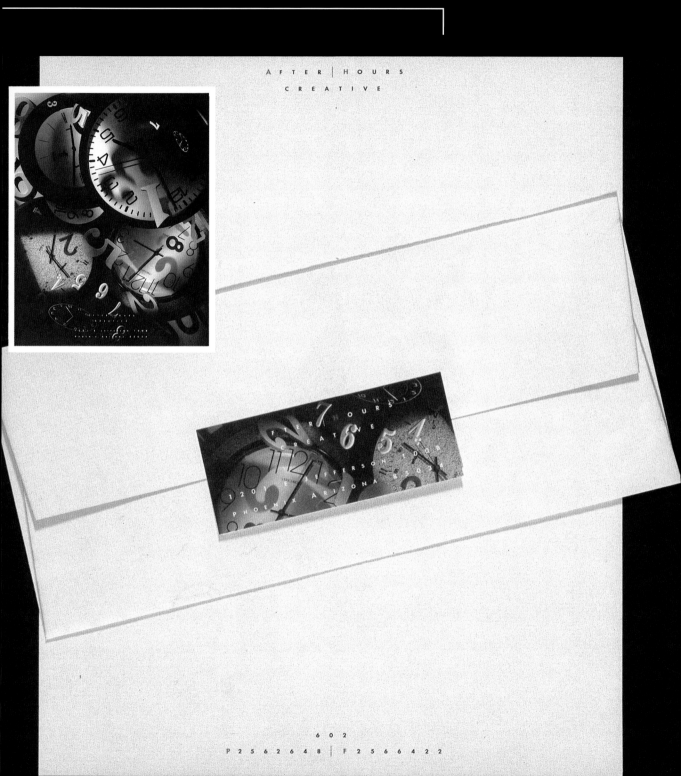

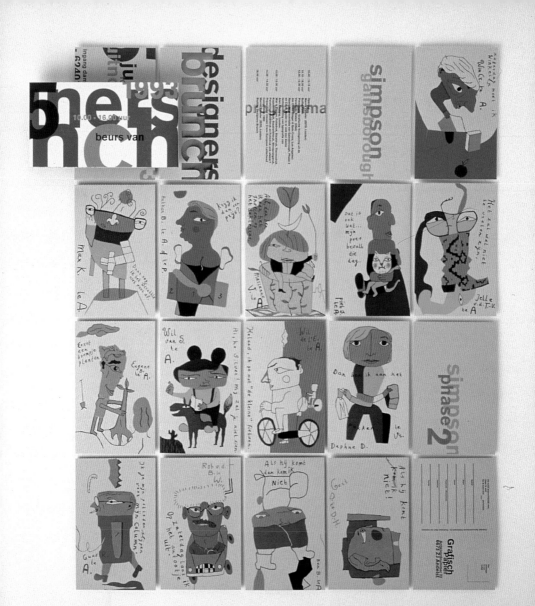

Design Firm: Samenwerkend

Art Director: André Toet

Designer: Helene Skjelter

Illustrator: Bart van Lee

Client: ISTD Fine Paper

Objective: To design an ⬚
brunch celebrating the la⬚

Innovation: Here's an inv⬚
fun at the guests as wel⬚
Cartoons illustrate imag⬚

GREG McCLATCHY FILMS, INC.

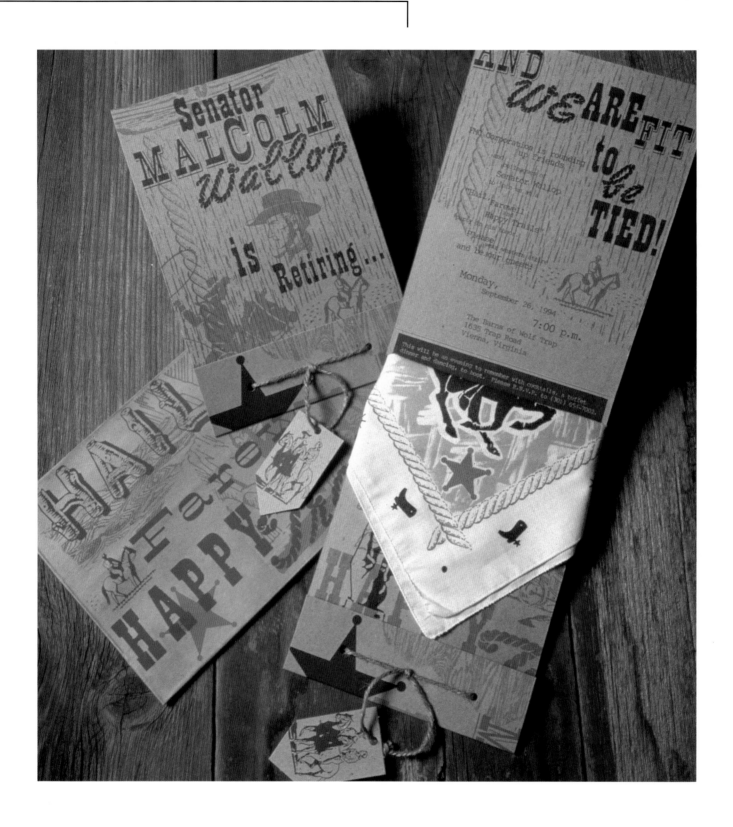

Design Firm: Sayles Graphic Design
Art Director: John Sayles
Designer: John Sayles
Illustrator: John Sayles
Copywriter: Wendy Lyons
Client: FMC Corporation

Objective: To create an invitation to a senator's retirement party that would echo the event's location—in a barn

Innovation: An animated approach—customized bandannas (which also serve as mementos of the event) encircle a rustic-style invitation. Its chipboard envelope is printed with graphics right off the ranch. Clip-art graphics and typewriter type reinforce the western theme of "hail, farewell, and happy trails."

Thank-You Card

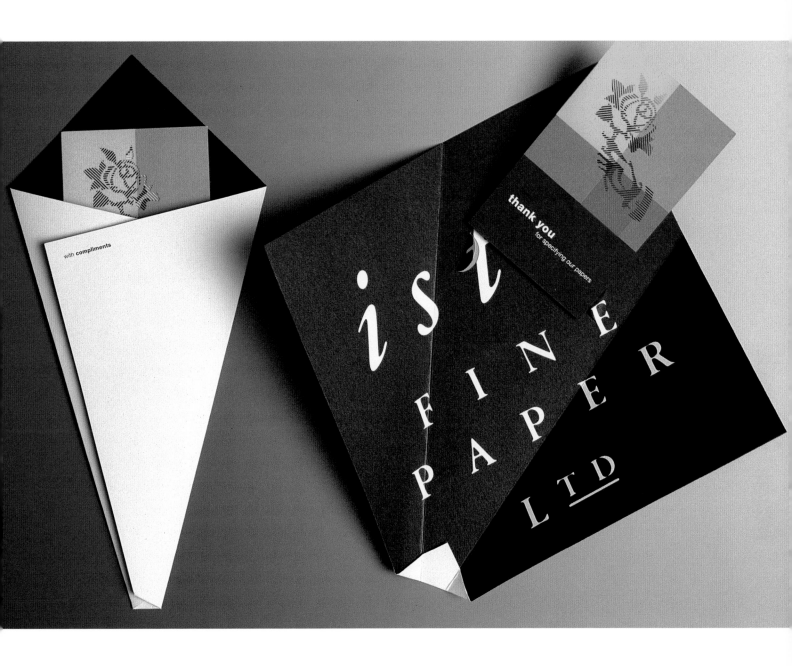

Design Firm: Trickett & Webb
Art Directors: Brian Webb,
Lynn Trickett, Martin Cox
Designer: Martin Cox
Illustrators: Trickett & Webb
Client: ISTD Fine Paper Ltd.

Objective: To design a thank-you card for
paper specifiers

Innovation: An unexpected bouquet of flowers
blooms from a folded paper cone, with a laser-
cut card heralding the thoughtful message.

Paul Rassam Stationery

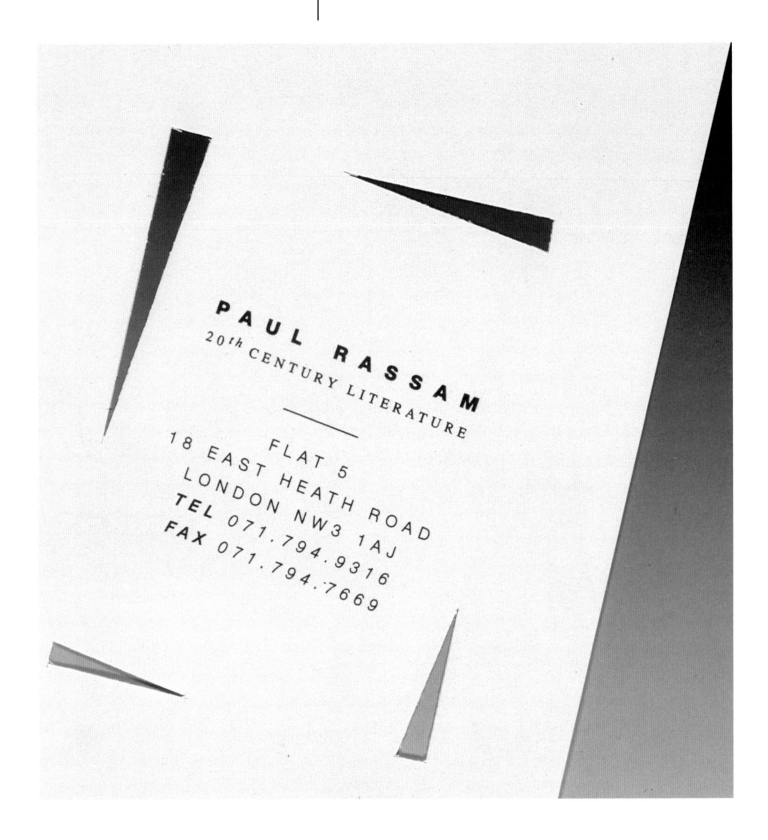

PAUL RASSAM
20th CENTURY LITERATURE

FLAT 5
18 EAST HEATH ROAD
LONDON NW3 1AJ
TEL 071.794.9316
FAX 071.794.7669

Design Firm: Trickett & Webb
Art Directors: Lynn Trickett, Brian Webb
Designer: Martin Cox
Client: Paul Rassam

Objective: To create stationery for a dealer in twentieth-century books and manuscripts

Innovation: The client's name and address are positioned within the stationery page, with triangular die-cuts surrounding it, giving the effect of a page within a page—a technique that is fairly unconventional for Antiquarian booksellers' letterheads.

Rouse Holiday Card

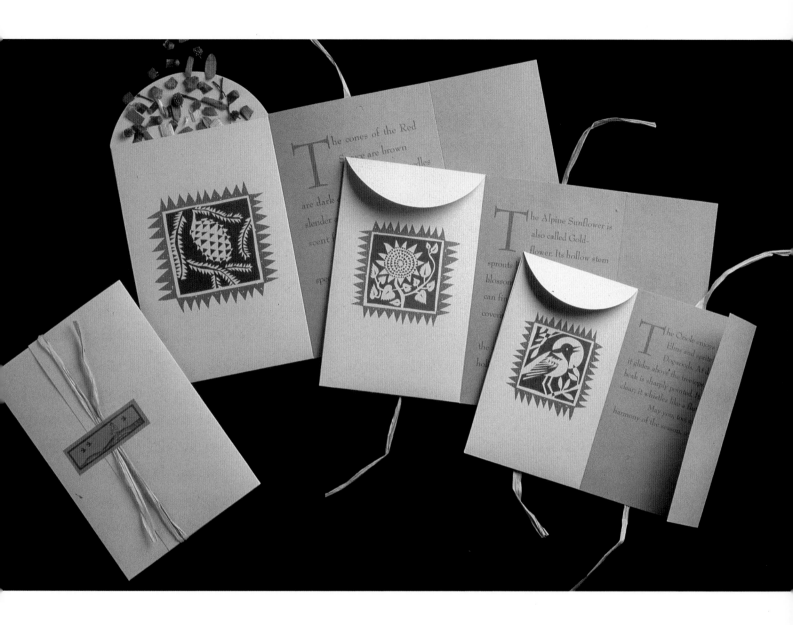

Design Firm: SullivanPerkins
Art Director: Ron Sullivan
Designer: Ron Sullivan
Illustrator: Ron Sullivan
Client: The Rouse Company

Objective: To enlighten and delight
the recipient

Innovation: Unconventional materials,
including birdseed, sunflower seeds, and
pine cone potpourri, linked with an environ-
mental preservation theme, are used in a
holiday card with an unusual presentation.
Cards of different sizes fit inside each
other and are bound with raffia wrapping.

Sing Cheong Printing Stationery

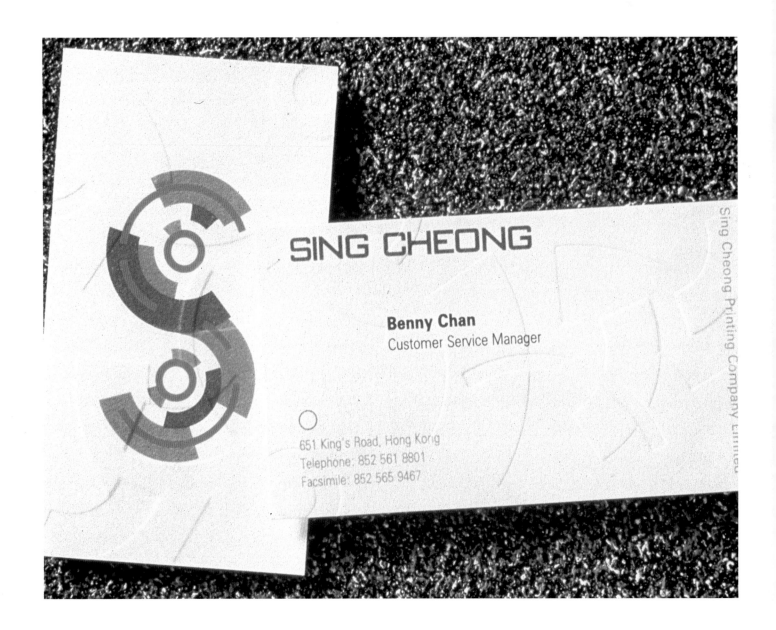

Design Firm: PPA Design Limited
Art Director: Byron Jacobs
Designer: Byron Jacobs
Printer: Sing Cheong Printing Co. Ltd.
Client: Sing Cheong Printing Co. Ltd.

Objective: To create a distinctive identity that illustrates the company's business

Innovation: The abstract logo illustrates paper flowing through printing rollers and concurrently forms the "S" letterform. Unlike most logos, however, this one can be fragmented to extend the identity system as a pattern device, which can then be used as debossed and embossed elements, as well as in different colors, tints, and materials.

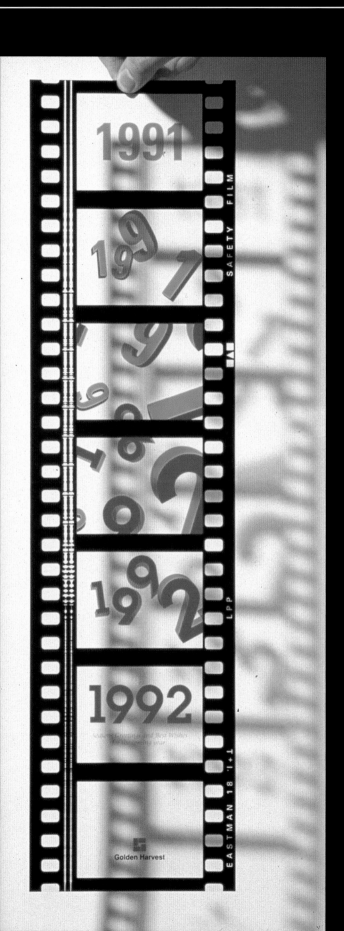

Design Firm: PPA Design Limited
Art Director: Byron Jacobs
Designer: Byron Jacobs
Client: Golden Harvest Films

Objective: To create a distinctive New Year's card that could be mailed internationally to promote a film production agency

Innovation: Cards are silk-screened on plastic to create the impression of a movie film strip. The card's graphics continue the entertaining effect by producing the illusion of moving letterforms, as if on an actual strip of film.

Identity for a Confectionery Business

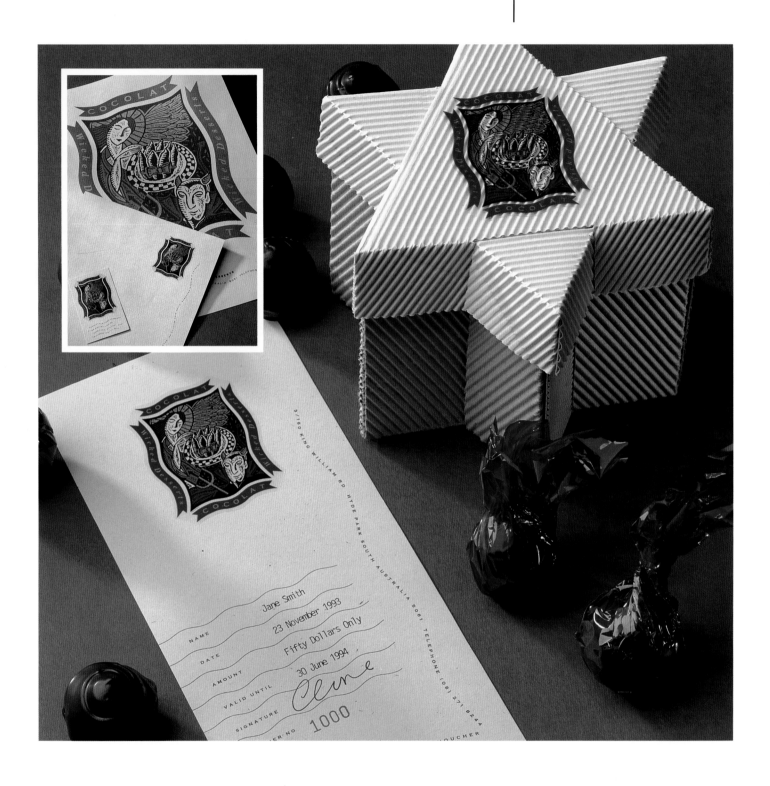

Design Firm: Tucker Design
Art Director: Claire Rose
Designer: Claire Rose
Illustrator: Claire Rose
Client: Cocolat and Wicked Desserts

Objective: To create a new corporate identity for a business specializing in quality chocolate and desserts

Innovation: The challenge of retaining an element of whimsy while adhering to a strict budget is overcome by capitalizing on chocolate's "divine and wicked" connotations (good and bad for you) and embodying them in angel and devil images. Because the design also has to be flexible enough to be used on items from stationery to store displays to packaging, a sticker that featured the new logo was produced.

Kita's Invitation

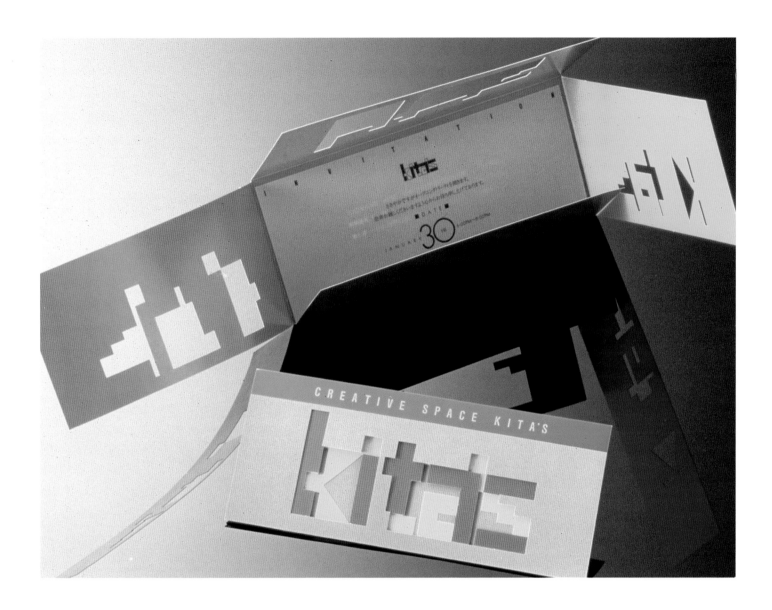

Design Firm: Tad Co., Ltd.
Art Director: Takashi Matsuura
Designer: Takashi Matsuura
Copywriter: Kunie Ishiyama
Client: I.D.K. Design

Objective: To create an invitation to a furniture store's event

Innovation: When the die-cuts of the three panels of an invitation are folded correctly on top of each other, the store name, "Kita's" appears—not in a stagnant arrangement, but through different layers and colors, to make the design as interesting as the event.

David Carter Design Holiday Card

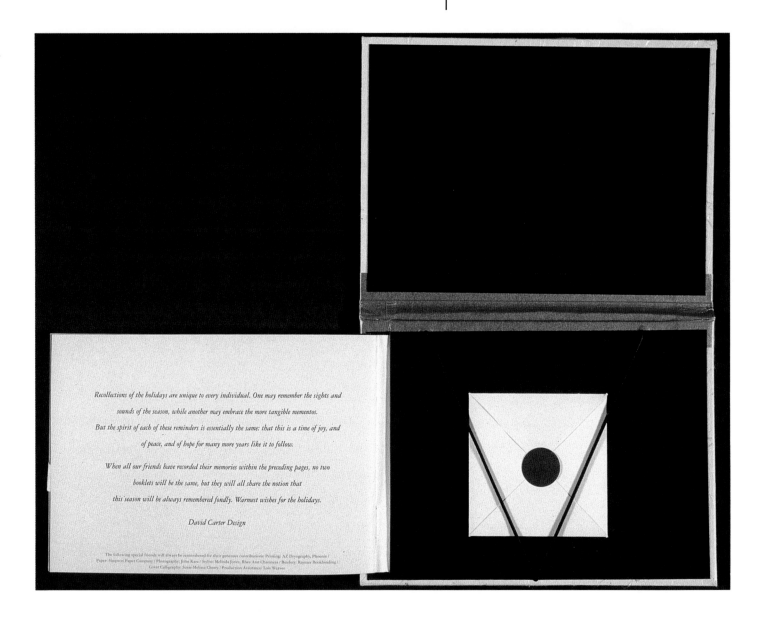

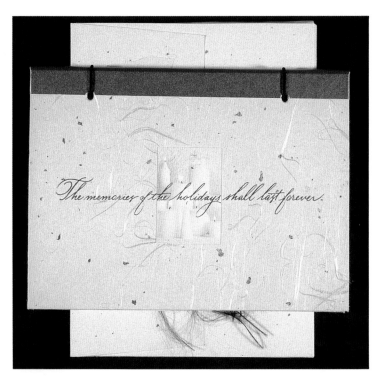

Design Firm: David Carter Design Associates
Art Directors: Lori B. Wilson, David Carter
Designers: Lori B. Wilson, studio staff
Photographer: John Katz
Bindery: Raymer Book Bindery
Client: David Carter Design

Objective: To create a holiday card that makes a lasting impression on friends and clients

Innovation: This card contains everything but a partridge in a pear tree: handmade Japanese paper, gold bookbinding cloth, antique black photography corners, three different paper stocks, gold foil stamping, 25 typefaces, and 150 hours of the staff's volunteer handwork to elevate the piece beyond a traditional card— and also to break the controller's rule on the amount of time and money allowed to create an in-house greeting.

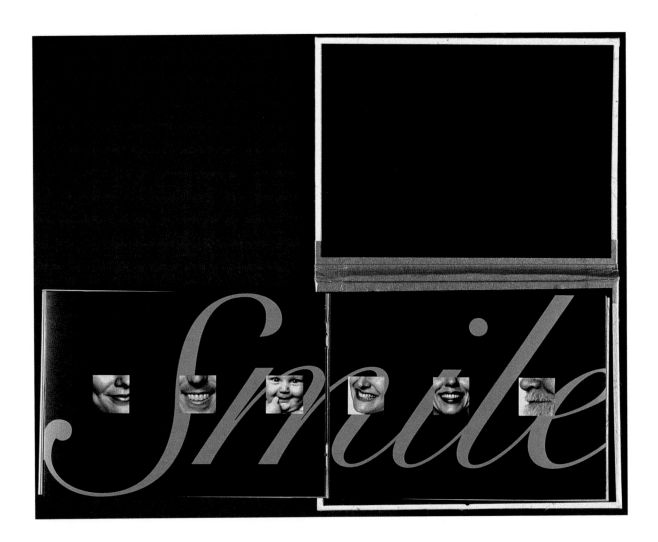

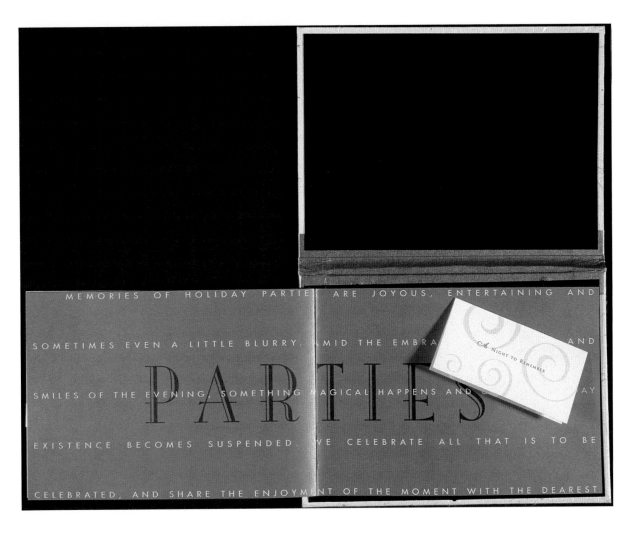

MEMORIES OF HOLIDAY PARTIES ARE JOYOUS, ENTERTAINING AND SOMETIMES EVEN A LITTLE BLURRY. AMID THE EMBRA... ...AND SMILES OF THE EVENING, SOMETHING MAGICAL HAPPENS ANDAY EXISTENCE BECOMES SUSPENDED. ...E CELEBRATE ALL THAT IS TO BE CELEBRATED, AND SHARE THE ENJOYMENT OF THE MOMENT WITH THE DEAREST

PARTIES

Mechanic Stationery

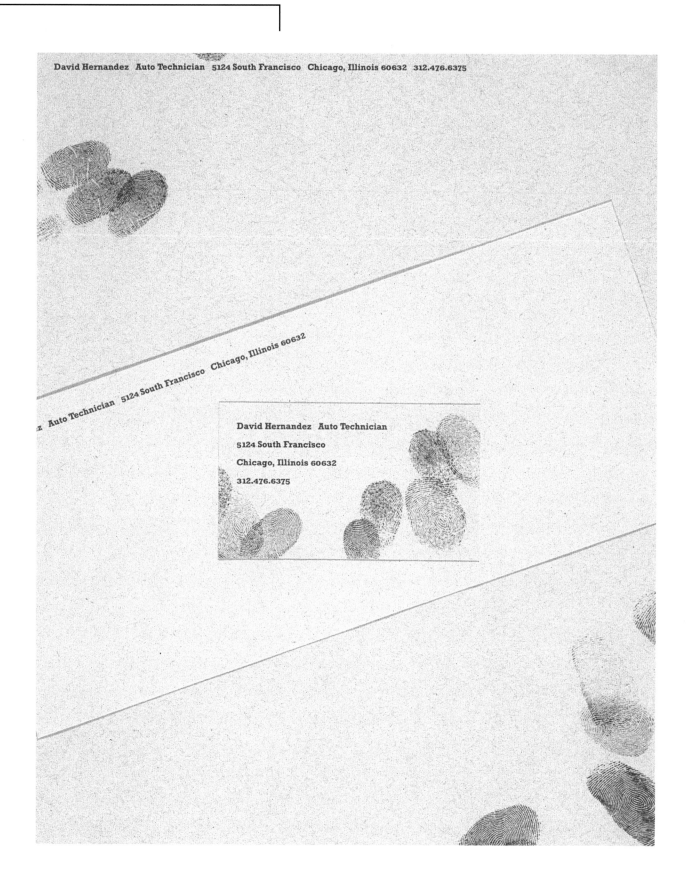

Design Firm: SullivanPerkins
Art Director: Art Garcia
Designer: Art Garcia
Client: Davis Hernandez

Objective: To design a letterhead system for an independent mechanic

Innovation: Although letterhead is traditionally as "clean" as possible, this stationery sports fingerprints that convey the client's profession in a straightforward manner, and with a smile.

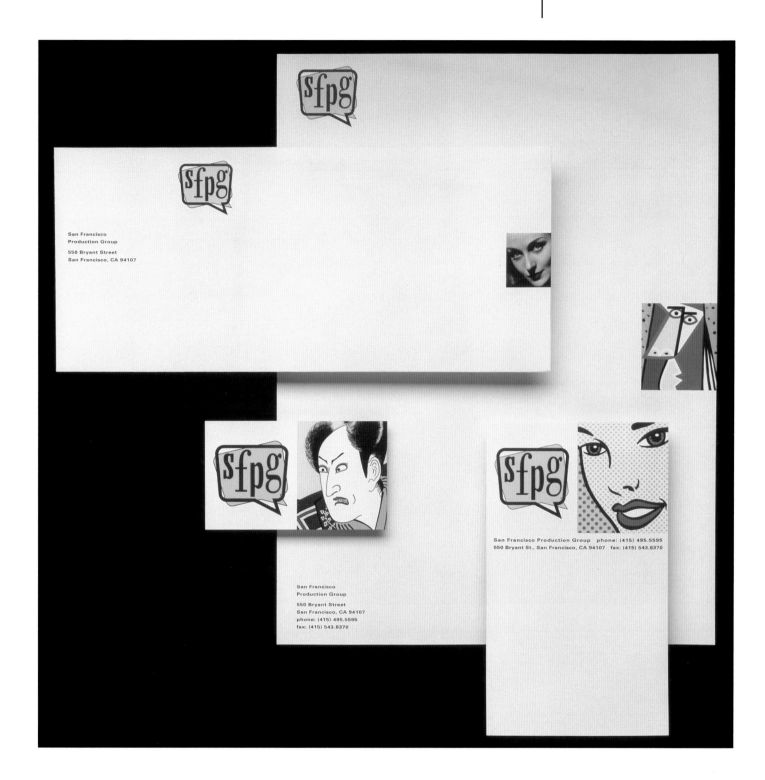

Design Firm: Morla Design
Art Director: Jennifer Morla
Designers: Jennifer Morla, Craig Bailey
Photographer: Bettmann Archive
Photo Imaging: Mark Eastman
Client: San Francisco Production Group

Objective: To create an identity for a San Francisco-based video production group that specializes in video animation, sound, and film

Innovation: Playfulness and image variety aren't often used when creating an identity system, but this "animated" logo accomplishes it successfully. The trademark portrays the vehicle used for viewing much of the client's work—a television monitor—paired with various portraits from entertainment venues to humorously illustrate the client's work.

Croatian Auto Club Corporate Identity

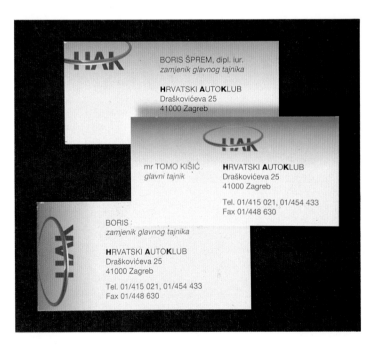

Design Firm: Studio International
Art Director: Boris Ljubičić
Designer: Boris Ljubičić
Illustrator: Igor Ljubičić
Photographer: Damir Fabijanić
Client: HAK

Objective: To create an appropriate identity for an association of Croatian auto clubs that insures vehicles

Innovation: It's the irregular concept that brings life to this project: initial type-faces of the client's name take on a three-dimensional perception via their strong volume and a metal element that seems to resist the paper and intrude into the design as a "live" object. The logo is applied so large on maps that it brings its own reality to the piece, and the perception of the metal curve gives the entire design a component of speed.

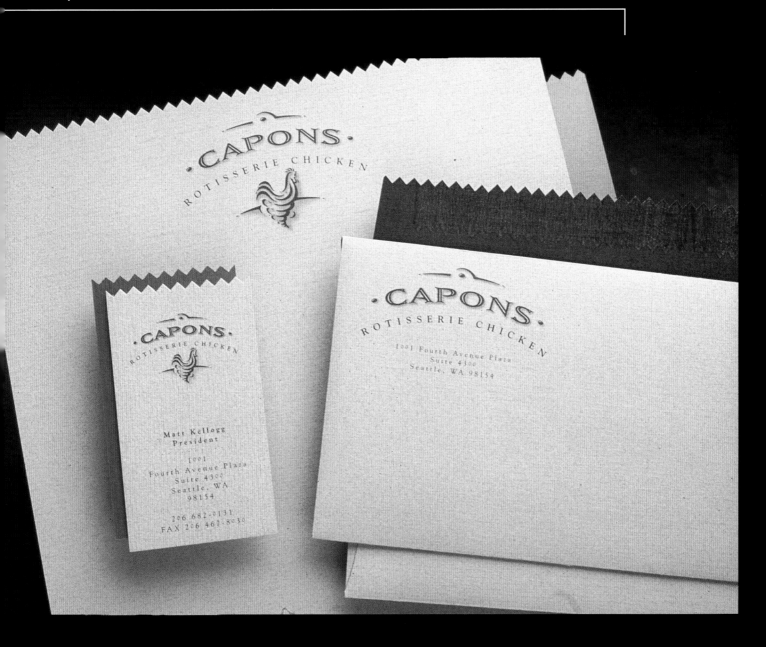

Design Firm: Hornall Anderson Design Works
Art Director: Jack Anderson
Designers: Jack Anderson, David Bates
Illustrators: David Bates, George Tanagi
Client: Capons Rotisserie Chicken

Objective: To design an identity that would distinguish Capons from commercial fast-food chains

Innovation: Because cost is generally prohibitive, stationery is rarely die-cut. But for this client, an upscale image was desired. Each component is cut with a zigzag top edge to suggest take-out bags, and warm, full-bleed colors were printed on the back of each piece. The spinning tornado of the chicken's body depicts the restaurant's quick service, further enhancing the concept of quality.

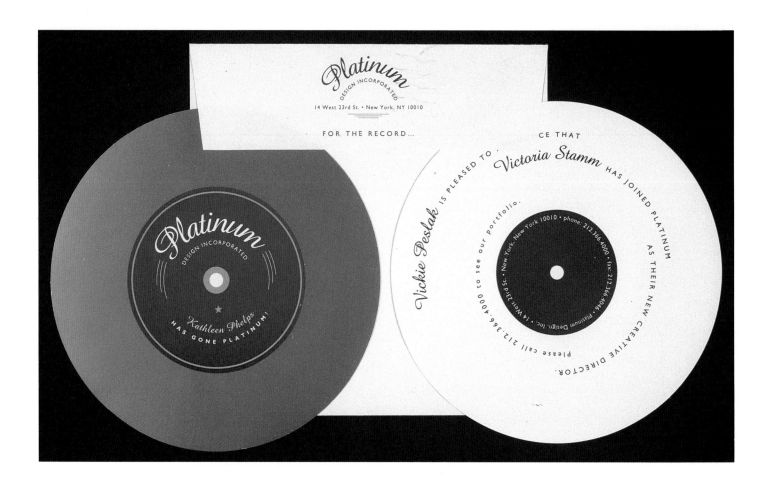

Design Firm: Platinum Design, Inc.
Art Director: Kathleen Phelps
Designer: Kathleen Phelps
Client: Platinum Design, Inc.

Objective: To design an announcement that would introduce the studio's two new creative directors

Innovation: Innovative use of ink, stock, and type placement provide the desired visual impact in this "platinum two-record set" of announcements that play off the studio name, "Platinum Design."

HADW Drywall and Metal Invitations

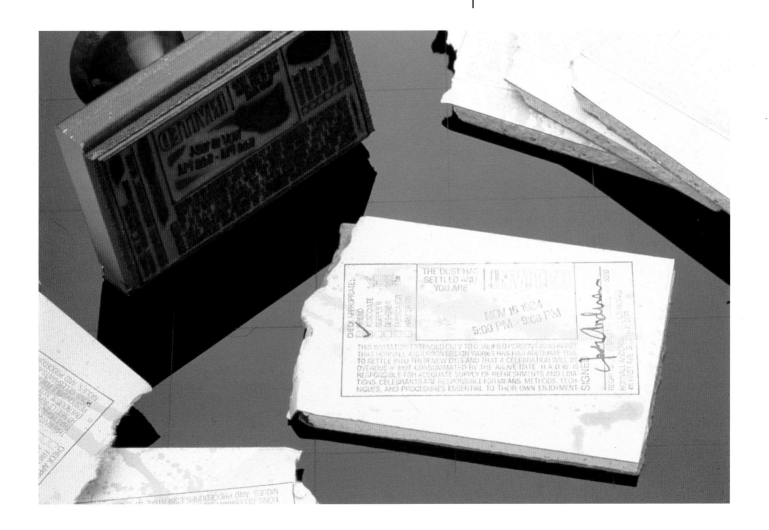

Design Firm: Hornall Anderson Design Works
Art Directors: Jack Anderson, John Hornall
Designers: Jack Anderson, John Hornall, Julie Lock
Illustrators: Greg Walters, Julie Lock
Copywriter: John Hornall
Client: Hornall Anderson Design Works

Objective: To invite recipients to opening events for the firm's new spaces as well as represent samples of the firm's ingenuity and personality

Innovation: Each drywall invitation is an individual work of art. Full-size drywall sheets were splatter-painted using drywall and paint left over from the studio's construction, and broken into invitation-sized pieces. A rubber stamp, molded after an architect's stamp of approval, was then applied with event information, and each invitation was hand-signed by a staff member. The metal invitation, unique in its materials and presentation, used a color palette and galvanized metal as extensions of the studio's interior elements. Graphics combine the architectural elements of the new studio design with the party's beach theme.

HADW 10th Anniversary Invitation and Postcard

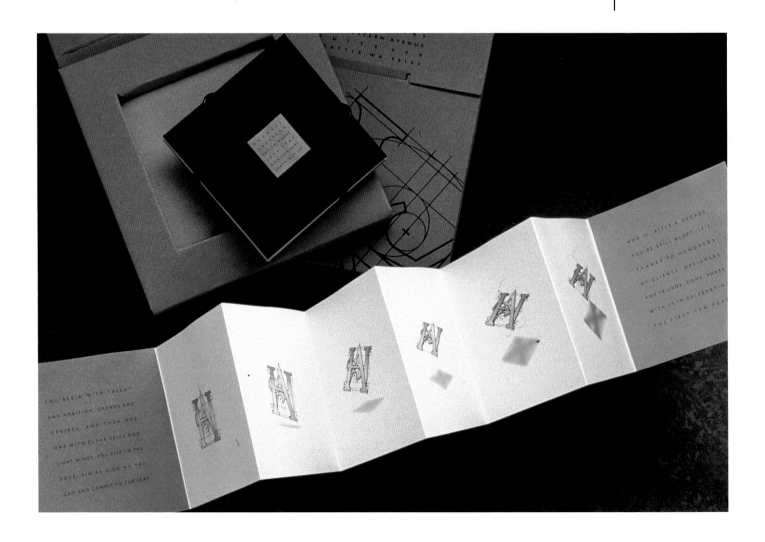

Design Firm: Hornall Anderson Design Works
Art Director: Jack Anderson
Designers: Jack Anderson, Jani Drewfs,
David Bates, Leo Raymundo, Lian Ng
Illustrators: Yutaka Sasaki, David Bates
Client: Hornall Anderson Design Works

Objective: To design a teaser that would prompt curiosity about the event, create a strong impression, and ensure that the event will receive recognition

Innovation: Vellum stock and an off-standard size are unusual choices for a mailer. Its mysterious message raises questions and does not provide answers, creating anticipation, while retaining the proof's color-match bars and crop marks suggests a work in progress, consistent with an event-notification postcard. The invitation integrates three-dimensional elements into a typically two-dimensional piece. The o-ring, accordion-fold format and textured stock give it substance. Designers laminated the fluted stock of the exterior cover to the smooth stock of the invitation body and debossed the fluted stock on the front and back covers for the informational tip-ins. The message's focal point is the pictorial evolution of the firm's logo, not the technical information about the party.

Elixir Design Co. Identity

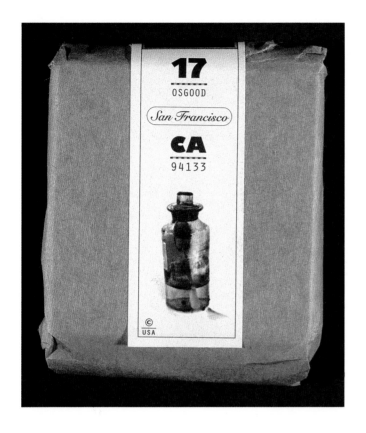

Design Firm: Elixir Design Co.
Art Directors: Jennifer Jerde, Mark Winn
Designers: Jennifer Jerde, Mark Winn
Photographers: Mark Winn, Scott Peterson
Client: Elixir Design Co.

Objective: To translate the firm's individuality and interest in experimentation into an identity system

Innovation: How does one generate individuality in an identity? One way is to respond to the studio's axiom—"the sum is greater than its parts." The individuality of the "parts" (its designers) is translated through tailor-made business card labels, while the cards themselves integrate the "sum" (the company). Embossing, novel type treatments, and off-beat colors and images add a secondary twist.

Four Seasons Identity Program

Design Firm: Pentagram Design
Art Director: John Rushworth
Designers: John Rushworth, Chiew Yong
Photographers: Peter Wood, Jane Baldwin
Client: Four Seasons Hotel Group

Objective: To redesign the visual identity for a group of prestigious international hotels, beginning with the London site

Innovation: The spectacular incorporation of texture in the components of this project, when compared with traditional hotel design, is in a class of its own. The policy of the hotel group was to allow the identity of each hotel to be influenced by the personality of its building and environment; the style of the London hotel literature embodies the management and staff's close attention to detail.

PRIVATE ROOM BAR

FITNESS

SPECIAL SERVICES
AND AMENITIES

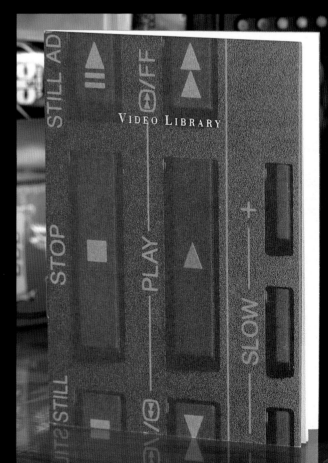

VIDEO LIBRARY

PUBLICATIONS

Design Firm: Pencil Corporate Art
Art Director: Arno Haering
Designer: Achim Kiel
Illustrators: Achim Kiel, Thomas Przygodda
Client: Gustav Luebbe Verlag

Objective: To create an authentic visual metaphor for author Ken Follett's book on building a medieval cathedral, without showing the book's protagonists

Innovation: The unprecedented graphic concept is based on a massive, 160-pound book sculpted from the same limestone used to build cathedrals in the Middle Ages. Following medieval building plans, the author's name is chiselled into the stone, while the book title is written using an ornamented initial and *uncial*—the common typeface of early books. Illustrations on the front and back covers show the beginning and end of the cathedral's construction.

The Bang (Kat-O-Log)

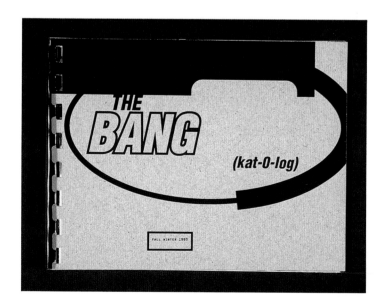

Design Firm: The Bang
Art Director: Bill Douglas
Designer: Bill Douglas
Client: The Bang Clothing

Objective: To create a clothing catalog that would connect with eclectic buyers from small stores

Innovation: Eschewing the slick clothing catalog style most popular in this market, the studio elected to "stay as close to the street as possible" by using an informal paper stock, a color copy printing process, pictures "taped" to the pages, and GBC binding, all assembled by hand.

Greetings Book

The Story of Greetings Stamps

Design Firm: Trickett & Webb
Art Directors: Lynn Trickett, Brian Webb
Designers: Lynn Trickett, Brian Webb,
Steve Edwards
Photographers: Jon Hamilton,
John Summerhayes, Carole Sharp
Client: The Royal Mail

Objective: To create a book, aimed at stamp collectors, that illustrates the Royal Mail's series of "Greetings" postage stamps

Innovation: The surprises are found in the front and back book covers, which form an envelope, and in the chapter titles, which are built into the photographs. The back cover flap holds a set of specially designed postal labels (stamp collectors love them) and the cover lettering is computer-generated.

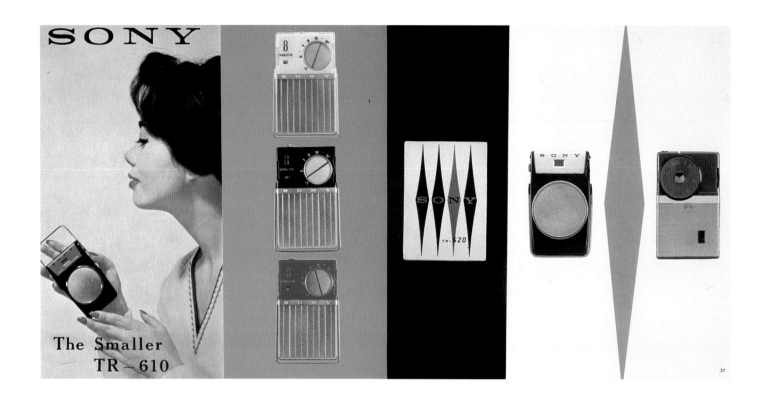

Design Firm: Maureen Erbe Design
Art Director: Maureen Erbe
Designers: Maureen Erbe, Rita A. Sowins
Photographer: Henry Blackham
Copywriter: Aileen Antonier
Client: Chronicle Books

Objective: To produce a pop-culture book on collectible Japanese transistor radios from the 1950s and 1960s

Innovation: The aberrant approach here is to show transistor radios as an art form as well as a reflection of popular culture. To attract American consumers, radio designers had borrowed from the best and worst stylistic excesses of the period—design used in automobiles, coffee shops, fashion, even rock and roll. The book depicts radios as larger-than-life to show their extraordinary design detailing.

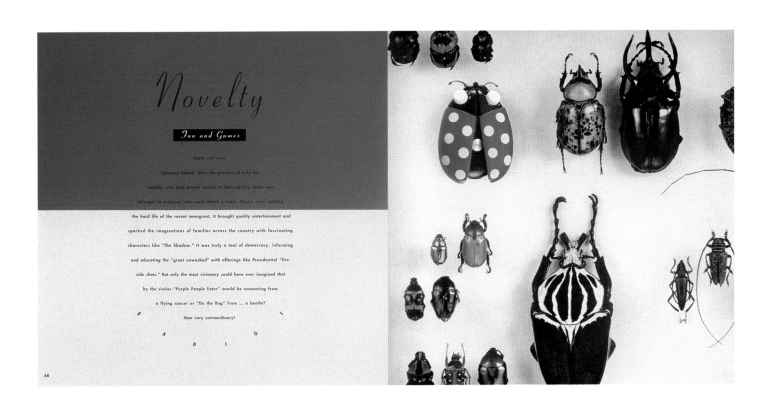

Novelty

Fun and Games

Radio was revolutionary indeed. Once the province of only the wealthy, who held private recitals in their parlors, music now belonged to everyone who could afford a radio. Puccini arias uplifted the hard life of the recent immigrant. It brought quality entertainment and sparked the imaginations of families across the country with fascinating characters like "The Shadow." It was truly a tool of democracy, informing and educating the "great unwashed" with offerings like Presidential "fireside chats." But only the most visionary could have ever imagined that by the sixties "Purple People Eater" would be emanating from a flying saucer or "Do the Bug" from ... a beetle?

How very extraordinary!

R A D I O S

68

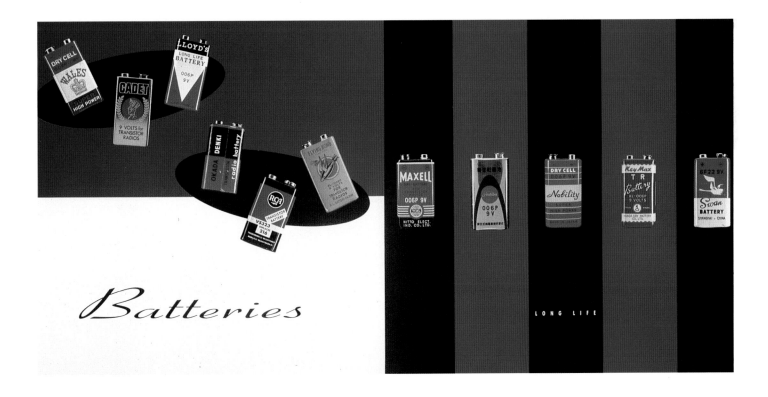

Batteries

LONG LIFE

141

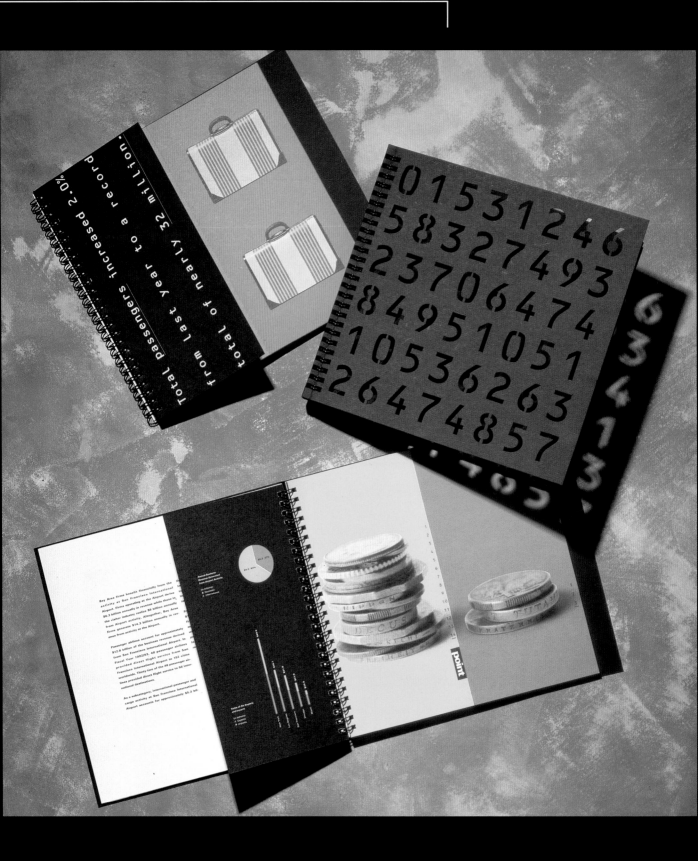

Design Firm: Morla Design
Art Director: Jennifer Morla
Designers: Jennifer Morla, Craig Bailey
Photographer: Holly Stewart
Client: San Francisco Airport Commission

Objective: To produce an annual report that reflects an airport's economic impact on the area

Innovation: A set of punched-out numerals on a cover page and each chapter's key financial figure displayed prominently create a dramatic visual. Readers browsing through the report can easily grasp each chapter's economic message.

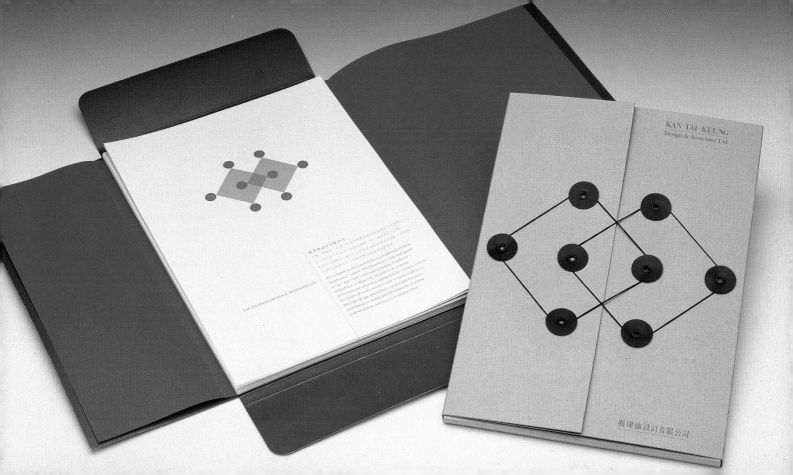

Marcas/Marks Book

Design Firm: Interface Designers
Art Director: Sérgio Liuzzi
Designers: André de Castro, Gustavo Portela
Client: Interface Designers

Objective: To create a self-promotional piece showing 100 of the logos the company has designed over the years

Innovation: Unusual materials—a plastic cover with brass screws—initially catch the eye, but they also help fit the project into the budget constraints. These materials produced a book that has durability and longevity.

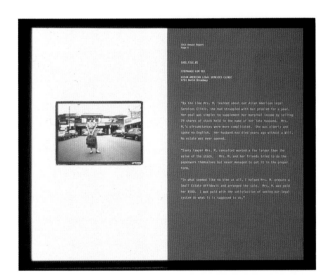

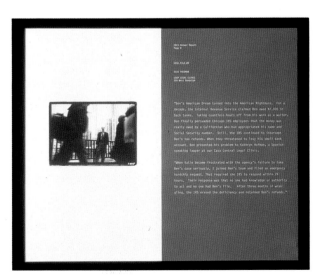

Design Firm: VSA Partners, Inc.
Art Directors: Ted Stoik, Chris Froeter
Designer: Chris Froeter
Photographer: Tony Armour
Printer: H M Graphics
Client: Chicago Volunteer
Legal Services Foundation

Objective: To design a compelling document that creates a sense of pride in staff, volunteers, and donors and encourages the involvement of new donors and volunteers

Innovation: The principal innovations for this report are the use of a "Pendaflex" file folder look for the cover, its straightforward design, and a unique binding treatment to support the "case files" theme. The client is an organization of attorneys providing free legal services to the poor. Photographs of volunteers, shot on location in Chicago's ethnic neighborhoods, show their clientele's cultural diversity.

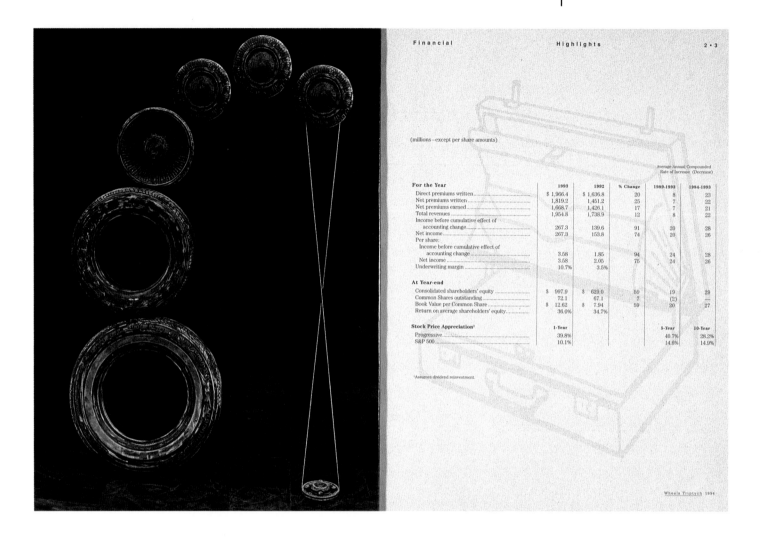

Design Firm: Nesnadny + Schwartz
Art Directors: Mark Schwartz, Joyce Nesnadny
Designers: Joyce Nesnadny, Mark Schwartz,
Michelle Moehler
Copywriter: Merriam-Webster, Inc.
Photographer: Zeke Berman
Client: The Progressive Corporation

Objective: To articulate obligatory "facts and figures" and also reflect the unique character of the company

Innovation: One groundbreaking technique is the use of fine art throughout this report—no CEO portraits or similar stand-bys can be found to detract from its elegance. Founded on the loose conceptual theme of a car and its meaning, the images respond through diagrammatic sculptures. To illustrate the company's attempt to redefine itself, the direct influence of the dictionary is apparent, as definitions for the word "progressive" are featured.

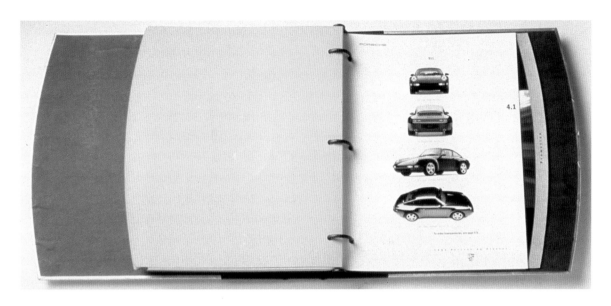

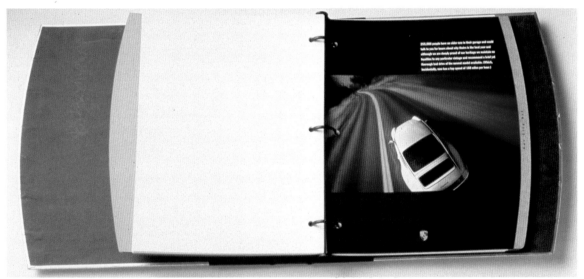

Design Firm: Goodby, Silverstein & Partners
Art Director: Paul Curtin
Designer: Peter Locke
Copywriter: Eric Osterhaus
Photographer: Clint Clemens
Client: Porsche

Objective: To support Porsche's newly reengineered automobile with a dealer marketing kit that reflects the car's lines, attitude, and advertising

Innovation: Car makers generally don't consider their dealers to be an "audience," and thus distribute dealer kits of low-quality binders stuffed with clip art. Porsche wanted to convey to dealers its pride in its new model 911. Hence, a metallic impregnated leather cover, foil-stamped dividers, and lots of sensual curves inspired by the design of the car itself, accent this binding.

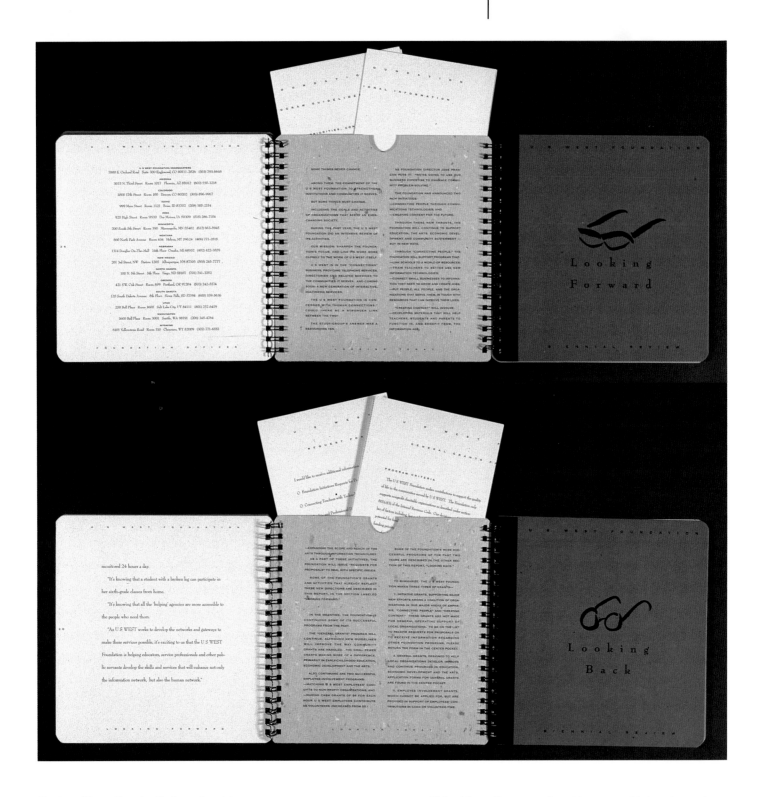

Design Firm: Vaughn Wedeen Creative
Art Director: Steve Wedeen
Designer: Steve Wedeen
Illustrator: Vivian Harder
Copywriter: Don Riggenbach
Client: U S West Foundation

Objective: To summarize the accomplishments and expenditures of the foundation for the previous two years and set the groundwork for guidelines in the years ahead

Innovation: Its childlike illustrations and small, 7-by-7-inch size give this report a friendly, storybook feel. Dual wire binding accentuates the two-books-in-one concept, and the two front covers ("Looking Forward" and "Looking Back") are black thermograph on Confetti cover and french folded. A center pocket, which gives the two books their backbone, also houses application forms.

Lasertechnics Annual Report

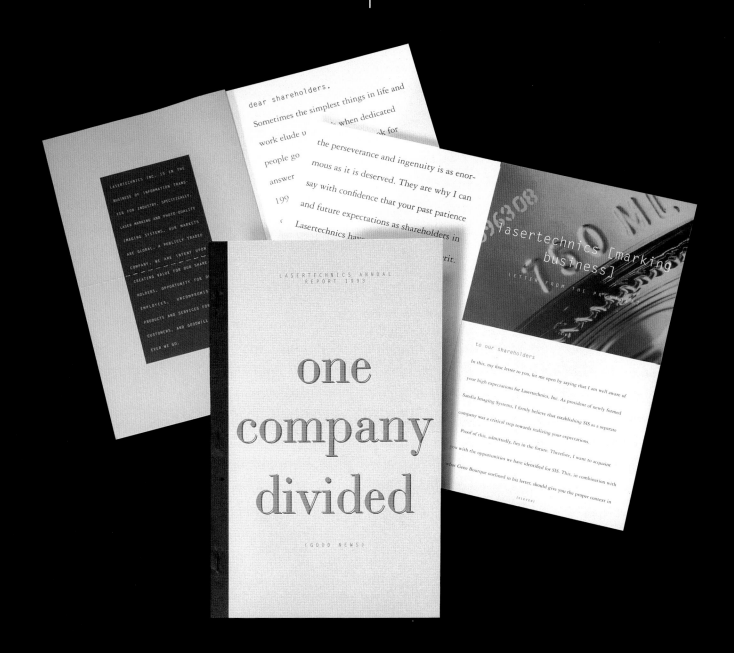

Design Firm: Vaughn Wedeen Creative
Art Director: Steve Wedeen
Designer: Steve Wedeen
Photographer: Michael Barley
Copywriter: Joann Stone
Client: Lasertechnics

Objective: To highlight the year's events and the company's future direction

Innovation: The client's most significant event that year was the separation of its two product divisions, forming a new company in a different state. The dramatic headline, "One Company Divided," is tangibly underscored by perforating the entire book and cover across the center, essentially making two smaller books. Inside, one section is horizontally cut to create two mini-reports. The book is an unconventional size (6.75 by 10.5 inches) and bound like a legal pad with chipboard backing and taped spine.

Claes Oldenburg Catalog

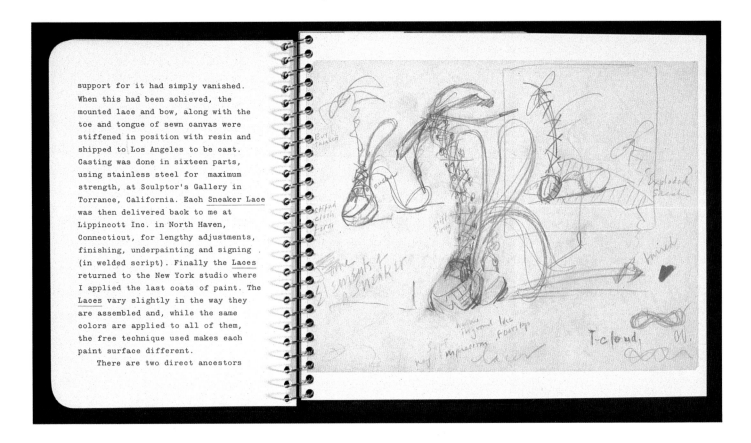

support for it had simply vanished.
When this had been achieved, the
mounted lace and bow, along with the
toe and tongue of sewn canvas were
stiffened in position with resin and
shipped to Los Angeles to be cast.
Casting was done in sixteen parts,
using stainless steel for maximum
strength, at Sculptor's Gallery in
Torrance, California. Each Sneaker Lace
was then delivered back to me at
Lippincott Inc. in North Haven,
Connecticut, for lengthy adjustments,
finishing, underpainting and signing .
(in welded script). Finally the Laces
returned to the New York studio where
I applied the last coats of paint. The
Laces vary slightly in the way they
are assembled and, while the same
colors are applied to all of them,
the free technique used makes each
paint surface different.
 There are two direct ancestors

Design Firm: COY
Art Director: John Coy
Designers: John Coy, Laurie Handler, Janine Vigus
Illustrator: Claes Oldenburg
Client: Gemini G.E.L.

Objective: To produce a documentation and sales brochure for Oldenburg projects

Innovation: Its surprisingly small size and "typewritten" pages—like a personal notebook—combined with machine metal composition and uncoated paper make this artist's catalog an outstanding entry both within the design field and among similar catalogs.

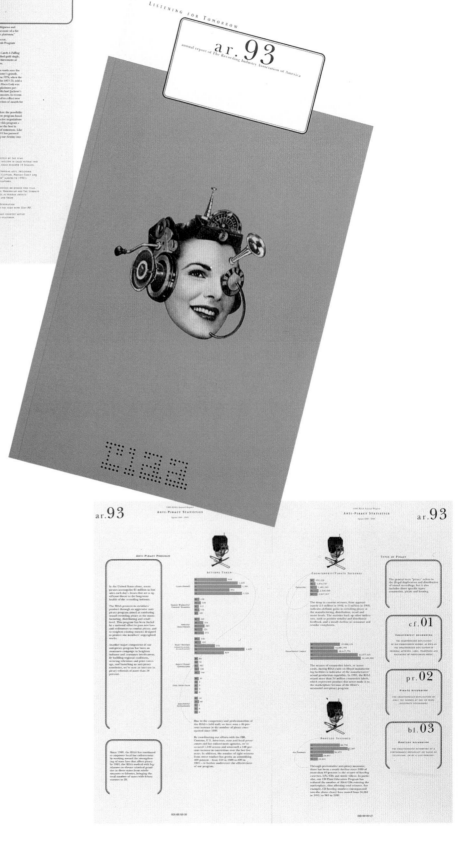

Design Firm: Recording Industry
Association of America
Art Director and Designer: Neal M. Ashby
Chart and Graph Designer: Bob Walker
Photographer: Steven Biver
Cyborg Illustrator: Dave Plunkert
Writers: Alexandra Walsh, Ellen Caldwell,
Angie Corio, Lydia Pelliccia, Fred Guthrie
Printer: Steckel Printing
Client: Recording Industry
Association of America (RIAA)

Objective: A stimulating annual report that
effectively tackles industry issues as diverse
as digital musical delivery and CD piracy

Innovation: Annual reports tend to be conserv-
ative and risk-free. The visuals of this
piece, however, are anything but conventional.
Its theme, "Old vs. New," is depicted by a
unique mix of typefaces—New Baskerville (old)
and Matrix (new)—and photo illustrations—
images of the past rearranged to create new
ones. A traditional woman cupping her hand to
her ear on the wrapper demonstrates the old
way of listening to music while, underneath,
a cyborg-like image represents today's multi-
media digital delivery.

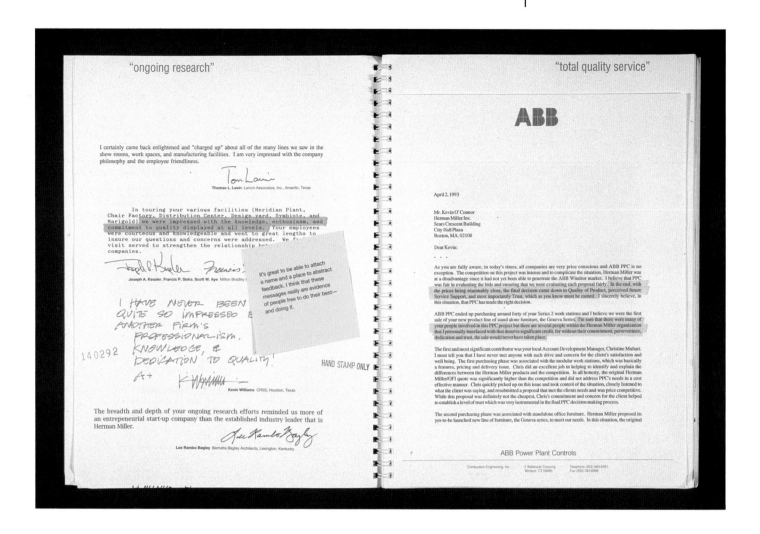

Design Firm: Herman Miller In-House Design Team
Art Director: Stephen Frykholm
Designers: Stephen Frykholm, Yang Kim, Sara Giovanitti
Copywriter: Clark Malcolm
Production: Marlene Capotosto
Client: Herman Miller, Inc.

Objective: To present the year's financial results; involve employees in the report; give the corporation a personal identity; and raise morale

Innovation: A ground-breaking print effort that highlights orginal customer correspondence (chosen from 400 letters, faxes, and voice-mail transmissions), reproduced exactly as they arrived, with the CEO's comments attached on yellow notes. To re-create the letters, the design process employed mechanicals, rather than using electronic methods. The project used 11 paper stocks and 16 ink colors, and left out big, glossy photos of the products or the CEO.

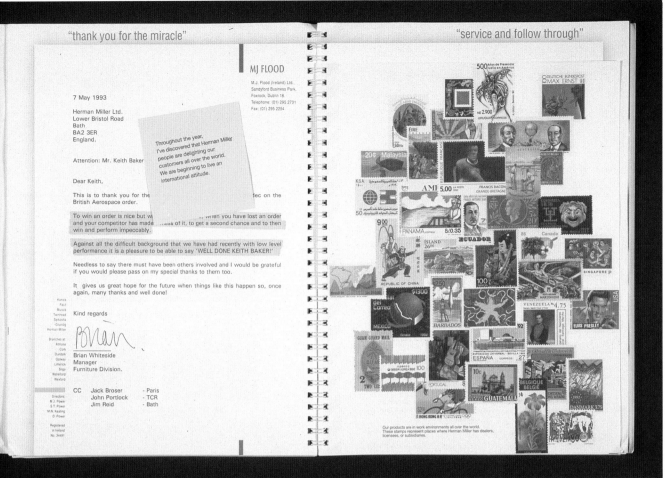

MJ FLOOD

M.J. Flood (Ireland) Ltd.,
Sandyford Business Park,
Foxrock, Dublin 18.
Telephone: (01) 295 2701
Fax: (01) 295 2254

7 May 1993

Herman Miller Ltd.
Lower Bristol Road
Bath
BA2 3ER
England.

Attention: Mr. Keith Baker

Dear Keith,

This is to thank you for the _____ ____ __ ___ ___ on the
British Aerospace order.

To win an order is nice but w___ _____, when you have lost an order
and your competitor has made ____ness of it, to get a second chance and to then
win and perform impeccably.

Against all the difficult background that we have had recently with low level
performance it is a pleasure to be able to say 'WELL DONE KEITH BAKER!'

Needless to say there must have been others involved and I would be grateful
if you would please pass on my special thanks to them too.

It gives us great hope for the future when things like this happen so, once
again, many thanks and well done!

Kind regards

Brian

Brian Whiteside
Manager
Furniture Division.

CC Jack Broser - Paris
 John Portlock - TCR
 Jim Reid - Bath

> Throughout the year, I've discovered that Herman Miller people are delighting our customers all over the world. We are beginning to live an international attitude.

Our products are in work environments all over the world.
These stamps represent places where Herman Miller has dealers,
licensees, or subsidiaries.

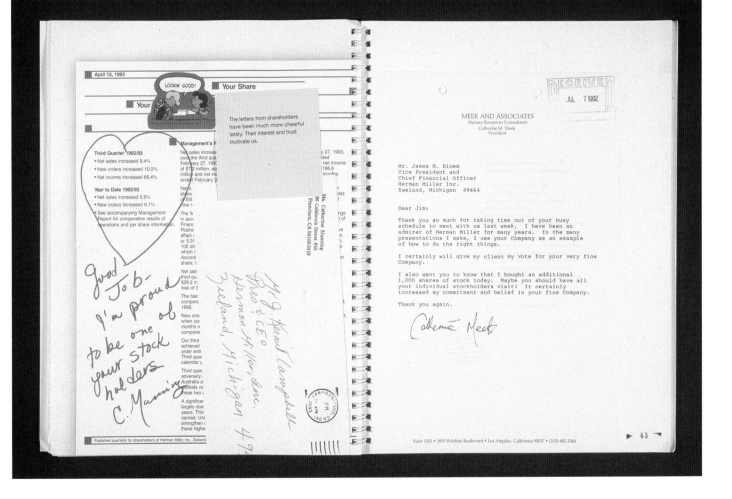

April 15, 1993

LOOKIN' GOOD!

■ Your ____ ■ Your Share

Third Quarter 1992/93
- Net sales increased 9.4%
- New orders increased 10.0%
- Net income increased 85.4%

Year to Date 1992/93
- Net sales increased 5.5%
- New orders increased 6.1%
- See accompanying Management Report for comparative results of operations and per share information.

> The letters from shareholders have been much more cheerful lately. Their interest and trust motivate us.

Good Job —
I'm proud
to be one of
your stock
holders

C. Manning

Published quarterly for shareholders of Herman Miller, Inc., Zeeland

MEEK AND ASSOCIATES
Human Resources Consultants
Catherine M. Meek
President

DECEIVED JUL 7 1992

Mr. James H. Bloem
Vice President and
Chief Financial Officer
Herman Miller Inc.
Zeeland, Michigan 49464

Dear Jim:

Thank you so much for taking time out of your busy
schedule to meet with us last week. I have been an
admirer of Herman Miller for many years. In the many
presentations I make, I use your Company as an example
of how to do the right things.

I certainly will give my client my vote for your very fine
Company.

I also want you to know that I bought an additional
1,000 shares of stock today. Maybe you should have all
your individual stockholders visit! It certainly
increased my commitment and belief in your fine Company.

Thank you again.

Catherine Meek

Suite 1503 • 1055 Wilshire Boulevard • Los Angeles, California 90017 • (213) 482-3344 ▶ 63 ◀

Paragon Trade Brands Annual Report

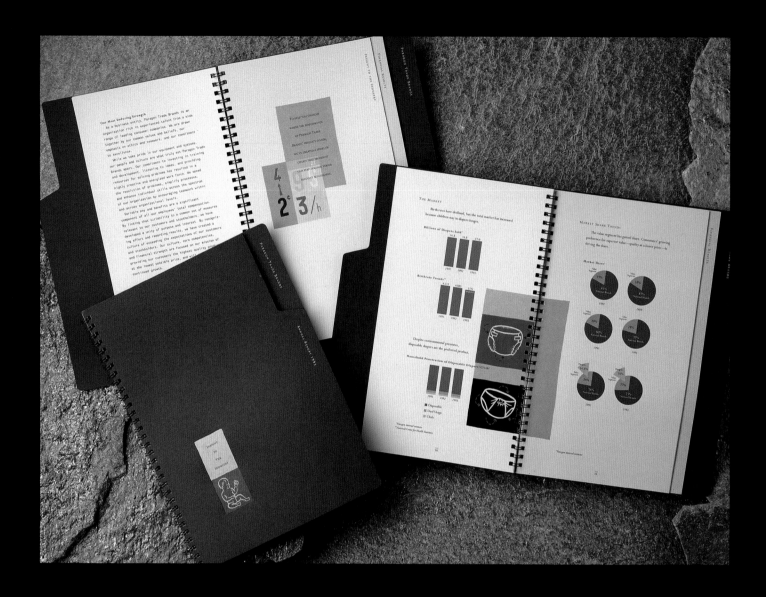

Design Firm: The Leonhardt Group
Designers: Susan Cummings, Jon Cannell
Illustrator: Brian Cairns
Client: Paragon Trade Brands

Objective: To position the client as an industry leader through an accessible reference tool targeted to sophisticated shareholders and analysts

Innovation: The traditional narrative is eliminated and replaced with a straightforward, substantive letter with a typewritten feel. Colorful bound-in notes provide visual relief, and an unexpectedly lively industry data section. All aspects of the design suggest not a report but a reference guide, including a file-like cover, wire o-binding (so that it will lay flat), and easy-to-access interior sections.

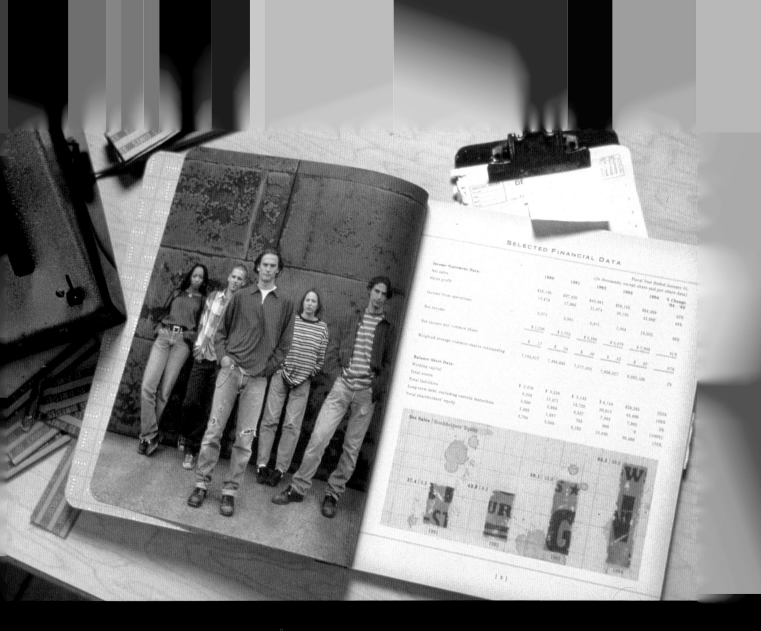

Design Firm: Urban Outfitters In-House Group
Art Director: Howard Brown
Designers: Howard Brown, Mike Calkins
Client: Urban Outfitters, Inc.

Objective: After the company's first public offering, to introduce new shareholders to their progressive retail aesthetic by using a workbook-style format

Innovation: At this organization, the art director and designers—not the CEO, CFO, or accountants—establish the design direction and make all qualitative decisions based on respect for both form and function. As it was the first annual report on which the design group had worked, they had no preconceived notions of rules to be broken, as they weren't aware of rules that existed, "and we did not ask."

Jim Hanson Masks

Design Firm: The Weller Institute
for the Cure of Design
Art Directors: Jim Hanson, Don Weller,
Craig Smallish, Rob Porazinski
Designers: Craig Smallish,
Rob Porazinski, Don Weller
Illustrators: Craig Smallish,
Rob Porazinski, Don Weller
Client: Jim Hanson

Objective: To promote a representative
for illustrators

Innovation: Sent out shortly before
Halloween, these graphically bizarre
masks weren't meant to just sit on the
page, but could be punched out and used
for the evening's festivities. They
could also function as samples of the
range of talent the client represents.

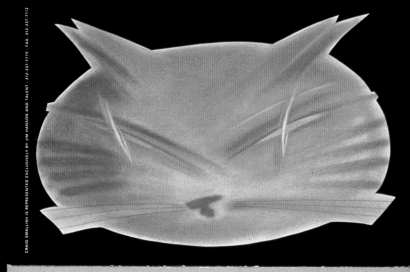

CRAIG SMALLISH IS REPRESENTED EXCLUSIVELY BY JIM HANSON AND TALENT · 312-337-7770 · FAX. 312-337-7112

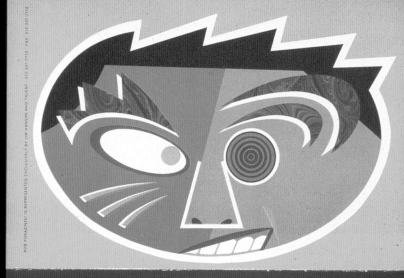

ROB PORAZINSKI IS REPRESENTED EXCLUSIVELY BY JIM HANSON AND TALENT · 312-337-7770 · FAX. 312-337-7112

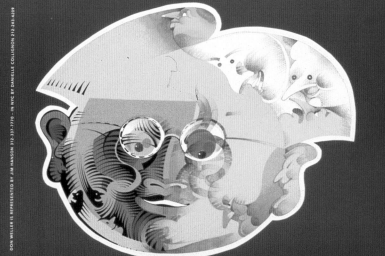

DON WELLER IS REPRESENTED BY JIM HANSON 312-337-7770 · IN NYC BY DANIELLE COLLIGNON 212-243-4209

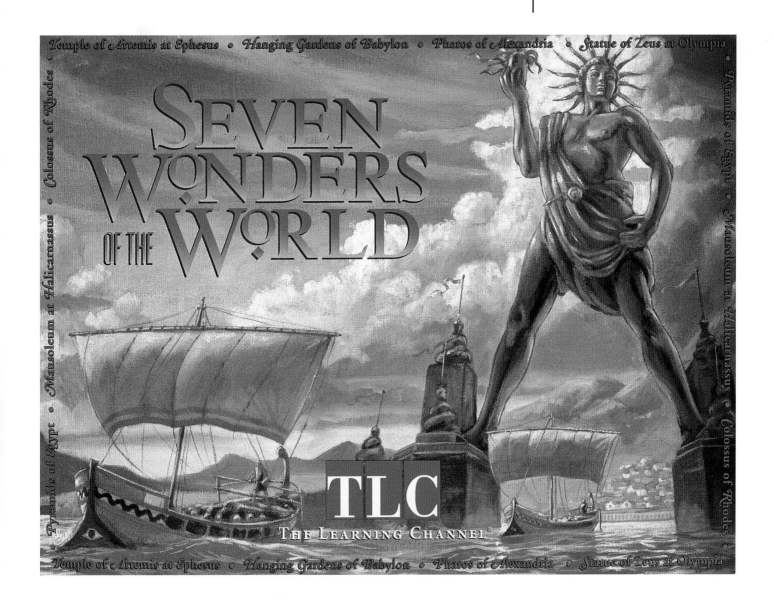

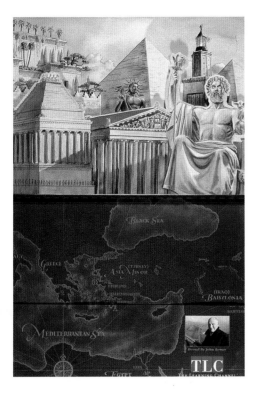

Design Firm: Discovery Design Group
Art Director: Richard Lee Heffner
Designer: Richard Lee Heffner
Illustrator: Patrick O'Brien
Client: Discovery Networks, Inc.

Objective: To produce an eye-catching kit that encourages press coverage and viewership

Innovation: Conveying the lively and educational content of the programming to promote interest—rather than just creating a sensational design—works well for this kit. The original concept was a three-dimensional pop-up folder of all seven wonders. Due to budget and time constraints, the end product accomplishes a similar "dimensional" perspective without the pop-ups—the pocket folder has a raised design in four colors and one metallic.

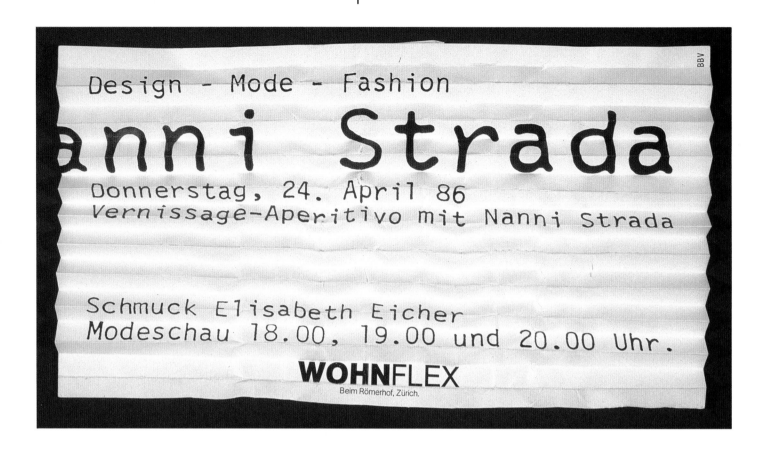

Design Firm: BBV Michael Baviera
Art Director: Michael Baviera
Designer: Michael Baviera
Illustrator: Michael Baviera
Client: Wohnflex

Objective: To produce an announcement for a clothing designer

Innovation: An out-of-the-ordinary use of knots is apparent in this announcement, which is printed on two sides and tightly folded accordion-style. Tied in a knot for distribution, the announcement takes on the structure of the clothing designer's fabric when unfolded.

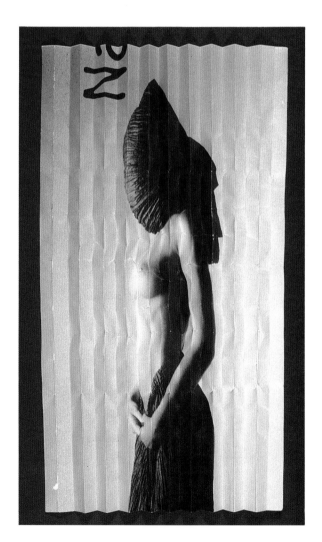

Diaper Birth Announcement

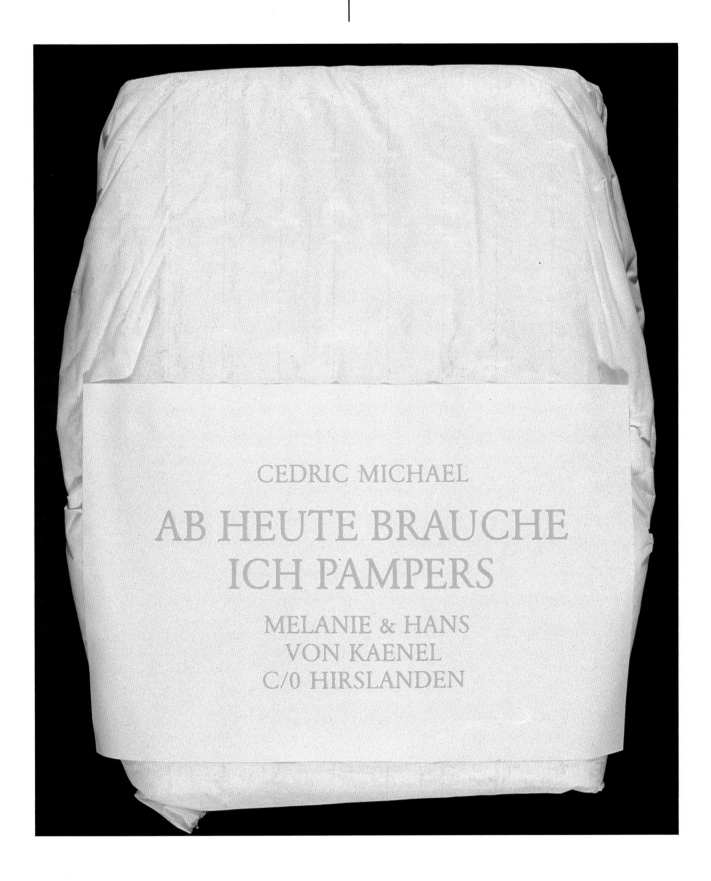

CEDRIC MICHAEL

AB HEUTE BRAUCHE
ICH PAMPERS

MELANIE & HANS
VON KAENEL
C/0 HIRSLANDEN

Design Firm: BBV Michael Baviera
Art Director: Michael Baviera
Designer: Michael Baviera
Illustrator: Michael Baviera
Clients: Melanie and Hans von Kaenel

Objective: To announce the birth of a child
in a humorous way

Innovation: A bizarre yet inspired use of
materials makes this announcement a stand-out.
A disposable diaper is the medium used to
announce the birth of a baby.

Design Firm: Morla Design
Art Director: Jennifer Morla
Designers: Jennifer Morla, Craig Bailey
Photographers: Holly Stewart, Craig Bailey
Client: Fox Broadcasting Company

Objective: To herald the premiere of the client's new fall programming

Innovation: An interesting concept was the foundation for this seven-day countdown that aired a week prior to the premiere of the client's fall season and used still-life configurations, objects, and exterior locations to depict numerals one through seven. The video was edited in syncopated fashion with positive and negative compositions.

Gotcha Sportswear Advertisements

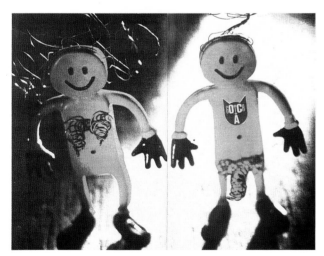

Design Firm: Mike Salisbury Communications
Art Director: Mike Salisbury
Designer: Mike Salisbury
Client: Gotcha Sportswear

Objective: To create advertising that will get the attention of the jaded surfwear customer

Innovation: These inserts use images and techniques never before used in this market to advertise surf clothing. Irreverent, messy, and funky, they are anything but hard-sell surf themes—waves, sun, or surfboards—which are the images one would expect.

Earth Vision Identity

Design Firm: Douglas Design Inc.
Art Director: Douglas Doolittle
Designer: Douglas Doolittle
Illustrator: Mr. Morimoto
Photographer: Mr. Mizukoshi
Client: Urban Communications Co. Ltd.

Objective: To create a visual identity for an international environmental film festival in Tokyo

Innovation: Graphics are based on the haired tortoise (a symbol of longevity); its shell is a stone rubbing of an ancient piece of Chinese pottery in which the globe is concealed. Three-dimensional digital renderings transform the image into "space station Earth" and suggest the more universal role of this planet. The use of acrylic in the trophies captures both the depth and light in its multilayered construction. The effort, craftsmanship, and respect devoted to each piece ensure recipients will view it as a small treasure reflecting the one on which we live.

"T" Time Identity

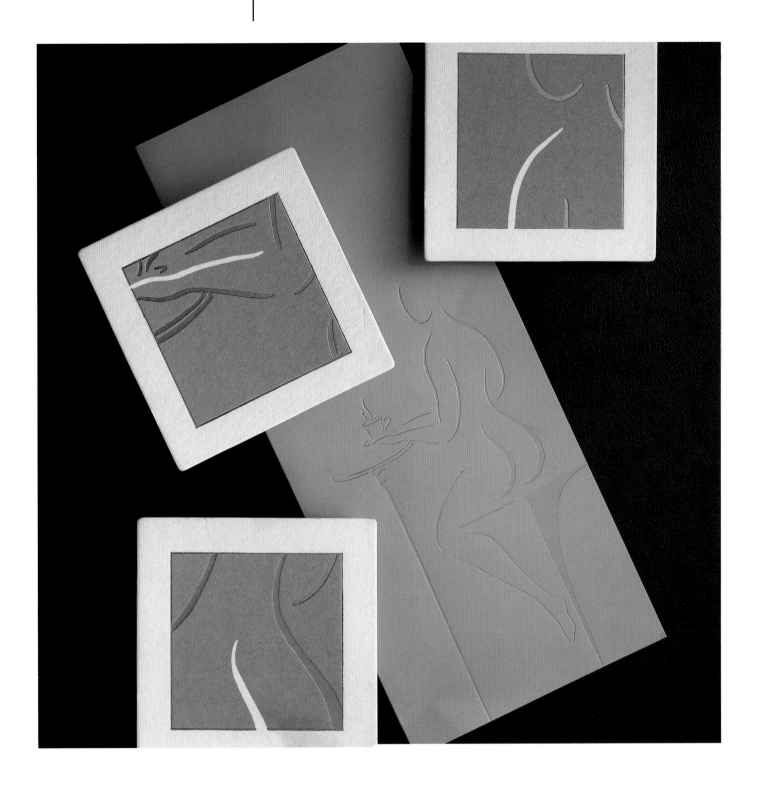

Design Firm: Douglas Design Inc.
Art Director: Douglas Doolittle
Designer: Douglas Doolittle
Illustrator: Mr. Kamata
Client: Tokyo Gas Co.

Objective: To create a visual identity for a beverage bar and showroom

Innovation: A Japanese conglomerate with a very conservative approach to design commissioned the studio to design the identity for its largest showroom. The logo evolved from the initial letters of Tokyo Gas Company, which are transformed into a torch—lighting the way to a new horizon. A beverage bar called "T" Time, located on the premises, uses the renaissance proportions of the woman drinking tea to subtly conceal the "TSS" logo.

Guess? Eyewear Display Tents

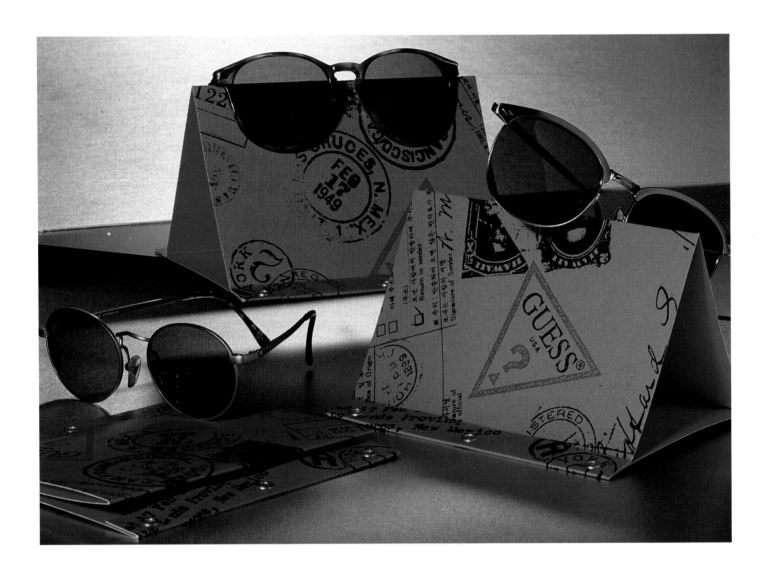

Design Firm: Parham Santana Inc.
Art Director: Millie Hsi
Designer: Millie Hsi
Illustrator: Jeanne Greco
Client: Viva International Group

Objective: To create a point-of-purchase eyewear display that is versatile and serves as a backdrop for the product

Innovation: The out-of-the-ordinary tent shape allows for easy product shipping and can double as a booklet to hold information sheets. The design incorporates a collaged stamp pattern, with the logo highlighted in red, to suggest an international presence. The simple use of two colors on brown card stock kept printing economical.

Equator Menus

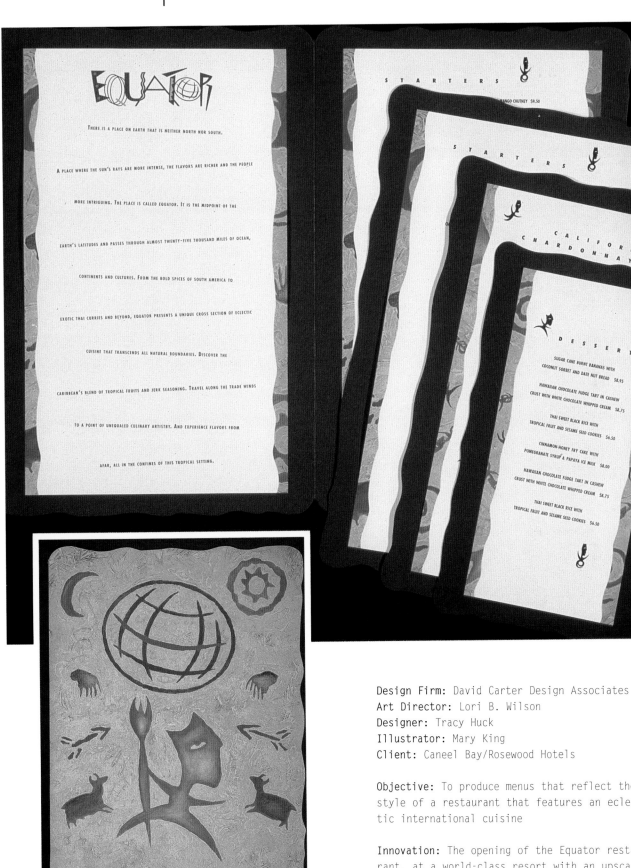

Design Firm: David Carter Design Associates
Art Director: Lori B. Wilson
Designer: Tracy Huck
Illustrator: Mary King
Client: Caneel Bay/Rosewood Hotels

Objective: To produce menus that reflect the style of a restaurant that features an eclectic international cuisine

Innovation: The opening of the Equator restaurant, at a world-class resort with an upscale conservative clientele, allowed the introduction of a funkier, primitive graphic look to complement the restaurant's personality. The new look contrasts dramatically with the client's ordinarily modest approach.

Five Elements of Nature Inflight Menus

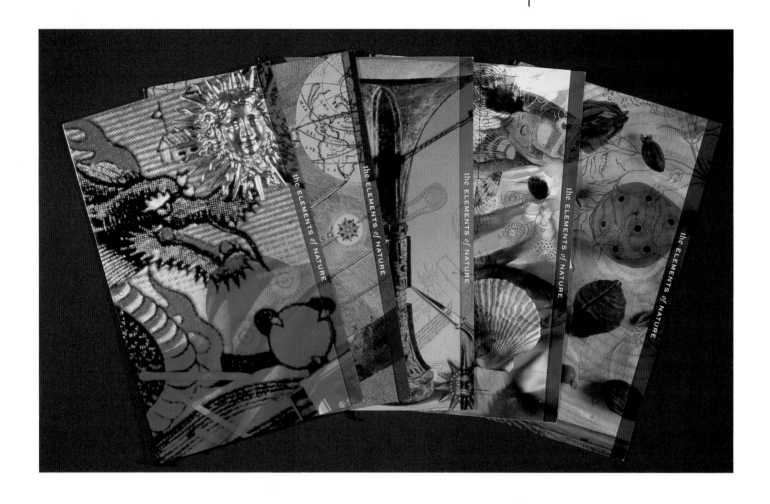

Design Firm: PPA Design Limited
Art Director: Byron Jacobs
Designer: Byron Jacobs
Photographer: Ka-Sing Lee
Copywriter: Joanne Watcyn Jones
Client: Cathay Pacific Airways

Objective: To create a distinctive series of menus that emphasized the client's philosophy of combining the best of Eastern and Western cultures

Innovation: A concept generations old—yet startlingly new for graphics—formed the foundation of these menu designs: the Chinese philosophy of the Five Elements of Nature, symbolized by colors, directions, seasons, and living creatures related to water, metal, wood, fire, and Earth. Each element is illustrated on an individual menu and the text describes the element's relationship to the environment and food.





Cathay Pacific's philosophy has always been to blend the best and most harmonious aspects of East and West. This menu is one of a series depicting the Five Elements of Nature that, in Chinese religious beliefs, are symbolised by colours, directions, seasons and living creatures related to Water, Metal, Wood, Fire and Earth. These five elements, like our service today, are a wonderful source of refreshment, nourishment, comfort and pleasure.

earth

IT IS SAID, FROM THE EARTH SPRINGS ALL THINGS.
FROM HER FERTILE SOIL COMES OUR CROPS, OUR PLANTS,
OUR TREES. EVERYTHING THAT GROWS FIRST HAD
ITS SEED IN THE EARTH AND SURVIVES THROUGH THE ROOTS
THAT REACH DOWN INTO ITS COOL DARKNESS FOR
LIFE-GIVING WATER AND NOURISHMENT.

FOR GENERATIONS MAN HAS SOUGHT TO TAME THE
LAND, TO POSSESS IT, TO HARVEST A RICH YIELD FROM IT,
RAISE LIVESTOCK OR SIMPLY HAVE THE PLEASURE OF A
FLOWER-FILLED GARDEN. WITH NATURE RULING THE SEASONS
AND THE BALANCE OF RAIN AND SUN, OUR DEPENDENCE
ON THE EARTH IS ALSO A DEPENDENCE ON NATURE
TO FULFILL OUR DREAMS.

BIRDS, INSECTS AND FORAGING ANIMALS ALSO RELY
ON EARTH TO PRODUCE THE PLANTS, FOLIAGE AND BERRIES
THAT ARE THE BASIS OF THEIR DIET. THEIR EXISTENCE, LIKE
OUR OWN, DEPENDS ENTIRELY ON THE GENEROSITY
OF 'MOTHER EARTH'.

YOUR MENU TODAY IS INSPIRED BY THE
BOUNTIFUL PRODUCE FROM THE EARTH AND THE SEA.
WE HAVE SELECTED THE CHOICEST INGREDIENTS,
FROM NATURE'S 'PANTRY'.

WINE & COCKTAIL SELECTION

COCKTAILS, APERITIFS & SPIRITS

BLOODY MARY, DRY MARTINI, MANHATTAN, SCREWDRIVER
MARTINI ROSSO, MARTINI EXTRA DRY, CAMPARI, SWEET AND DRY SHERRY
DOW'S LATE BOTTLED VINTAGE PORT
GIN, RUM, VODKA, SCOTCH, BOURSIN, CANADIAN CLUB

WINES

LOUIS ROEDERER BRUT PREMIER CHAMPAGNE
*This golden coloured champagne is rich and round with an elegant
bouquet-making it a champagne of remarkable quality and character*

POUILLY-VINZELLES 1989
*An Opulent Chardonnay from the excellent 1989 vintage.
Produced in the village of Vinzelles, near Macon.
It has aromas of flowers and fruits and an elegant yellow colour.
Rich, dry and fresh in the mouth*

STEFAN B. RESS RÜDESHEIMER BURGWEG
RIESLING KABINETT 1989
*This wine from Rheingau shows a distinctive flavour with a delicate
fruity nose and all the exceptional harmony of 1989 vintage*

OR

FRIEDELSHEIMER R. RIESLING 1990
*This medium dry wine was produced from a vineyard
in Rosengarten, part of the renowed Rheinpfalz area of Germany.
Its fine fruity taste and elegance is characteristic of the Riesling vine variety*

MOULIN A VENT 1989
*A powerful and spicy wine.
With a flowery bouquet and a subtlety on thepalate,
this is irrefutably an astounding bottle of wine*

CHATEAU BARREYRES 1988
*A wine produced in the renown Haut Medoc appellation area in Bordeaux, France.
This is a elegant wine skillfully blended of Merlot,
Cabernet Sauvignon and Cabernet Franc grapes variety*

BEER

INTERNATIONAL SELECTION

LIQUEURS & COGNAC

DRAMBUIE, COINTREAU, BAILEY'S IRISH CREAM
COGNAC ROS DES ROIS NAPOLÉON XO

NON-ALCOHOLIC BEVERAGES

バンコック－香港
曼谷－香港
BANGKOK－ HONG KONG

the ELEMENTS of NATURE

the ELEMENTS of NATURE

Architect's Award Program

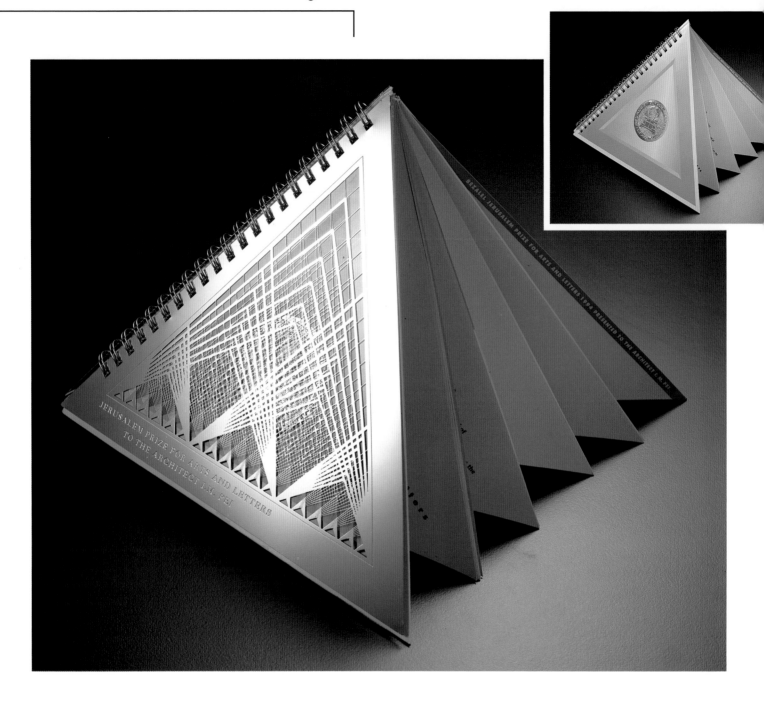

Design Firm: Visual Persuasion
Art Directors: Roni Hecht, Aryeh Hecht
Designers: Roni Hecht, Aryeh Hecht
Illustrators: Roni Hecht, Aryeh Hecht
Client: Friends of Bezalel Academy of Arts and Design

Objective: To create a program for an architect's award ceremony that embodied a festive but architectural tone

Innovation: A spectacular program inspired by the pyramid at the Louvre, it mirrors this work of art when opened and uses its pages as structural "columns." Special tooling that binds the triangular pages was developed to compensate for the odd angles. An unusual grid/layout kept the work in budget; through careful planning and unconventional assembly, only two dies and three signatures were used. A chemically etched stainless steel cover that symbolized the architect's trademark "lace of steel" technique draws immediate attention.

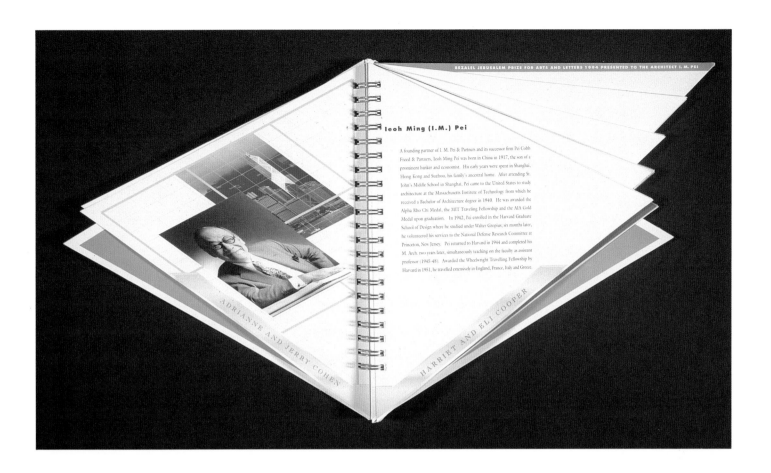

Ieoh Ming (I.M.) Pei

A founding partner of I. M. Pei & Partners and its successor firm Pei Cobb Freed & Partners, Ieoh Ming Pei was born in China in 1917, the son of a prominent banker and economist. His early years were spent in Shanghai, Hong Kong and Suzhou, his family's ancestral home. After attending St. John's Middle School in Shanghai, Pei came to the United States to study architecture at the Massachusetts Institute of Technology from which he received a Bachelor of Architecture degree in 1940. He was awarded the Alpha Rho Chi Medal, the MIT Traveling Fellowship and the AIA Gold Medal upon graduation. In 1942, Pei enrolled in the Harvard Graduate School of Design where he studied under Walter Gropius; six months later, he volunteered his services to the National Defense Research Committee at Princeton, New Jersey. Pei returned to Harvard in 1944 and completed his M. Arch. two years later, simultaneously teaching on the faculty as assistant professor (1945-48). Awarded the Wheelwright Travelling Fellowship by Harvard in 1951, he travelled extensively in England, France, Italy and Greece.

ADRIANNE AND JERRY COHEN

HARRIET AND ELI COOPER

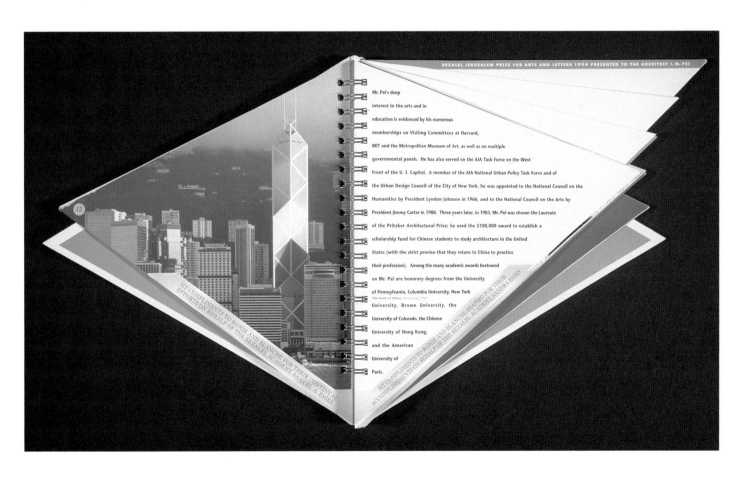

Mr. Pei's deep interest in the arts and in education is evidenced by his numerous memberships on Visiting Committees at Harvard, MIT and the Metropolitan Museum of Art, as well as on multiple governmental panels. He has also served on the AIA Task Force on the West Front of the U. S. Capitol. A member of the AIA National Urban Policy Task Force and of the Urban Design Council of the City of New York, he was appointed to the National Council on the Humanities by President Lyndon Johnson in 1966, and to the National Council on the Arts by President Jimmy Carter in 1980. Three years later, in 1983, Mr. Pei was chosen the Laureate of the Pritzker Architectural Prize; he used the $100,000 award to establish a scholarship fund for Chinese students to study architecture in the United States (with the strict proviso that they return to China to practice their profession). Among the many academic awards bestowed on Mr. Pei are honorary degrees from the University of Pennsylvania, Columbia University, New York University, Brown University, the University of Colorado, the Chinese University of Hong Kong, and the American University of Paris.

The Bank of China, Hong Kong 1990

MY COMPLIMENTS TO ROMIE AND BLANCHE FOR THEIR CONTINUAL EFFORTS ON BEHALF OF THE BEZALEL ACADEMY SAMUEL A. ESSES

MY COMPLIMENTS TO ROMIE AND BLANCHE SHAPIRO FOR THEIR ACCOMPLISHMENTS ON BEHALF OF THE BEZALEL ACADEMY SANDRA ESSES

Michael W. Smith: The Wonder Years Boxed Set

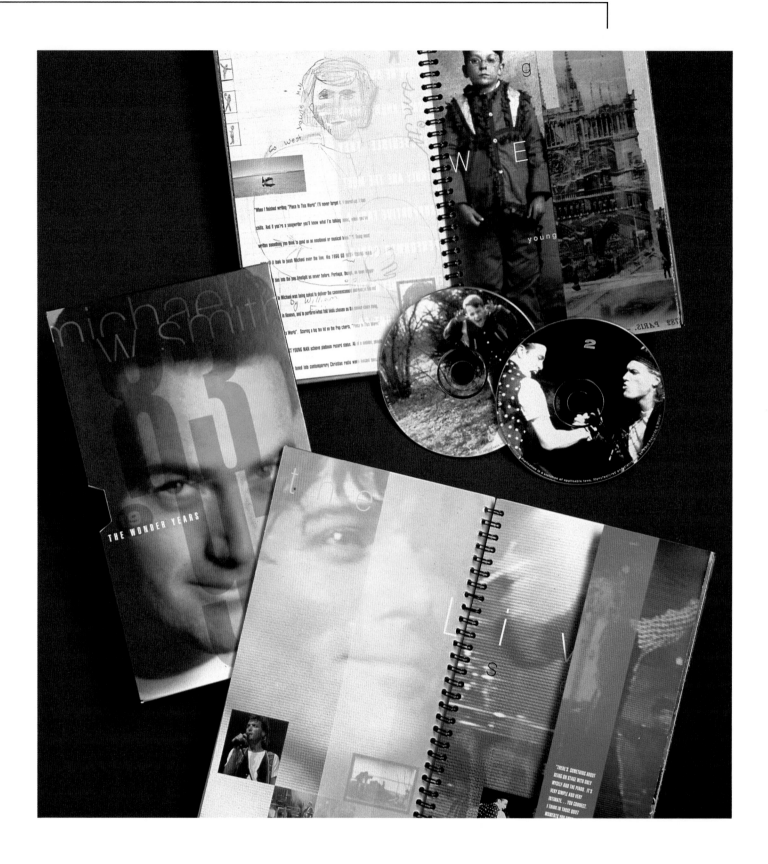

Design Firm: Jackson Design
Art Director: Buddy Jackson
Designer: Beth Middleworth
Illustrator: William Fritz
Photographers: Mark Tucker, Michael Wilson,
Alan Messer, Beth Gwinn, Jeffery Mayer
Client: Reunion Records

Objective: To create a retrospective of the
last 10 years of Michael W. Smith's music

Innovation: This complex retrospective was
designed using several layers: pictures that
included both old and new images, text, and vellum
pages. The layers infuse the design with movement
and overlapping visions, like a memory.

Anzu Menus

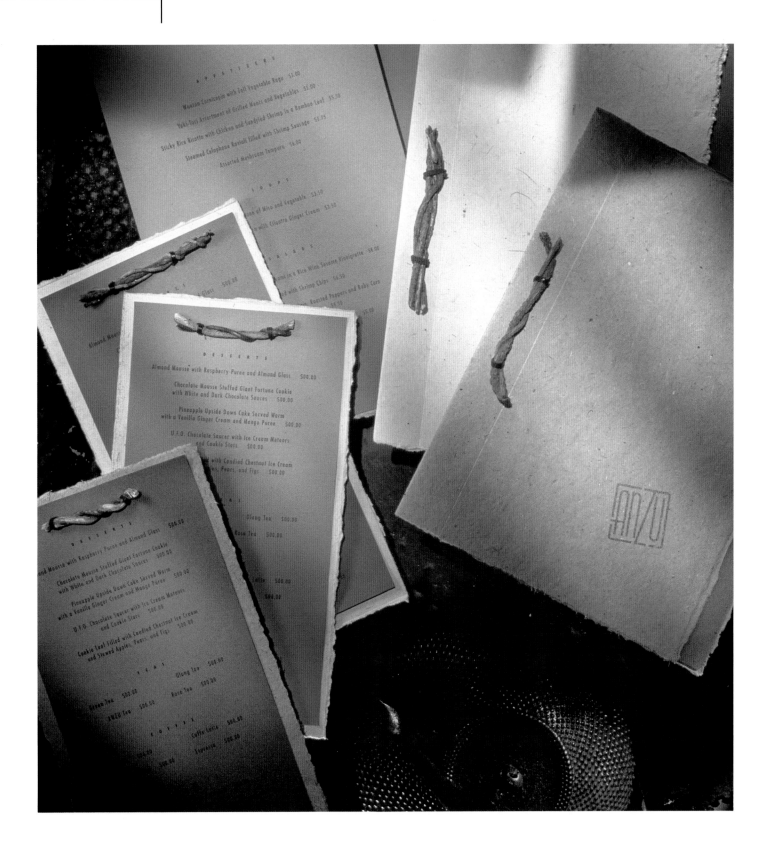

Design Firm: David Carter Design
Art Director: Sharon Lejeune
Designer: Sharon Lejeune
Illustrator: Sharon Lejeune
Client: Anzu

Objective: To create unique menus that accent the restaurant's interior design

Innovation: These menus prove that novel results are possible regardless of budget limitations. Created without traditional printing, menu covers were hand torn, bound with leather strips and twigs, and rubber-stamped with the company logo. Inserts were laser-printed on colored recycled papers.

Virtual 3-D Aeron Chair Presentation

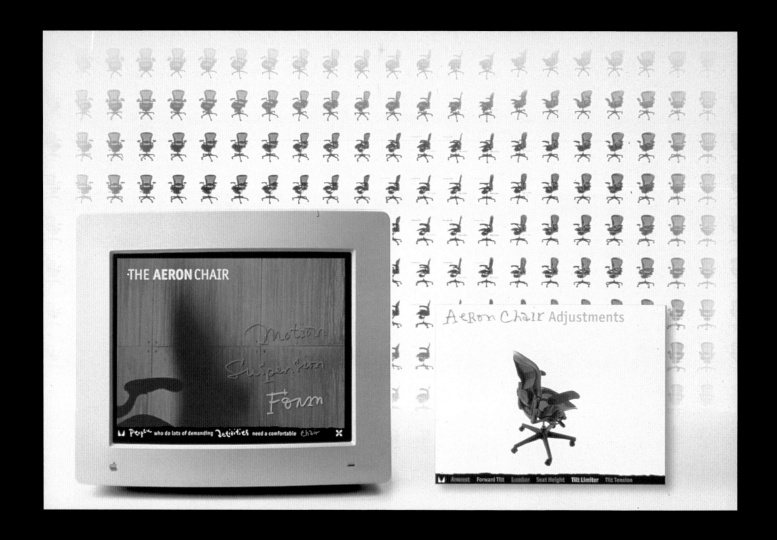

Design Firm: Clement Mok designs, inc.
Art Director: Claire Barry
Designers: Claire Barry, Paul Meiselman,
Blair Beebee, Dan O'Sullivan
Photographer: Stan Meuslik
Client: Herman Miller

Objective: To create a unique way to display and demonstrate the complexity and features of the client's product

Innovation: Can't transport a 40-pound chair to every customer site? The solution: a "navigable movie" of the chair, which combines more than 1,700 digital photographs in a computer-based presentation for a seamless, 360-degree view of the chair from multiple angles and zoom levels.

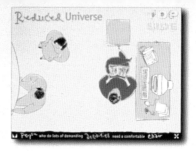

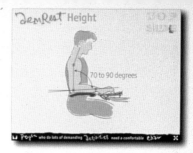

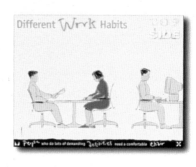

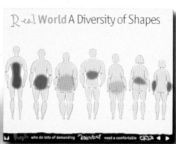

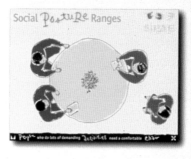

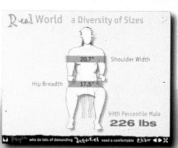

Label Bar Codes

Design Firm: THARP DID IT
Art Director: Rick Tharp
Designers: Jana Heer, Karen Nomura, Rick Tharp
Illustrator: Michael Bull
Clients: H.T. Rentsch Co., Sebastiani Vineyards

Objective: To integrate the Universal Pricing Code (UPC) into an overall label theme or package design

Innovation: The UPC symbol is illustrated so that it appears as a field of cattails on a wine bottle label, and as a set of screwdrivers in a hanging wall rack on a hardware store product. Although unlike any bar codes customers have seen before, the UPCs are scannable because the visual elements—leaves, spiked tops, screwdriver heads—are either placed out of the scanning area or printed in specially mixed inks that the scanner can not read.

Self-Promotion Kit

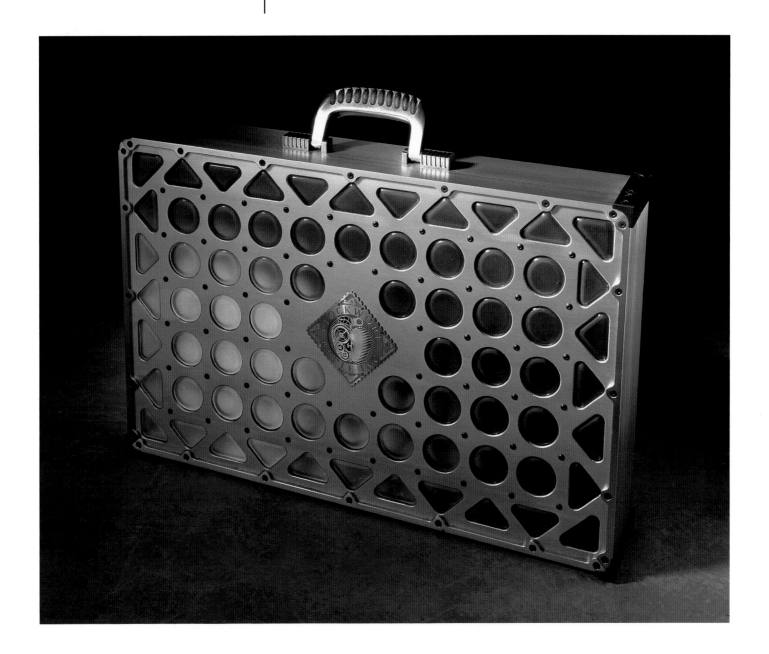

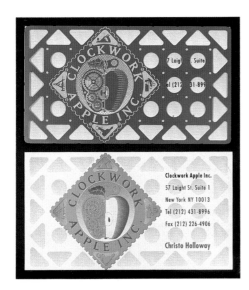

Design Firm: Clockwork Apple Inc.
Designer: Christo Holloway
Computer Work: Aryeh Hecht
Client: Clockwork Apple Inc.

Objective: To represent the range and quality of the studio's three-dimensional work to client

Innovation: By ignoring cost in the initial stages, Holloway found do-it-yourself ways of executing original, powerful techniques. The portfolio case was created first, and became the inspiration for the graphics. The business card, in its etched stainless steel case, is an actual example of the studio's detailed model-making work, and the case design was inspired by the cast-iron sidewalk grates on the streets of New York's Soho district.

Snow Dome Promotion

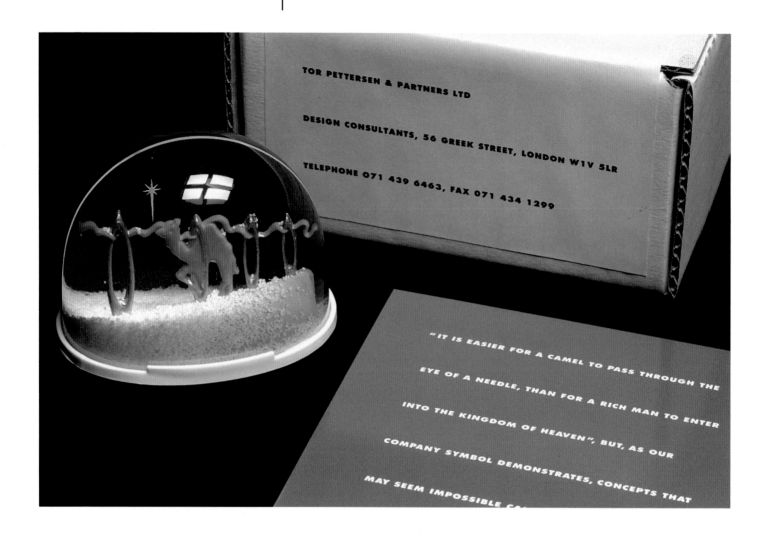

Design Firm: Tor Pettersen & Partners Ltd.
Art Director: Tor Pettersen
Designers: Tor Pettersen, Nick Kendall,
Claire Barnett, Joanna Pettersen
Model Maker: Tor Pettersen & Partners Ltd.
Client: Tor Pettersen & Partners Ltd.

Objective: To demonstrate their studio's creative ability through a project that would be used as both a Christmas mailer and a promotion for new contacts

Innovation: A visual joke and a biblical phrase were the bases of this unique promotion. The studio trademark was adapted from the phrase, "It is easier for a camel to go through the eye of a needle than for a rich man to enter the kingdom of heaven." Pettersen's mark implies that anything is possible through creative thought and design. The desert camel, ordinarily more familiar with sand storms, is represented in a snow storm to bring the middle eastern story into the northern part of the world.

Powerhouse Museum Sponsors' Board

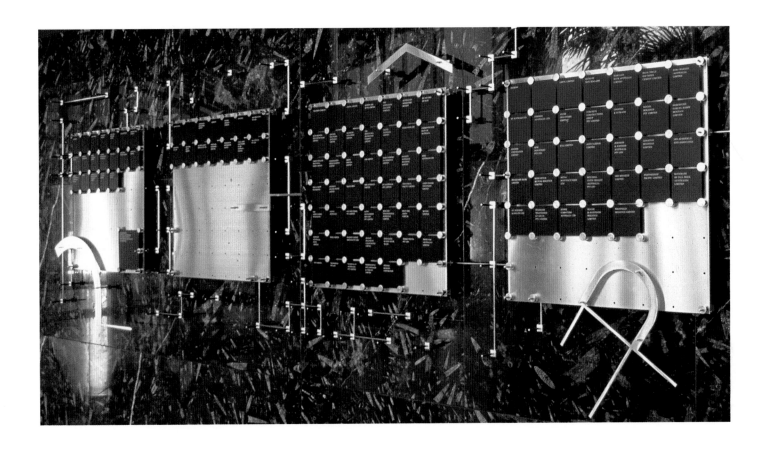

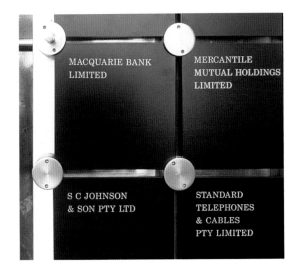

Design Firm: Emery Vincent Design
Art Director: Garry Emery
Designers: Emery Vincent Design
Illustrators: Emery Vincent Design
Client: Powerhouse Museum of Applied Arts and Sciences

Objective: To design a space for a list of sponsors' names on a museum wall

Innovation: Functionally, the sponsors' board needed to be no more than a simple list applied to a plaque. Intentions of this design are left ambiguous, however, so that it encompasses artistic object, exhibit, and a list of text information. The museum's distinctive roof profile, stylized to form the basis of its visual identity, was also used in this installation—a three-dimensional abstraction of the museum's identity.

Smith Sport Optics Merchandising Materials

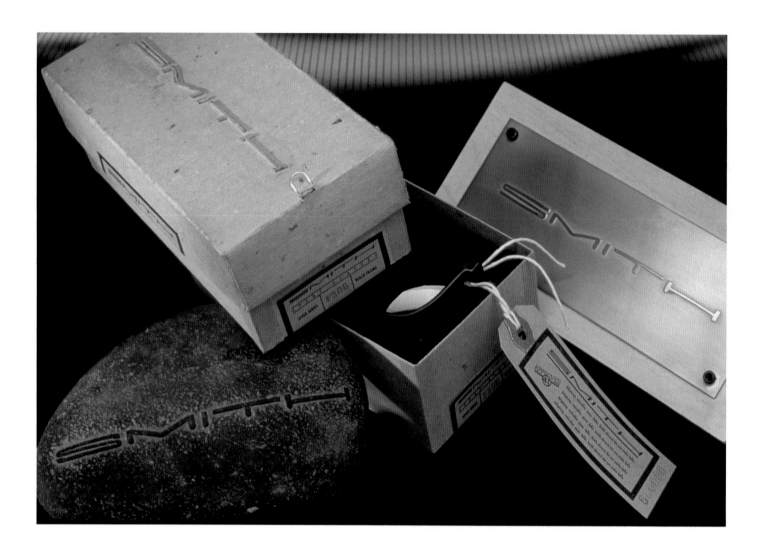

Design Firm: Hornall Anderson Design Works
Art Director: Jack Anderson
Designers: Jack Anderson, David Bates,
Cliff Chung
Client: Smith Sport Optics, Inc.

Objective: To capture the purity of the out-
doors in the merchandising of the company's
products and to differentiate the company from
its competitors

Innovation: The back-to-nature quality of the
sandblasted rock merchandising prop conveys
the client's river origins, contrasts with the
pristine glass, lucite, or wood presentations
of its competitors, and leaves an embossed
image rather than the debossed one more often
fabricated in rock substrates. Instead of
covering up the box's construction, old-fash-
ioned metal fasteners and tape are exposed
and, along with the product labels applied to
open fiber board, support an industrial image.

BOOKS, MUSIC & MORE

amazon.com

http://www.amazon.com
orders@amazon.com

Amazon.com
1 Centerpoint Blvd
P.O. Box 15550
New Castle, DE 19720–5550
USA

Toll–Free: (800) 201–7575
Voice: +1 (206) 266–2992
FAX: +1 (206) 266–2950

Your order of October 25, 1999 (Order ID 002–1639969–8203430)

Qty	Item
	In This Shipment
1	Breaking the Rules in Graphic Design (85–7–460)

This shipment c...

You can always check the status of your orde...

Thanks for shopping at Ama...

Li...
Girl Scou...
420 Fifth A...
New Yo...

ornall Anderson Design Works
Jack Anderson
ck Anderson, Jani Drewfs, David
Ryan, Scott McDougall, Rebecca Arnold
soft University

create a non-intimidating image
rials, suggestive of an experimental,
spective to learning

The overall look of this program is
the computer industry—it is not rigid,
, or structured in its graphic represen-
mplementation. The theme is based on a
computer icons, and the sedate subject
made more inviting with a palette of
ors mixed with various textures and sub-
ise of materials, such as corrugated plas-
nother avenue of distinction. Elements
eir manufacturing technology by revealing
gated plastic, rather than the usual
of coating it with vinyl.

Alley Hoop Environmental Graphics

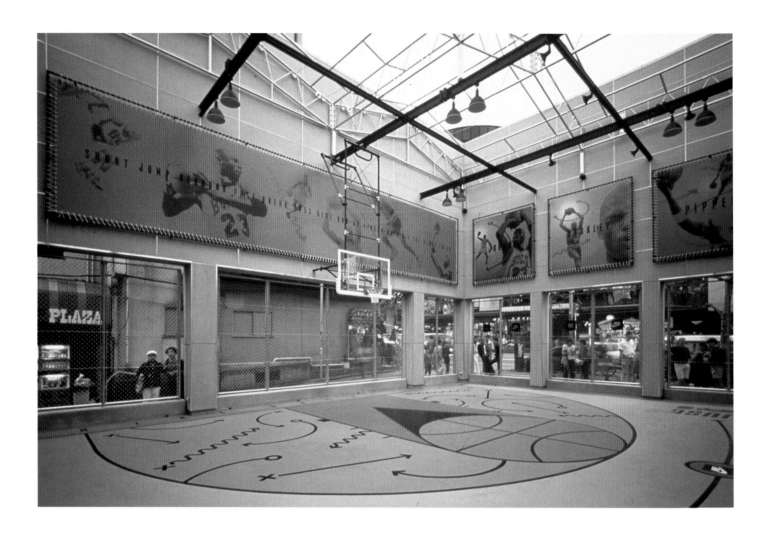

Design Firm: Nike, Inc.
Art Directors: Jeff Weithman, John Norman
Designers: John Norman, Jeff Weithman
Illustrators: Gerald Bustamante, Ben Wong
Mural Illustrator: Gerald Bustamante
Architect: Brad Berman
Copywriter: Bob Lambie
Client: Niketown Tokyo

Objective: To educate the Japanese culture about Nike "street ball" and create enthusiasm about Nike basketball

Innovation: Alley Hoop created an environment combining a competitive basketball court with retail space, so that visitors could play a game of three-on-three hoops and shop at the same time. It features a basketball concept shop, a three-on-three court, interior banners graphically linked to the court, a large exterior mural highlighting street ball, and three-dimensional exterior banners emulating basketball. Because research shows that American typography is popular in Japan, the mural and banners use type that communicate a high-energy basketball image. Grout paint was used for the court.

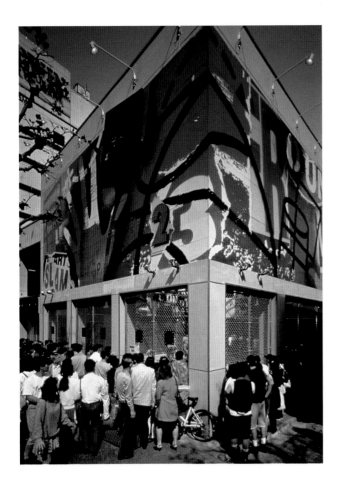

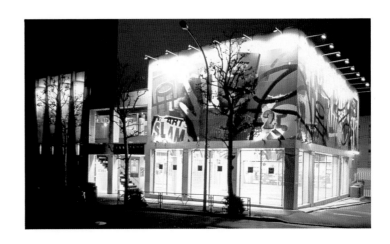

Urban Outfitters Holiday Advertisements

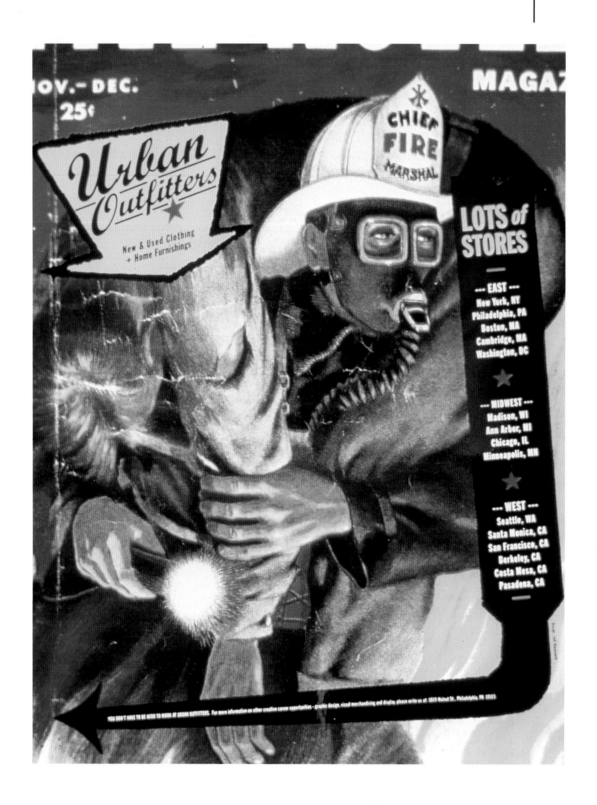

Design Firm: Urban Outfitters
Art Director: Howard Brown
Designer: Howard Brown (fire chief)
Designer: Jeff Kleinsmith (cake)
Copywriter: Howard Brown
Client: Urban Outfitters

Objective: To portray Urban Outfitters' unique image through print-media advertising

Innovation: Print ads designed for the retail industry are generally product-driven, e.g., they feature photos or descriptions of merchandise for sale. These two Urban Outfitter ads break this rule with various retro illustrations. This graphic style has, in effect, become the store's image. Items for sale are neither mentioned nor shown in the ads.

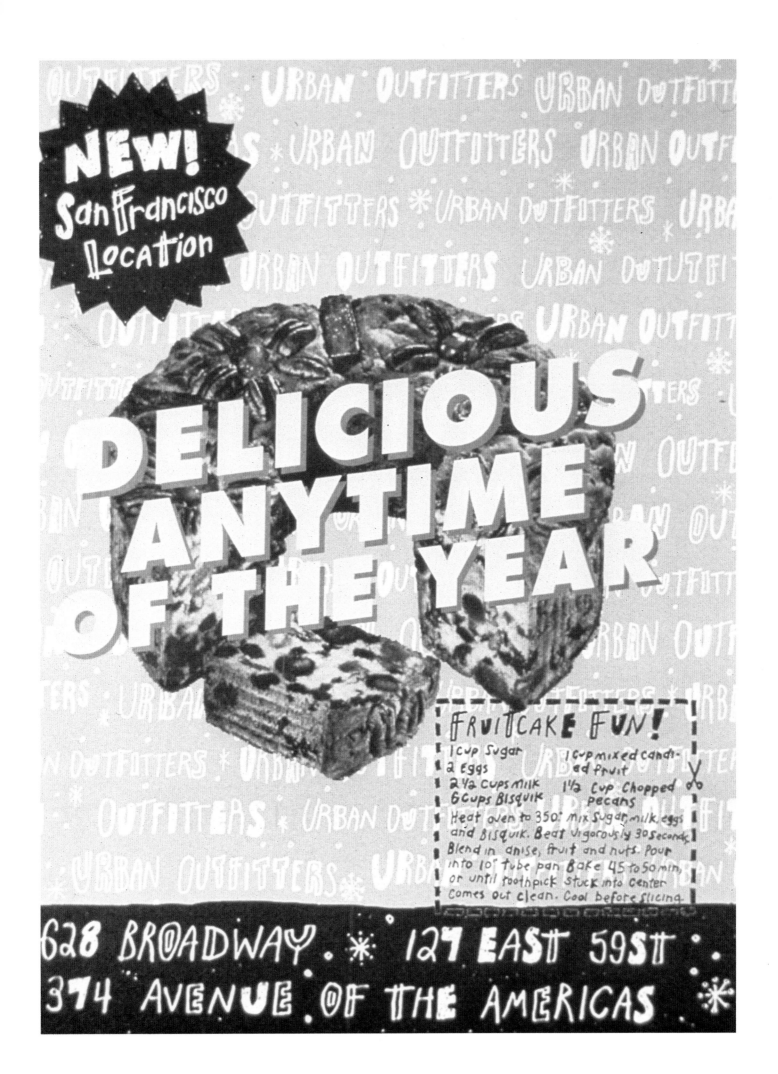

Slant Newspaper

Design Firm: Urban Outfitters
Creative Director: Howard Brown
Art Directors: Howard Brown, Art Chantry
Designer: Art Chantry
Slant Logo & Typography: Howard Brown
Editorial Director: Howard Brown
Client: Urban Outfitters

Objective: To consolidate advertising dollars, normally used for small, seasonal ads in various publications throughout the country, into a single, versatile medium

Innovation: *Slant*, a tabloid newspaper designed and distributed by Urban Outfitters, contains ads of its own brands as well as those of vendors and other companies. It also features editorial content of interest to the retailer's market. Graphically, the publication is bold, retro, and very striking—the perfect formula to reach the store's trendy, urban customer.

Design Firm: Urban Outfitters
Art Director: Howard Brown
Designer: Mike Calkins
Illustrator: Mike Calkins
Copywriter: Mike Calkins
Client: Urban Outfitters

Objective: To design a print identity for Big Smokey, a new line of outdoor clothing and accessories

Innovation: An old-time outdoorsman in flannel hat and camouflage jacket became the centerpiece for this and other ads for Big Smokey-brand clothing. Its grandfatherly identity with text written as if spoken by Doug Henderpender himself—gave the campaign authenticity and helped it reach its intended market.

Design Firm Index

After Hours Creative
15, 72, 75, 104, 105
1201 E. Jefferson, Suite 100B
Phoenix, AZ 85034

Ashby Design
84
5 Maryland Ave., Suite 1
Annapolis, MD 21401

The Bang
98, 138
618 Logan Avenue
Toronto, Ontario, Canada M4K 3C3

BBV Michael Baviera
160, 161
Rutistrasse 72
CH-8032 Zurich, Switzerland

Byron Jacobs Design
11, 135, 170
D-3, 11 MacDonnell Road
Hong Kong

Clement Mok designs, inc.
176
600 Townsend Street, Penthouse
San Francisco, CA 94103

Clockwork Apple Inc.
179
57 Laight St., Suite 1
New York, NY 10013

COY
32, 87, 150
9520 Jefferson Blvd.
Culver City, CA 90232

David Carter Design
118, 169, 175
4112 Swiss Ave.
Dallas, TX 75204

Discovery Design Group
89, 157, 159
7700 Wisconsin Ave.
Bethesda, MD 20814

Dogstar Design
7
626 54th Street South
Birmingham, AL 35212

Douglas Design Inc.
166, 167
#601 Stellaheim, Kamiyama, 5-8
Kamiyama-Cho Shibuya-Ku,
Tokyo, Japan

Earl Gee Design
9, 37
38 Bryant Street, Suite 100
San Francisco, CA 94105

Elixir Design Co.
127
17 Osgood Place
San Francisco, CA 94133

Emery Vincent Associates
181
80 Market Street
South Melbourne, Victoria 3000,
Australia

Goodby, Silverstein & Partners
147
200 Vallejo Street
San Francisco, CA 94111

Gordon Mortensen Design
27
416 Bush Street
Mountain View, CA 94041

Herman Miller In-House Design Team
152
855 E. Main Ave., P.O. Box 302
Zeeland, MI 49464

Hornall Anderson Design Works
25, 60, 123, 125, 126, 182, 183
1008 Western Ave., Suite 600
Seattle, WA 98104

I Comme Image
21
48 Rue Leon Gambetta
59000 Lille, France

Interface Designers
42, 144
Rua do Russel, 300/702
Rio de Janeiro - RJ 22210-010
Brazil

Jackson Design
174
220 25th Ave. N., Suite 205
Nashville, TN 37203

John Evans Design
68
2200 N. Lamar, Suite 220
Dallas, TX

Kan Tai-keung Design
& Associates Ltd.
8, 41, 65, 66, 67, 86, 99, 143
28/F Great Smart Tower
230 Wanchai Road
Hong Kong

Laughing Dog Creative, Inc.
95, 96, 97
900 N. Franklin, Suite 600
Chicago, IL 60610

The Leonhardt Group
154
1218 3rd Ave., Suite 620
Seattle, WA 98101

Mark Oldach Design
18
3525 N. Oakley
Chicago, IL 60618

Margo Chase Design
59, 78
2255 Bancroft Ave.
Los Angeles, CA 90039

Maureen Erbe Design
44, 109, 140
1948 South La Cienega Blvd.
Los Angeles, CA 90034

Mike Salisbury Communications
47, 103, 107, 108, 163, 164
2200 Amapola Ct.
Torrance, CA 90501

Morla Design
74, 121, 142, 162
463 Bryant Street
San Francisco, CA 94107

m/w design
56
149 Wooster Street, Room 403
New York, NY 10012

Nesnadny + Schwartz
26, 137, 146
10803 Magnolia Drive
Cleveland, OH 44106

Nike, Inc.
184
One Bowerman Drive
Beaverton, OR 97005-6453

Osborn & DeLong
94
510 E. Washington St., Suite 306
Bloomington, IL 61701

Parham Santana Inc.
14, 48, 76, 101, 168
7 W. 18th St.
New York, NY 10011

Pencil Corporate Art
88, 131, 132, 133
Heinrich-Buessing-HOF,
Boecklerstr 219
38102 Braunschweig, Germany

Penn State Design Practicomm
136
110 Patterson Bldg.
University Park, PA 16802

Pentagram Design Limited
128
11 Needham Rd.
London, W11 2RP, UK

Planet Design Company
45
229 State St.
Madison, WI 53703

Platinum Design, Inc.
124
14 W. 23rd St.
New York, NY 10010

PPA Design Limited
16, 20, 114, 115
69 Wyndham Street, 7th Floor
Hong Kong

Primo Angeli Inc.
40
590 Folsom Street
San Francisco, CA 94105

Quod Diseño y Marketing, S.A.
79, 80, 81
Carles Mercader, 9
08960 Sant Just Desvern
Barcelona, Spain

Recording Industry Association
of America
151
1020 19th Street, NW
Washington, DC 20036

Samenwerkende Ontwerpers
106
Herengracht 160-1016 BN
Amsterdam, The Netherlands

Sampson Tyrrell Ltd.
10, 28, 43, 134
6 Mercer St.
London, WC2H 9QA, UK

Sayles Graphic Design
17, 38, 49, 50, 51, 70, 73, 83,
110
308 Eighth Street
Des Moines, IA 50309

SlaughterHanson
61
2100 Morris Avenue
Birimingham, AL 35203

Sommese Design
69
481 Glenn Road
State College, PA 16803

Studio International
77, 122
Buconjićeva 43
41000 Zagreb, Croatia

SullivanPerkins
46, 90, 91, 92, 93, 113, 120
2811 McKinney, Suite 320, LB111
Dallas, TX 75204

Supon Design Group Inc.
34, 58
1700 K St., NW, Suite 400
Washington, DC 20006

Tad Co., Ltd.
22, 24, 117
5-1-5 Namba Chuo-Ku
Osaka, Japan

THARP DID IT
57, 165, 178
50 University Avenue, Suite 21
Los Gatos, CA 95030

Tor Pettersen & Partners Ltd.
180
56 Greek Street
London W1V 5LR, UK

Trickett & Webb
13, 100, 102, 111, 112, 139
The Factory
84 Marchmont Street
London, WC1N 1AG, UK

Tucker Design
52, 53, 116
4/245 Fullarton Road
Eastwood, Adelaide, South Australia
Australia 5063

Urban Outfitters
71, 155, 186, 188, 189
1809 Walnut
Philadelphia, PA 19103

Vaughn Wedeen Creative
30, 54, 148, 149
407 Rio Grande NW
Albuquerque, NM 87104

Visual Persuasion
172
303 Greenwich St., Suite 3L
New York, NY 10013

VSA Partners, Inc.
145
542 S. Dearborn, Suite 202
Chicago, IL 60605

Wages Design
19
1201 W. Peachtree St., Suite 3630
Atlanta, GA 30309

Warner Bros. Records
63
3300 Warner Blvd.
Burbank, CA 91505

The Weller Institute for the
Cure of Design
12, 158
P.O. Box 518
Oakley, UT 84055

Woods + Woods
62
414 Jackson St., Suite 304
San Francisco, CA 94111

CLIENT INDEX